SPECTACULAR RUBENS

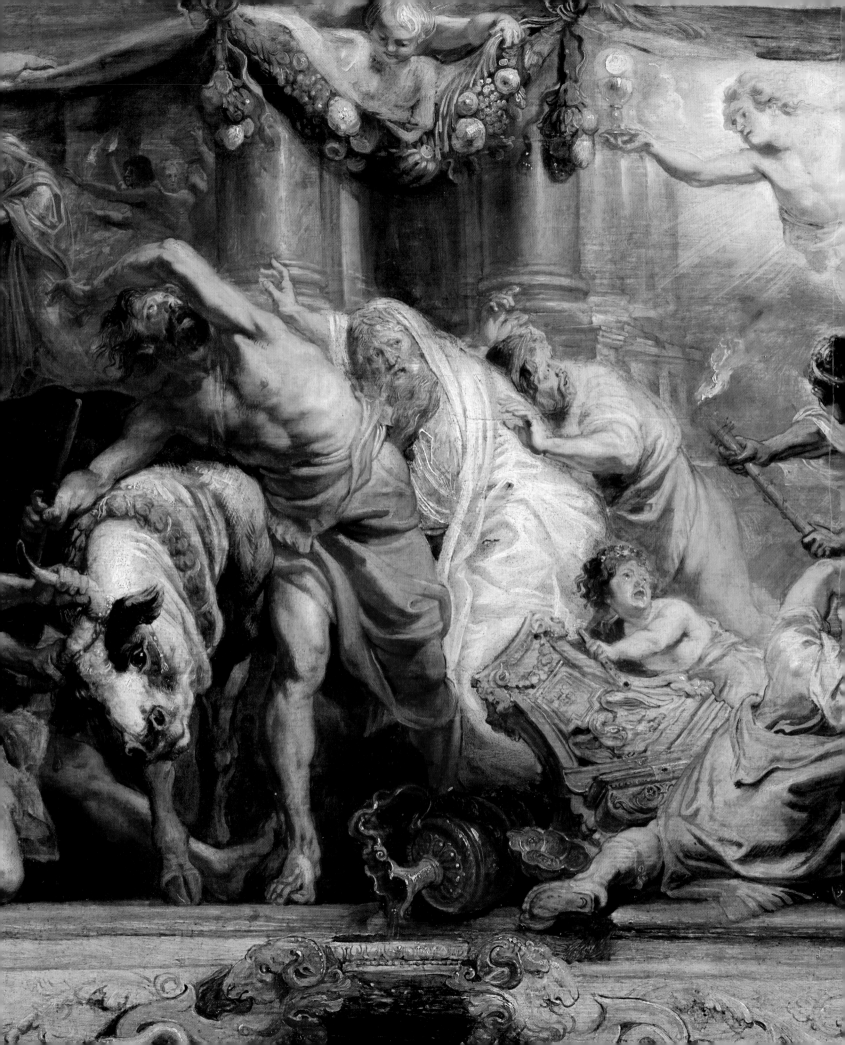

SPECTACULAR RUBENS

THE TRIUMPH OF THE EUCHARIST

EDITED BY ALEJANDRO VERGARA AND ANNE T. WOOLLETT

THE J. PAUL GETTY MUSEUM | LOS ANGELES

MUSEO NACIONAL DEL PRADO | MADRID

This publication is issued on the occasion of the exhibition *Spectacular Rubens: The Triumph of the Eucharist*, on view at the J. Paul Getty Museum at the Getty Center, Los Angeles, from October 14, 2014, to January 11, 2015, and at the Museum of Fine Arts, Houston, from February 15 to May 10, 2015. The exhibition debuted at the Museo Nacional del Prado, Madrid, with the title *Rubens. El triunfo de la Eucaristía*, from March 25 to June 29, 2014.

The exhibition is organized by the Museo Nacional del Prado in collaboration with the J. Paul Getty Museum.

The restoration of the Rubens *Eucharist* paintings in the Prado was undertaken with the sponsorship of Fundación Iberdrola and the support of the Getty Foundation Panel Paintings Initiative.

Published by the J. Paul Getty Museum, Los Angeles
Getty Publications
1200 Getty Center Drive, Suite 500
Los Angeles, California 90049-1682
www.getty.edu/publications

Elizabeth S. G. Nicholson, Editor
Sheila Berg, Manuscript Editor
Catherine Lorenz, Designer
Amita Molloy, Production Coordinator

The essay by Ana García Sanz was translated from the Spanish by Debra Nagao and Elizabeth Nicholson; the essay by María Antonia López de Asiaín was translated by Debra Nagao, the essay by George Bisacca, José de la Fuente, and Jonathan Graindorge Lamour was translated from the Spanish by Jenny Dodman.

NOTE TO THE READER
In a revision to *Rubens. El triunfo de la Eucaristía* (the Spanish edition of this publication), the *Eucharist* tapestries are here ascribed to Jan Raes I (1574-1651), in accordance with Brosens 2010, which updates earlier scholarship on the Raes family.

Printed in China

Library of Congress Cataloging-in-Publication Data

Spectacular Rubens : the Triumph of the Eucharist / edited by Alejandro Vergara and Anne T. Woollett.
 pages cm
 "This publication is issued on the occasion of the exhibition Spectacular Rubens: The Triumph of the Eucharist, on view at the J. Paul Getty Museum at the Getty Center, Los Angeles, from October 14, 2014, to January 11, 2015, and at the Museum of Fine Arts, Houston, from February 15 to May 10, 2015. The exhibition debuted at the Museo Nacional del Prado, Madrid, with the title Rubens. El triunfo de la Eucaristía, from March 25 to June 29, 2014."—ECIP galley.
 "The exhibition is organized by the Museo Nacional del Prado in collaboration with the J. Paul Getty Museum."—ECIP galley.
 "The essay by Ana García Sanz was translated from the Spanish by Debra Nagao and Elizabeth Nicholson; the essay by María Antonia López de Asiaín was translated by Debra Nagao. The essay by George Bisacca, José de la Fuente, and Jonathan Graindorge Lamour was translated from the Spanish by Jenny Dodman."—ECIP galley.
 Includes bibliographical references and index.
 ISBN 978-1-60606-430-6 (pbk.)
 1. Rubens, Peter Paul, 1577-1640. Triumph of the Eucharist—Exhibitions.
 2. Rubens, Peter Paul, 1577-1640—Criticism and interpretation. I. Rubens, Peter Paul, 1577-1640, artist. II. Vergara, Alejandro, 1960- editor. III. Woollett, Anne T., editor. IV. J. Paul Getty Museum, host institution, issuing body. V. Museo del Prado, host institution.
 ND673.R9A777 2014
 759.9493--dc23
 2014019225

COVER: Peter Paul Rubens, *The Triumph of the Church* (cat. 6), detail.
FRONT FLAP: Woven by Jan Raes I after designs by Peter Paul Rubens, *The Triumph of the Church* (cat. 7), detail.
FRONTISPIECE: Peter Paul Rubens, *The Victory of the Eucharist over Idolatry* (cat. 8), detail.

ILLUSTRATION CREDITS
Antwerp, Sint-Pauluskerk, © Lukas-Art in Flanders vzw
 (photo: Hugo Maertens), fig. 7
Boston, photo © 2014. Museum of Fine Arts, Boston, fig. 9
Cambridge, Fitzwilliam Museum, Bridgeman Art Library, fig. 12
Chicago, © The Art Institute of Chicago, fig. 18
Gloucester, England, courtesy the Earl of Wemyss and March, K.T., fig. 3
Los Angeles, J. Paul Getty Museum, fig. 4
Los Angeles, Los Angeles County Museum of Art, fig. 11
Louisville, Speed Art Museum, fig. 10
Madrid, Archivo del Monasterio de las Descalzas Reales, fig. 19
Madrid, Archivo Fotográfico del Museo Nacional del Prado, figs. 1, 2, 5, 8, 13, 16, 44–52, 59, 60, 66–80, and cat. 1, 2, 4, 6, 8, 9
Madrid, © Patrimonio Nacional, figs. 25–43, cat. 3, 5, 10
Madrid, © Patrimonio Nacional / Fundación Carlos de Amberes
 (photo: P. M. R. Maeyaert), figs. 17, 24
New York, courtesy Bruce M. White, cat. 7
Pasadena, Norton Simon Art Foundation, Gift of Mr. Norton Simon, fig. 6
Sarasota, John and Mabel Ringling Museum of Art, fig. 15
Washington, National Gallery of Art, figs. 14, 56

CONTENTS

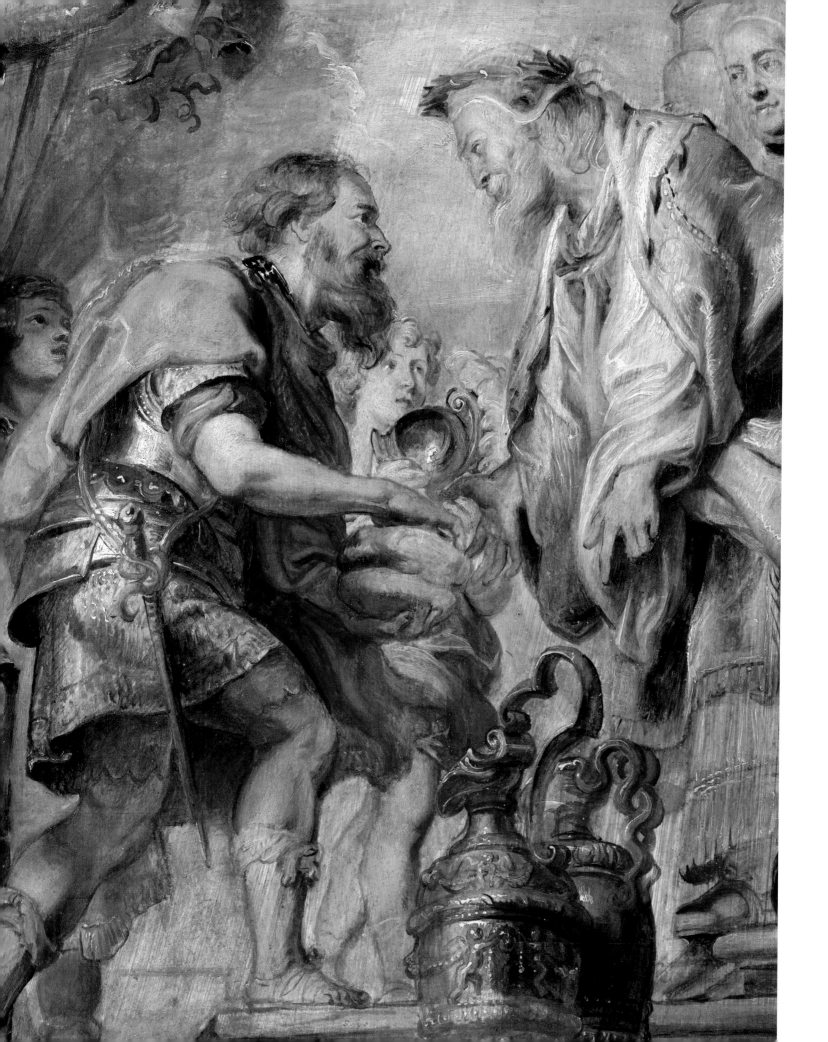

FOREWORD

Miguel Zugaza | Director | Museo Nacional del Prado
Timothy Potts | Director | J. Paul Getty Museum

Among the most important duties of a museum are caring for its collection, making it available to the public, and studying and interpreting it in accordance with the highest standards. Collaboration with partner institutions enhances the ability to achieve and extend these aims.

The conservation and study of the *Triumph of the Eucharist* paintings by Peter Paul Rubens, which are among the highlights of the Museo Nacional del Prado's superb collection of Flemish paintings, has been carried out in partnership with the Getty Foundation in Los Angeles. The exhibition *Spectacular Rubens: The Triumph of the Eucharist*, a collaborative project of the Prado and the J. Paul Getty Museum, celebrates the art of Rubens and provides an in-depth examination of one of his most important commissions.

In 2010 the Prado decided to undertake the complex restoration of this important group of paintings, which involved removing later additions to the wood panel supports. The pictures are large, brilliantly detailed sketches (*modelli*) painted in preparation for the tapestries of the *Eucharist* series, one of Rubens's greatest commissions. Unfortunately, subsequent additions, introduced long after the paintings were created, made the panels considerably larger than Rubens intended and caused serious damage to the original sections. The paintings have now been restored and returned to their original dimensions.

With its expertise in the restoration of panel supports and paintings by Rubens, the Prado's conservation department was ideally suited to undertake this endeavor. The complexity of the task and the experience of the conservation team resulted in the project's selection as a model for similar restorations. The Getty Foundation's Panel Paintings Initiative, led by Antoine Wilmering, senior program officer, had been established in 2008 to ensure that the next generation of conservators of paintings on wood supports is properly trained. A two-year grant through that initiative (2011–13) supported the restoration of these six panels and the training of panel conservators, which has taken place in the Prado's conservation studio. Seven trainees from seven countries and at different stages in their careers were selected by José de la Fuente, the Prado conservator in charge of this project, together with George Bisacca, conservator at the Metropolitan Museum of Art. In June 2013 an international conference was held at the Prado to present the results of the restoration and training to a larger group of conservators. Thanks to the support of the Panel Paintings Initiative, the Prado has become a leader in the treatment and training of conservators of wood supports for paintings.

With their supports stabilized and the surfaces newly cleaned, the magnificent oil sketches can once again be placed on public view. In Madrid, a long-held dream of uniting Rubens's designs with the original tapestries from the nearby Convent of the Descalzas Reales became a reality with the organization of the present exhibition. Alejandro Vergara, senior curator of Flemish and Northern European paintings at the Prado, and Anne Woollett, curator of paintings at the Getty Museum, are responsible for the selection of works in the exhibition and have collaborated on this publication, which provides many new insights into the history of the *Eucharist* series and Rubens's art.

The tapestries of the *Eucharist* series are among the finest made in Europe in the seventeenth century. Thanks to the generosity of the Patrimonio Nacional, four tapestries (from the series of twenty) have been lent to our museums from the Monasterio de las Descalzas Reales in Madrid, the place for which they were made. The opportunity to show them to a broad public is in itself reason for celebration and is an extraordinary privilege for both the Prado and the J. Paul Getty Museum.

The restoration of the six paintings in this exhibition was also made possible by the support of the Fundación Iberdrola, patron of the Programa de Restauración del Museo del Prado, whose generosity we wish to acknowledge.

We are pleased to mark the fruitful partnership between our institutions with this exhibition, which presents the newly conserved paintings for the *Triumph of the Eucharist* tapestries to the public for the first time in many years, and which attests to the exhilarating art of Peter Paul Rubens.

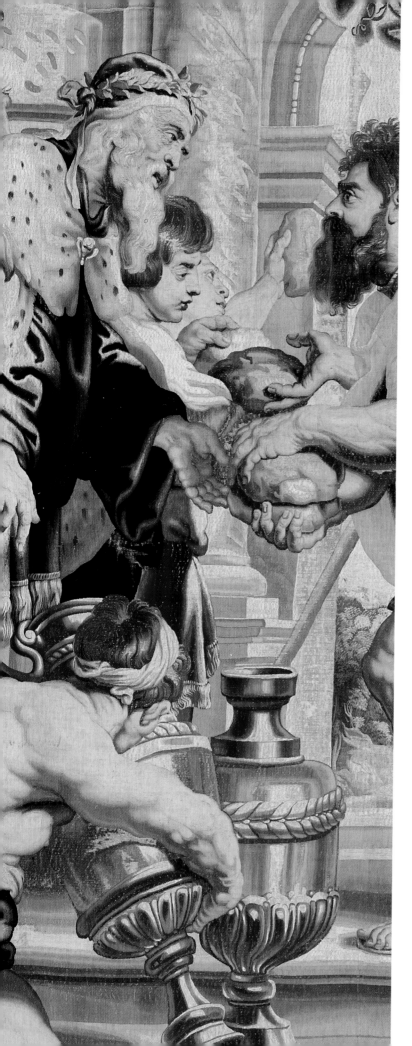

ACKNOWLEDGMENTS

The art of Peter Paul Rubens occupies a central place in the collections and scholarship of the Museo Nacional del Prado and the J. Paul Getty Museum. The Prado houses the largest collection of *modelli* for the *Triumph of the Eucharist* series, only a few miles from the tapestries and the convent for which they were made. This exhibition realizes the simple but meaningful ambition to experience the magnificent creative power of Rubens's inventions in both their initial painted compositions, recently transformed by restoration, and the expression of his vision on a grand scale in wool and silk that are among the most celebrated treasures at the Monasterio de las Descalzas Reales. The juxtaposition of both media has only rarely been achieved in the past, and the number of paintings and corresponding tapestries presented in Madrid and Los Angeles is the largest group assembled in over fifty years.

The vitality and conviction of Rubens's visual language moves with extraordinary ease from the confines of the oak panels to the expanse of the monumental tapestries. Unlike the other major projects that occupied him during the 1620s, such as the *Story of Constantine*, the Medici cycle, and the Whitehall ceiling, the series of tapestries commissioned by the Infanta Isabel Clara Eugenia was a collaborative project between patron and painter. Rubens was wholly committed to the Habsburg state and its policies, but the vigor and energy of the compositions reveal something much more personal about his deep spiritual convictions—a plane on which he connected with his patron.

Miguel Zugaza, director of the Museo del Prado, recognized and supported the need to conserve the paintings and from the beginning embraced the idea of a small exhibition with enormous visual impact. Without the willingness and generosity of Patrimonio Nacional, the juxtaposition of spirited paintings and stirring hangings in Madrid and Los Angeles could not have taken place, and we thank José Rodriguez-Spiteri Palazuelo, president of the Consejo de Administración; José Luis Diéz, director of the Colecciones Reales; Alicia Pastor Mor, consejera gerente; and Ana García Sanz, curator of the Descalzas Reales, for their generous support. We are grateful to Timothy Potts, director of

Alejandro Vergara and Anne T. Woollett

the J. Paul Getty Museum, for seizing the opportunity to bring the exhibition to the West Coast.

The restoration of the wood panels and the training of restorers were supported by the Getty Foundation Panel Paintings Initiative, and we recognize the insightful leadership of the Getty Foundation director, Deborah Marrow. Senior program officer Antoine Wilmering's zeal and good humor shaped the project during its earliest stages at the Prado.

In Madrid, we are particularly indebted to Álvaro Soler del Campo, Patrimonio Nacional, and the Reverend Mother Abbess Sor María Rosa de Santiago for their heartening positive response to the concept.

We are grateful to the Los Angeles County Museum of Art (LACMA), the Norton Simon Museum, the San Diego Museum of Art, and the National Gallery of Art, Washington, DC, for generous loans to the Los Angeles venue, which helped to expand on themes and represent the holdings of paintings related to the *Eucharist* series in Southern California.

Despite considerable and insightful scholarship on the *Triumph of the Eucharist* over the past century, many practical questions remain unanswered. Exploring issues such as the timing of Rubens's execution of the sketches, the likely reasons for the size and nature of the commission by the Infanta Isabel Clara Eugenia, and the various plausible arrangements of the tapestries, among many others, made this project especially intriguing. We would like to thank our fellow authors for their stimulating conversations and excellent contributions to the catalogue. Gabriele Finaldi's thoughtful suggestions significantly improved our texts at a crucial stage.

Numerous friends and colleagues have contributed to our thinking on Rubens's working method, including Joost van der Auwera, Virginia Brilliant, Fiona Healy, Alexandra Libby, Susan Merriam, Arthur Wheelock, and Marjorie E. Wieseman. At the Getty Museum, Charissa Bremer-David was a source of inspiration and expertise from the outset, and Scott Schaefer provided crucial early support for the project. Koen Brosens and Elizabeth Cleland generously shared their insights on Rubens and the tapestry medium.

Many colleagues at the Museo del Prado and the J. Paul Getty Museum worked with alacrity and enthusiasm to realize the exhibition and catalogue, and their efforts are much appreciated. In Madrid, the exhibition was realized by Karina Marotta and Carmen Morais of the Prado's Exhibitions Department. Jesús Moreno y Asociados created the harmonious exhibition galleries, and Mikel Garay, from the Prado, was responsible for graphic design. The Spanish catalogue was expertly produced by María Dolores Gómez de Aranda, Raquel Gónzalez Escribano, and Chusa Hernández Pezzi, with translations by María Luisa Balseiro and María Condor. In Los Angeles, the exhibition was organized by Quincy Houghton and Amber Keller in the Exhibitions Department and deftly implemented by Sally Hibbard, Jacqueline Cabrera, Betsy Severance, Mari-Tere Alvarez, Chris Keledjian, Kevin Marshall, and Michael Mitchel. Conservators Yvonne Szafran, Sue Ann Chui, and Brian Considine were important collaborators. Elie Glyn and Amanda Ramirez, working with Merritt Price in the Design Department, developed the handsome installation of the exhibition. The production of the catalogue in Los Angeles under the direction of Kara Kirk and Rob Flynn reflects the expertise of Elizabeth Nicholson, Catherine Lorenz, and Amita Molloy and the key contributions of Sheila Berg, Karen Stough, and Debra Nagao.

For their many and varied contributions, we express our appreciation to Carlos Bayod Lucini, Pilar Benito, Veronique Bücken, Paloma Callejo, Immaculada Candil, Carolina García-Romeu, Catherine Geens, Chiyo Ishikawa, Rhonda Kasl, Kristin Kennedy, Aimee Lind, Adam Lowe, Lourdes de Luis Sierra, Juan Carlos de la Mata, Archna Patel, Thomas Kren, Andrea San Valentín, and the community of the Franciscan Poor Clares of the Descalzas Reales.

To all those who helped realize this splendid experience—a Baroque spectacle—we extend our deepest gratitude.

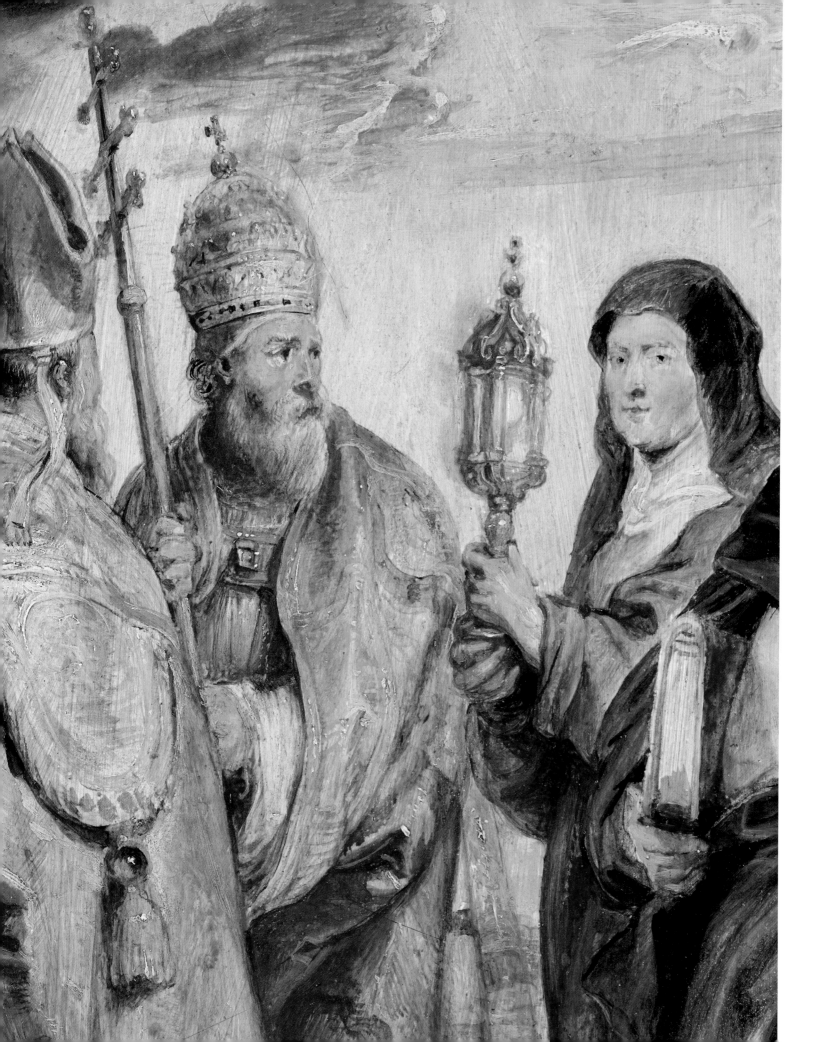

FAITH AND GLORY
THE INFANTA ISABEL CLARA EUGENIA AND THE *TRIUMPH OF THE EUCHARIST*

Anne T. Woollett

Among the artistic feats of Peter Paul Rubens (1577–1640), few were more extraordinary than the series of tapestries known as the *Triumph of the Eucharist* (ca. 1625–33). Designed by the painter in oil on small panels (*modelli*) and transformed into monumental hangings by the finest Brussels weavers, the set of twenty pieces celebrates the central mystery of the Roman Catholic Church, the real presence of God in the Eucharist (transubstantiation). Rubens's vivid compositions promote the transcendent nature of the sacrament with exhilarating visual strategies and powerful allegories. The tapestries were commissioned by the Infanta Isabel Clara Eugenia (1566–1633), governor-general of the Southern Netherlands, as a gift to the Franciscan Monasterio de las Descalzas Reales (Convent of the Barefoot Royals) in Madrid, where they remain today. The vigorous spirit of the series reflects the dynamic partnership between the Infanta and Rubens, her court painter and diplomat. They envisioned a unified decorative program that would transform the austere convent church and cloister during the annual eucharistic feasts with vibrant figural compositions within illusionistic architectural frames arrayed on two levels.[1] Rubens innovatively enhanced the spectacle by portraying the largest scenes as tapestries within the tapestries, shown being installed by cherubs. The Infanta and Rubens were united in their devout faith and commitment to the successful execution of Habsburg religio-political ideals. The resulting paintings and tapestries of the *Eucharist* series were Isabel Clara Eugenia's greatest act of patronage and an eloquent expression of the power of art in the service of the Catholic Church.

Almost nothing is known about the circumstances of the *Eucharist* series' commission, as documentation, including contracts, directives, and accounts, has been lost.[2] The installation and use of the tapestries in the convent have been much discussed but until recently little understood.[3] The series was famous in Spain,[4] and the compositions and pictorial innovations of Rubens's *modelli* influenced painters and tapestry design. Some of the *modelli*, including those in the Museo Nacional del Prado today (cat. 1, 2, 4, 6, 8, 9), eventually entered the Spanish royal collection, while others dispersed widely to private owners.[5]

Rubens was a master at devising large-scale projects. The *Eucharist* series was among the most complex challenges of the 1620s, a decade of major commissions for ceiling programs (the Jesuit church in Antwerp and the Banqueting Hall at Whitehall, London), tapestry series (the *Story of Constantine*), and biographical cycles (the *Medici* series and the *Henry IV* series).[6] Scholars engaged in the immense task of interpreting the *Eucharist* series in its multiple phases of preparatory designs and execution in the workshops of four weavers have focused primarily on analysis of the rich allegorical program, identification of Rubens's sources, and reconstruction of the arrangement of the tapestries in the church of the Descalzas Reales.[7] Until the late twentieth century, a paucity of information about the art collection of the Descalzas Reales, little appreciation of the convent's role in the political life of the Spanish court, and the absence of a balanced biography of the Infanta obscured the importance of the life and values of Isabel herself to the creation of the series. Moreover, Isabel's presentation of the *Eucharist* tapestries to the Descalzas Reales became too neatly summarized as the offering of an aged, devout, and nostalgic Spanish princess—consigned to a life of duty in Brussels—to a distant enclosed community of nuns.

Recent scholarship sheds light on many facets of the historical context of the commission, its charismatic and ambitious patron, and Rubens's approach to tapestry design. Analysis of the political and religious upheavals in the territories of the Netherlands both prior to and during the period they were governed by Isabel, first jointly with her husband, Archduke Albert (1559–1621), from 1599 to 1621 and then alone until her death in 1633, reveals the difficulties they inherited and strove to ameliorate with firm and often sympathetic policies.[8] In-depth studies based on archival investigation illuminate the

FIG. 1 | Peter Paul Rubens, *The Defenders of the Eucharist* (cat. 1), detail showing Saint Augustine, Saint Gregory the Great, and Saint Clare of Assisi.

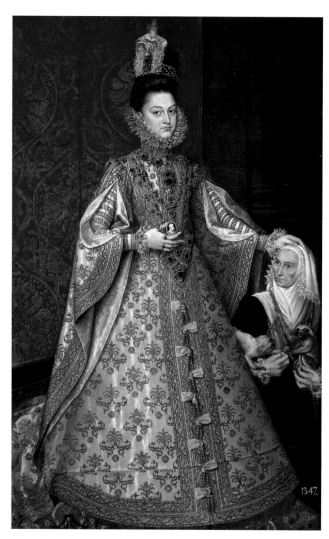

FIG. 2 | Alonso Sánchez Coello, *The Infanta Isabel Clara Eugenia with Magdalena Ruiz,* ca. 1585–88. Oil on canvas, 208.5 × 130.6 cm (82⅛ × 51⁷⁄₁₆ in.), Madrid, Museo Nacional del Prado, P-861.

quasi-monastic character of the archducal court in Brussels.[9] Research in the burgeoning field of female religious communities suggests the variety of practices among foundations in different regions. Investigations of female Habsburg rulers reveal that Isabel and her female relations constituted an effective network of regents, widows, and queens who participated in politics from the protected environments of convents, either as residents or as nuns.[10] Renewed interest in the archdukes Albert and Isabel, resulting from exhibitions devoted to their government and art patronage held in Brussels and Madrid, spurred publication of specialized studies examining their lives.[11]

One of the most highly born women in Europe, Isabel Clara Eugenia not only exercised an important function in Habsburg hegemony but served as a role model. Along with territorial battles, she and her husband engaged in a policy of militant Catholicism, working tirelessly to implement the decrees of the Council of Trent.[12] The Infanta was exuberantly praised for her piety and generosity. Shortly after her death, the populace of the Netherlands was exhorted "vehemently to strive, if we wish to be useful to church and state, to excel in every kind of virtue, emulating the most holy princess Isabel."[13] The priest Philippe Chifflet, head of her oratory, assembled lively anecdotes of her brilliant character in preparation for a hagiography of the Infanta. The unpublished material in turn provided the basis for the first comprehensive biography of Isabel, published in 1912.[14] Sensational contemporary accounts of Isabel's spirited personality, boldness, and wit influenced modern treatments of her.[15] Among the most fascinating portrayals are numerous early portraits in which she appears as a towering figure encased in formal gowns glittering with pearls and precious stones. In the portrait at left, made when she was twenty, her steely gaze commands attention amid the accouterments of her rank (fig. 2).

The Infanta almost certainly ordered the *Eucharist* series, perhaps as early as 1622. Her decision to celebrate the sacrament, to which she was deeply devoted, and the conviction of the tone of the series not only reflected the immediate circumstances of her rule in the 1620s but also originated from the deepest levels of Habsburg dynastic tradition. Her gift in addition deliberately celebrated the talents of Flemish artists in Spain. After briefly tracing the Infanta's path from the court of her father, Philip II of Spain (1527–1598), to her own pious court in Brussels, this essay considers why the tapestries may have been undertaken early in her sole reign, and then it examines the commission in more depth. Employing a familiar but

nonetheless remarkable working process, Rubens translated a devotional and political agenda into an exhilarating array of enduring beauty.

THE INFANTA'S UPBRINGING IN SPAIN

Isabel Clara Eugenia was born on August 12, 1566, in Segovia, the eldest daughter of Philip II and his third wife, Elizabeth de Valois (1545–1568). She was named for her mother and paternal grandmother, Isabel of Portugal (1503–1539), the Franciscan Saint Clare of Assisi (1194–1253), on whose name day she was born, and Saint Eugene (d. 657), whose relics were transferred to Toledo at the time of her birth. The life of Isabel, who was described by ambassadors at court as beautiful and intelligent, was defined by the extremes of privilege and humility that confronted Habsburg women in the late sixteenth and early seventeenth centuries.[16]

Within the circumscribed society of the court, Isabel observed regular devotional practices and varied pastimes. From an early age, the Infanta heard mass daily and took communion according to a rigorous program she later recalled wistfully.[17] She was considered an "Amazon" by court commentators, and her robust pursuits included singing and dancing with aplomb,[18] riding, and falconry. Her proficiency with the crossbow at age twenty-two, when she shot a deer from her carriage, thrilled courtiers.[19]

The portraits of the Infanta as a young woman convey confidence and intelligence, in contrast to the official likenesses of some of the Habsburg princes, notably those of her future spouse, the cardinal-archduke Albert, who appears reticent in early portraits.[20] Diplomatic reports, such as the account by the Venetian ambassador Matteo Zane in 1584, made Philip II's preference for Isabel well known outside Spain: "Besides being of so pious and religious a mind . . . she is endowed with such virtue and prudence as would make her very worthy to rule."[21] She received valuable preparation for her later role as ruler assisting her father with affairs of state by annotating and helping him to sign documents.

The affairs of the Netherlands and its art and artists played a defining role in the culture of the Spanish court. Isabel grew up with an affinity for the Habsburg territories, shaped in part by her father's fond recollection of his tour in 1548–49, when he was received as the heir of Emperor Charles V (1500–1558) by all the principal cities.[22] However, one of the most troublesome situations in Philip II's dominions was the religious uprising and then rebellion of the northern provinces. Spurred in part by Protestant outdoor preachers, angry mobs attacked churches and the accouterments of Catholic worship seen as symbols of Spanish authority, such as altarpieces.[23] The brutality of the third duke of Alva, dispatched by Philip II to bring the defiant population into line, and Spain's failure to support its troops led to the organization of anti-Catholic forces. Alessandro Farnese recaptured the major cities of the south, including the commercial center of Antwerp in 1585, after a long, damaging siege, and forcibly returned them to the Catholic faith.[24] The Infanta's birth in 1566, the year of the outbreak of the violent iconoclastic riots across the Netherlands, symbolically marked her destiny. Working at her father's side, she possessed an intimate perspective on the rebellion and subsequent decisions to reestablish the Catholic faith and obedience to Spain.

As the daughter of one of Europe's most significant patrons, with a marked taste for Flemish art, the Infanta was familiar with the artistic heritage of the region, which was of the greatest import for her future role. Philip II continued the practice of his aunt Mary of Hungary (1505–1558) and father, bringing Flemish devotional paintings back to Spain and commissioning his court painter, Michiel Coxcie (1499–1592), to paint copies of important works. The king's collection included several works by Hieronymus Bosch (ca. 1450–1516), and in one of numerous letters to his daughters, he tells them he has seen a Corpus Christi procession in Lisbon featuring devils like those depicted by "Jéronimo Bosco."[25]

The Habsburg court expressed princely piety in the form of major building projects that combined royal retreats with enclosed religious communities. On the grandest scale was the Monasterio San Lorenzo El Escorial in the Sierra de Guadarrama, at the base of Mount Abantos (begun 1563). Built under Philip II's direction by the royal architect Juan Bautista de Toledo (ca. 1515–1567) and finished by his assistant Juan de Herrera (1530–1597), it combined a royal palace with a library and a Hieronymite monastery and basilica and housed administrative offices and the king's collection of religious paintings, while serving occasionally as a hunting lodge, all in a vast edifice of local gray granite.[26]

Though far smaller in scale than the king's monastery-palace, the Madrid convent for noblewomen occupied a disproportionately important role in the life of the royal family. The Infanta Juana of Austria (1535–1573), sister of Philip II, founded the Descalzas Reales in 1556 and installed a community of Franciscan nuns from the celebrated convent of Poor Clares at Gandía (Valencia) in 1559.[27] As with El Escorial, the restrained brick and granite exterior represented an enduring commitment to the

ideals of faith and duty, and the structure associated the Habsburgs with Rome through its austere architectural style. Because it was an institution under royal protection, female members of the royal family and their children resided within its walls when the king traveled to other regions of the kingdom. Isabel Clara Eugenia visited the convent frequently, including for longer stays in 1581 and 1598. With the transfer of the capital from Toledo to Madrid in 1561, the convent assumed greater significance. In addition to the community of nuns, the empress María of Austria (1528–1603) lived there, along with her daughter Margarita (1567–1633), who professed and entered the convent with the name Margarita de la Cruz. A distinctive feature of the Descalzas Reales was its semipermeable nature. The king and royal family attended mass in its church, which was treated as a royal chapel. The empress, a widow who had not taken orders but committed herself to a life of humility and devotion in keeping with the Order of the Poor Clares, moved freely in and out of the convent and maintained her active involvement in affairs of state.[28]

The celebration of the feast of the Holy Sacrament was a vital part of the convent's presence in Madrid. The Infanta Juana honored the feast with lavish gifts of jewels and ensured that the feasts of Corpus Christi and Octave were celebrated publicly with processions.[29] The royal family attended mass and participated in the Holy Day festivities, and young Isabel would have observed the decoration of the church and cloister with "drapery" as specified by her aunt so that "feasts are celebrated with especial solemnity with the devotion that Our Lord has been pleased to instill in me."[30] Contemporaries perceived no conflict between the marked contrast of the humility of the Descalzas Reales and the overt, celebratory splendor deemed a fitting honor to the sacrament. In 1616, Juan Carrillo, confessor to the convent and diplomatic representative of Isabel's husband, elaborated on the Infanta Juana's desired celebration of feasts and veneration of the sacrament. While the strictest poverty was to be observed, only in the celebration of the feast of the Holy Sacrament "did she wish to be rich, and it seemed to her that all the riches of the earth were too little for this purpose." He recounted how the "whole cloister" (*todo el claustro*) was decorated with the most treasured tapestries in the royal collection: the *Siege of Tunis*, a set of twelve enormous hangings woven in Brussels between 1549 and 1554 celebrating the victory of the Holy Roman emperor Charles V over Turkish forces in 1535. The Infanta Juana had inherited the set from her father and given them to Philip II on condition they be hung in the cloister of the Descalzas Reales on feast days.[31]

Juana's founding of a convent devoted to the Eucharist manifested traditional familial Habsburg duty as defenders of the faith, specifically of the sacrament, and countered current threats. According to an early account, Rudolf I of Habsburg (1218–1291) gave his horse to a priest who was traveling on foot with the Host to administer communion to a dying man but was unable to cross a roiling river.[32] This act of deference and humility by Rudolf I signified the essential qualities in a ruler. During the sixteenth century, transubstantiation (the real presence of Christ in the species of bread and wine) was vigorously attacked by Protestant reformers. Only a few years before the foundation of the Descalzas Reales, the Council of Trent had issued its Eighth Decree (1551), defining the Eucharist and its role in the mass. The language of Chapter 5 of the decree (*On the cult and veneration to be shown this most holy Sacrament*) is notable for its combative spirit and exemplifies the militant response of the Roman Catholic Church to Protestant criticism, which continued to resound over succeeding decades and informed the *Eucharist* series.[33] For the young Infanta Isabel, whose presence at the Descalzas Reales ceremonies is nearly certain though not documented, defense of the faith and magnificence were inextricably entwined in acts of patronage enacted by powerful, devout women.

While some female relatives chose enclosed lives as nuns, the eldest daughter of Philip II was destined for marriage. However, due in part to his affection for and reliance on Isabel, the king vacillated about her future. Four suitors were negotiated with or considered. Philip II first sought to place her on the French throne and then to marry her to her cousin Archduke Ernst (1553–1595), who governed the Southern Netherlands from the summer of 1594 until his death in February 1595.

DEVOTION AND RULE

Instead, in 1598, Isabel married her cousin Archduke Albert of Austria by proxy. The fourth son of Emperor Maximilian II and Empress María had been raised at the court of Philip II and groomed for a career of wealth and influence as a prelate. An intelligent, soft-spoken man, he had been cardinal and then bishop of Toledo and achieved a number of important diplomatic and military victories on behalf of Spain as viceroy of Portugal. According to the Act of Cession (1598), Isabel brought the Habsburg Netherlands, defined as all seventeen provinces regardless of rebellion, and the Franche-Comté to the marriage as her dowry. She was appointed by Philip II cosovereign of the Netherlands as a strategy to calm the region after decades

of strife. However, secret clauses undermined the role of the archdukes as corulers and accounted for every contingency. If Albert, who was thirty-nine, and Isabel, thirty-two, failed to produce an heir, the territories would return to the direct control of Spain.[34]

During the early years of their reign, the couple (fig. 3) maintained regular contact with members of the court at the convent of the Descalzas Reales, including Empress María, Albert's sister, Sor Margareta de la Cruz, and Father Carrillo. In the early seventeenth century, Philip III (1578–1621) and Queen Margaret of Austria (1584–1611) frequently heard mass in the convent church. The king regularly discussed political matters with his aunt the empress on these visits. The duke of Lerma, royal *privado* (favorite), maintained a large residence directly across from the convent. The king frequently dined with him, but Lerma kept a close eye on the sovereign's associations with female relatives in the convent.[35] Rubens, who painted a magnificent equestrian portrait of Lerma, made his first visit to Spain in 1603–4 as a representative of the Mantuan court.[36] While he might well have been aware of the importance of the Descalzas Reales, it is not known whether he attended any of the processions. As a young painter of modest status, he would not have had access to the convent church.

After the signing of the Twelve Years' Truce between the Spanish monarchy and the United Provinces in April 1609, the Southern Netherlands enjoyed a golden age of peace and increased prosperity. Rubens had been in Antwerp only a few months when, in early 1609, the archdukes persuaded him to become their court painter. The terms of his appointment as "paintre de [leur] hostel" were exceptional among the artists serving the archdukes. In addition to an annual pension of 500 florins, he could live in Antwerp rather than at the Brussels court and was exempt from the regulations and fees of the local painters' guild.[37] Rubens was a devout Catholic of unassailable integrity. In powerful altarpieces from 1609–12, the related themes of Lamentation and Entombment (fig. 4), for example, provide trenchant devotional imagery in the revitalized Counter-Reformation climate of the Southern Netherlands, with a focus on Christ's sacrifice and suffering.

While the archdukes vigorously supported Tridentine policies, such as the 1607 synodal decree affirming the responsibilities of bishops to rebuild and redecorate churches,[38] they also engaged in less doctrinal interactions with their subjects. Whether attending a country wedding (fig. 5) or winning the 1615

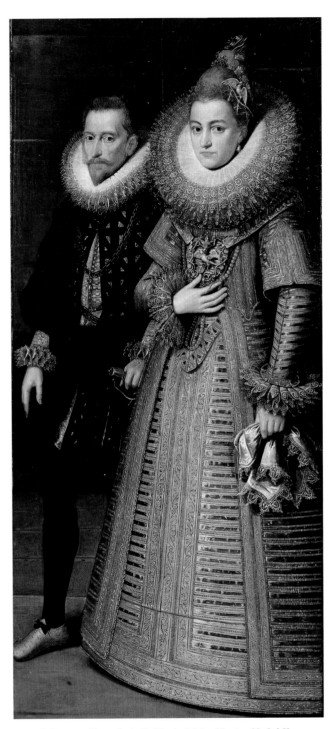

FIG. 3 | Otto van Veen, *Portrait of the Archdukes Albert and Isabel Clara Eugenia*, ca. 1615. Oil on panel, 153 × 73 cm (60¼ × 28¾ in.), Gloucestershire (England), The Earl of Wemyss and March, K.T.

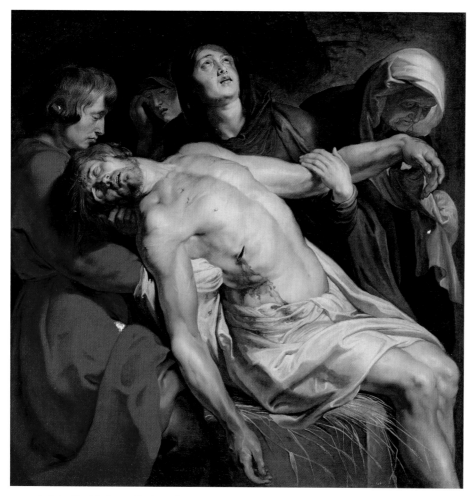

FIG. 4 | Peter Paul Rubens, *The Entombment*, ca. 1612. Oil on canvas, 131 × 130.2 cm (51⁹⁄₁₆ × 51¼ in.), Los Angeles, J. Paul Getty Museum, inv. 93.PA.9.

shooting contest of the Brussels Senior Guild of Crossbowmen,[39] Isabel and her husband forged a relationship with their subjects as sympathetic rulers tied to the rhythms of their country.

1621: THE BEGINNING OF A NEW ERA

In 1621, everything changed. On March 31, Philip III died, and on April 9, the Twelve Years' Truce between Spain and the United Provinces officially ended. A new era of uncertainty loomed for both sides.[40] After a few tense months, Albert, long in tentative health, declined, and he died on July 13. The Act of Cession came into effect, and the territories of the Southern Netherlands reverted to the Spanish monarch, sixteen-year-old Philip IV (1605–1663), the Infanta's nephew. Isabel petitioned the king to allow her to retire and enter the convent of the Descalzas Reales.[41] With no candidates as capable and trust-

worthy to replace her, Philip IV instructed her to remain in the Southern Netherlands, no longer as sovereign princess but as governor-general. She received additional powers that gave her extraordinary authority, notably the position of captain-general with control over the finances and personnel of the military.[42] In Madrid, Don Baltasar de Zúñiga (1561–1622), former ambassador at the Brussels court, asserted, "The country regards her Ladyship the Infanta with love and esteem and these provinces are used to being governed by women."[43] Although the transition took place peacefully, Isabel never returned to Madrid.

The commission of the *Eucharist* series and the gift of the tapestries to the Descalzas Reales are usually associated with Isabel's inability to return to Spain and take up life as a Poor Clare. As we shall see, this is but one possible reason for ordering such an expensive and immense undertaking as a large set of tapestries.

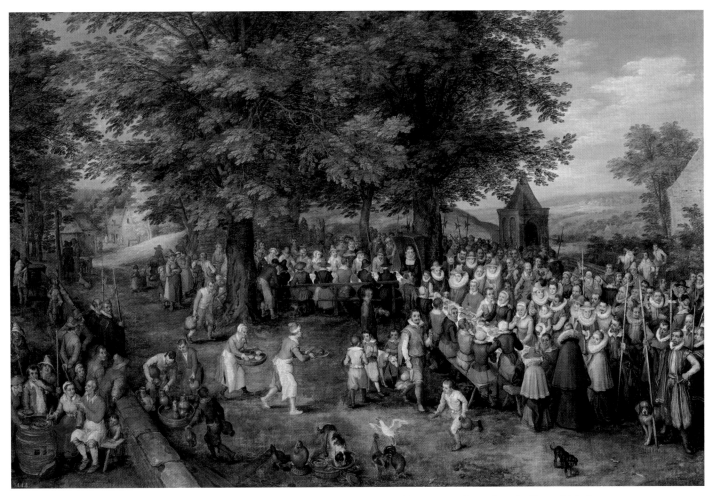

FIG. 5 | Jan Brueghel the Elder, *Wedding Banquet Presided over by the Archdukes*, ca. 1612–13. Oil on canvas, 84 × 126 cm (33¹⁄₁₆ × 49¹³⁄₁₆ in.), Madrid, Museo Nacional del Prado, P-1442.

She must have expected to follow in the footsteps of her female relatives and participate in discussions about peace and a united Netherlands from within the convent walls. Her request was also entirely in keeping with Habsburg tradition and the expectation of a widow of her rank to retire from public view.[44]

The series of decisive steps in which she recast herself as a pious, humble ruler exemplifies Isabel's formidable character. By replacing ostentatious displays of courtly splendor with a dramatic demonstration of piety, she was a role model for her subjects and affirmed her God-given authority.[45] To the surprise of some foreign observers at court, she even "chased [away] all her dogs, parrots and dwarfs."[46] The Infanta moved swiftly in 1621 to prepare for her widowhood and requested the rough wool habit of the tertiary Franciscan order from her confessor, the Franciscan Andrés de Soto, when Albert's demise was imminent. She as-

sumed the habit on the second day after Albert's death and wore it for the remainder of her life.[47] Isabel kept to her private chambers in the palace for forty days, emerging in August with her hair shorn, dressed in the Franciscan habit, to resume consultation with her advisers.[48] In October 1621, on the feast day of Saint Francis, she became a member of the Franciscan Third Order, and in 1622, after a year's novitiate, she made her profession. Saint Francis founded the tertiary order in 1221 for those unable to live a cloistered life but wishing to enter Franciscan rule. Isabel Clara Eugenia lived according to the ideals and spirit of the Franciscans, which emphasized humility and poverty, while exercising her secular responsibilities as governor.[49] The already notably pious character of the Brussels court, which had continued the Habsburg practice of near-monastic spiritual focus, became even more restrained as the Infanta withdrew to semiseclusion.

THE COMMISSION

In the absence of contracts or specifications for the weaving and delivery of the tapestries, most scholars date the commission of the *Eucharist* series to about 1625.[50] In June of that year, Spanish forces won a crucial victory over Protestant forces of the United Provinces, giving the Army of Flanders control over the fortified city of Breda. The Infanta reviewed the troops after the battle, dispensed gifts, and ordered masses.[51] On her return to Brussels, she visited Rubens's Antwerp studio to sit for a new official likeness, dressed in the habit of the Order of Saint Clare and holding the ends of the long black mourning veil (fig. 6).[52] It has been argued that the *Eucharist* series should be understood as an ex-voto, expressing the Infanta's thanks to God for the victory.[53]

However, Isabel may well have begun to plan the series earlier, around 1622, when she emerged from mourning, aware of her own mortality, and assumed her dual role as a paragon of humility and a political leader committed to resolving ongoing hostilities on behalf of the Spanish crown.[54] In the early seventeenth century, tapestry was still one of the most expensive art forms. The *Eucharist* set was extremely costly and constituted a major act of patronage in keeping with the Infanta's princely status. The combined cost of Rubens's designs and the tapestries themselves has been thought to amount to 130,000 florins. The set was the most expensive gift of her rule and comparable to the Infanta's monthly budget for military expenditures.[55] Sovereigns had long understood the value of tapestry as propaganda and an index of their wealth and status. Isabel's investment in didactic magnificence was in the tradition of the grandest courts.[56]

The presumed commission date of about 1625 presents practical difficulties for tapestry production. In a document dated July 21, 1628, Philippe Chifflet, whose observations constitute the only contemporary commentary on the series, noted that two wagons "laden with tapestries, cloths, geographic maps and some paintings" had left for Madrid.[57] While it is no longer thought that the entire series, presumed to constitute the twenty weavings in the Descalzas Reales today, was sent to Madrid on that date,[58] it would still have been a remarkable feat for the weavers to have supplied a significant portion of the hangings for delivery in just three years.[59] The collaborative nature of the production, which involved two prominent Brussels workshops, those of Jan Raes I and Jacob Geubels II (whose workshop was run by his widow later), as well as two weavers surely reporting to the entrepreneur Raes, Jacob Fobert and Hans Vervoert, points to a desire on the part of the Infanta for an expeditious production.[60] The

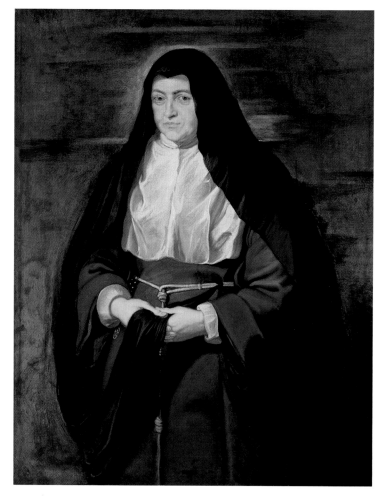

FIG. 6 | Peter Paul Rubens and Workshop, *Isabel Clara Eugenia, Governor of the Southern Netherlands, in the Habit of a Poor Clare*, ca. 1625. Oil on canvas, 115.6 × 88.6 cm (45½ × 34⅞ in.), Pasadena, Norton Simon Art Foundation, Gift of Mr. Norton Simon, inv. M.1966.10.10.P.

low-warp (*basse-lisse*) technique of the Brussels tapestry weavers, involving both hands and feet to work the loom, was suited to swift execution of complex designs. More than one tapestry could be under way on different looms in the workshop. Even so, production of a series of monumental compositions on the scale of *The Triumph of the Church* (cat. 7), of which there were eleven in the *Eucharist* series, might have required several years. The well-documented example of the twelve tapestries of the *Siege of Tunis* that decorated the Descalzas Reales shows that a significant amount of time was required to produce large, important sets. Ordered by the Holy Roman emperor Charles V in 1546, the cartoons were designed by Jan Vermeyen (ca. 1500–ca. 1559) under a contract signed in June 1546, and the pieces, which were larger

than the *Eucharist* series and incorporated gold and silver metal-wrapped thread, were woven in a single workshop by Willem de Pannemaker (d. 1567) and finished in 1554.[61] Further investigation is needed to gain a better understanding of the creation of the *Eucharist* tapestries.

The Infanta was extremely fortunate to have not only Europe's greatest painter in her service but also a familiar and trusted member of court who was committed to Habsburg rule in the Netherlands and its aims. Rubens had long represented the Spanish Netherlands in diplomatic missions, notably after the signing of the Twelve Years' Truce in 1609. After Albert's death, Isabel engaged Rubens to carry out complex political duties on her behalf, including increasingly delicate negotiations with English diplomats. Initially, he operated covertly, but he became gradually more visible, as his artistic vocation gave him a passport to all courts.[62] Philip IV acknowledged Rubens's devotion to Isabel with a knighthood in 1624. He and the Infanta were in frequent contact during the 1620s. Rubens's direct manner of communication with his patron can be seen in a 1625 letter: "Although I am certain that Your Highness knows all that is going on . . . I hope Your Highness will not take offense if I express my opinion according to my capacity, and with accustomed freedom."[63]

The *Eucharist* series was the third of four tapestry series designed by Rubens, and the only site-specific project. The series celebrating the Roman consul Decius Mus (designed 1616–18) was woven in Brussels, and the *Story of Constantine* (designed in 1622) was a speculative project financed by Flemish entrepreneurs and woven in Paris.[64] For Rubens, thorough preparation was vital to tapestry design. At about the time of his last series portraying the life of Achilles (ca. 1630–35), Rubens described the process in response to a request from the papal nuncio at the Brussels court. While the nuncio had referred to only one tapestry, Rubens noted that "a tapestry presupposes an entire story distributed over seven or eight pieces." He went on to observe, "This is a matter which requires inspection of the place and detailed information about measurements, proportions and number of pieces."[65] Rubens probably had detailed plans of the interior of the church of the Descalzas Reales at his disposal, perhaps from the Infanta (although there had been changes to the interior of the church since her youth) or relayed by someone at the convent.[66] He was therefore able to devise at a remove two of the distinctive features of the set: the sophisticated perspectival system of the architectural framework and the light effects of the scenes within.

THE *EUCHARIST* TAPESTRIES

The *Eucharist* series consists of eleven monumental compositions nearly 5 meters (16 ft. 5 in.) high and about 7½ meters (24 ft. 7 in.) long that covered the side walls of the church, and possibly the presbytery, in two tiers. Eight smaller pieces decorated other areas of the interior. It is also possible they covered the exterior walls.[67] The large scenes on the lower row feature Tuscan columns and a level viewpoint and were intended to be viewed primarily from one side. They include familiar Old Testament prefigurations of the Eucharist, *The Meeting of Abraham and Melchizedek* (cat. 3) and the *Sacrifice of the Old Covenant* (fig. 39), along with the procession of saints devoted to the Eucharist, *The Defenders of the Eucharist* (fig. 38), and victorious processions, *The Triumph of Divine Love* (cat. 10) and *The Triumph of Faith* (fig. 35). In *The Defenders of the Eucharist*, Saint Clare of Assisi was given the Infanta's features (see fig. 1). Solomonic columns sinuously frame the scenes on the upper level, which were to be viewed from a lower vantage. The top tier featured the dramatic procession *The Victory of Truth over Heresy* (cat. 5), along with the striking narrative *The Victory of the Eucharist over Idolatry* (fig. 37), the Old Testament prefigurations *The Gathering of Manna* (fig. 26) and *The Prophet Elijah Being Fed by an Angel* (fig. 24), and the processional *The Four Evangelists* (fig. 36). *The Triumph of the Church* (cat. 7), which encapsulates the entire program of the series, also hung in the upper register, perhaps in the position of honor above the altar.[68] For the wall opposite the altar, five smaller scenes, also with upper and lower registers denoted by Tuscan and Solomonic columns, form a complementary ensemble of sacred and secular figures in adoration, with two scenes of angels playing music, a smaller architectonic scene of two cherubs holding the monstrance aloft, and, on the lower level, *The Sacred Hierarchy in Adoration* (fig. 30) and *The Secular Hierarchy in Adoration* (fig. 31). Four supplementary scenes complete the series of twenty: *David Playing the Harp* (fig. 32), *Allegory of Charity* (fig. 41), *Allegory of Divine Wisdom* (fig. 42), and *Allegory of Eternity* (or *Allegory of the Succession of the Popes*) (fig. 43). While the fictive architecture presented a splendid trompe l'oeil effect in the confined space of the church and cloister, the series may not have been symmetrical or installed in the same sequence on every liturgical occasion.[69]

Tapestry as a vehicle for fictive decoration in the manner of fresco paintings was already well established by this time. Rubens undoubtedly recalled the *Acts of the Apostles* designed by Raphael (1483–1520), which decorated the Sistine Chapel at the Vatican and combined architecture, Solomonic columns, and

large-scale figures in legible compositions. The series was woven in the Brussels workshop of Pieter Coecke van Aelst (1517–21), and the cartoons (1515) were enormously influential sources of Italian stylistic ideas in the Netherlands throughout the sixteenth century.[70] While in Rome in 1602 and 1606–8, Rubens might also have observed the lavish decoration with tapestries of the interior of the Church of the Gesù.[71] Woven in brilliant wool and silk, the *Eucharist* tapestries were spectacular but lacked the sumptuous element of gilt metal thread found in the *Acts of the Apostles* and many of the sixteenth-century sets obtained by Philip II. Since the Infanta could have ordered its use, albeit at considerable expense, but evidently chose not to, we may infer she felt the extent of the series and magnificence of the visual conceits constituted the value of the gift.

THE DESIGN

A eucharistic subject was a natural choice for the Infanta, who shared with the Descalzas Reales a deep reverence for the sacrament. Rubens assumed the challenge of devising a multipart treatment of the Eucharist, a complex sign. Rather than embark on a dogmatic theological exercise, for which he might have returned to subjects such as the Disputation of the Holy Sacrament (fig. 7), in which theologians debate transubstantiation, or the Last Supper, representing the scriptural basis for the Eucharist, or a literal representation of the mass, or familiar narratives from the lives of saints combating heresy, he treated the *Eucharist* series as a dramatic theater of ideas articulated through his diverse visual vocabulary. Rubens was aided by the Tridentine definition of the display of the Eucharist as a victorious event—a concept still relevant seventy years after the decree. Recent developments in the display and presentation of the Host allowed for greater visibility as it was placed within monstrances of precious materials that shone brightly in the light,[72] a practice that Rubens used throughout the series to feature the Host as a source of symbolic illumination.

Rubens's working practice of febrile invention shaped his presentation of the transformative powers of the Eucharist and the key Old Testament precedents. He completed major projects such as the ceiling of the Antwerp Jesuit church, the *Story of Constantine*, and the *Medici* cycle in quick succession and in conjunction with other projects by drawing on an extraordinary mental store of visual and literary ideas. Not infrequently in large projects, he reworked earlier compositions. For example, *Abraham and Melchizedek*, completed only a few years before

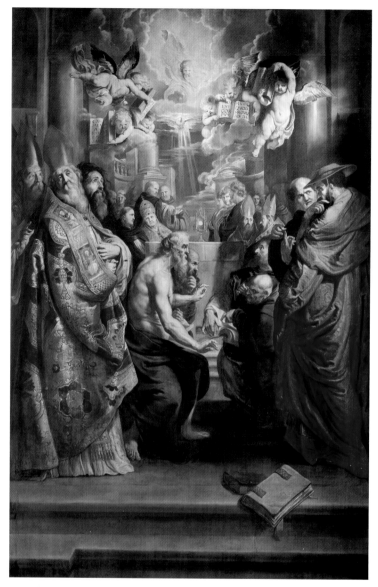

FIG. 7 | Peter Paul Rubens, *The Disputation of the Holy Sacrament*, ca. 1609. Oil on panel, 377 × 246 cm (148¼ × 96⅞ in.), Antwerp, St. Pauluskerk.

FIG. 8 | Peter Paul Rubens and Jan Wildens, *Rudolf I Habsburg's Act of Devotion*, ca. 1625. Oil on canvas, 199 × 286 cm (78⅜ × 112⅝ in.), Madrid, Museo Nacional del Prado, P-1645.

(ca. 1617–18), informed the same subject in the *Eucharist* series.[73] The victorious processions *The Triumph of the Church*, *The Triumph of Faith*, and *The Triumph of Divine Love* are among the most spectacular scenes in the *Eucharist* series. By the late sixteenth century, humanist painters like his teacher Otto van Veen (1556–1629) had combined antique ideas of triumph with militant Catholic ideals. However, van Veen's didactic, small-scale compositions of *The Triumph of the Church* (Bamberg, Bayerische Staatsgemälde-sammlungen) were not the primary source for the *Eucharist* series.[74] Rubens was extremely knowledgeable on the subject of triumphs, and his interest in the pictorial possibilities offered by multiple figures and lavish details is borne out by the frequency with which triumphal processions appear in important projects from the 1620s, including the *Story of Constantine* and the *Triumph of Henry IV*, which was never completed but is known from *modelli* (ca. 1630; New York, Metropolitan Museum of Art).[75] At about the

time of the *Constantine* series, and perhaps also the design of the *Eucharist* series, he corresponded with a friend about a gem showing the Triumph of Licinius, in which the hero's quadriga, seen from the front, rides over fallen enemies.[76] Andrea Mantegna's (1431–1506) series of nine large paintings *Triumph of Julius Caesar* (1484–92; Mantua, Palazzo Ducale, now in London, Hampton Court) and Giulio Romano's designs (1531–32) for a tapestry series called *Triumph of Scipio* were sources of inspiration throughout his career and underlie the processions of the *Eucharist* series.[77] Presenting the sacrament in procession also resonated with Habsburg mythology and Rudolf I's accompaniment of the Host on foot, as rendered by Rubens and Jan Wildens in the same period, *Rudolf I Habsburg's Act of Devotion* (fig. 8).[78]

Rubens's ability to compose in paint directly on a prepared wood panel, his preferred support for designs, was extraordinary. As with other large projects from his midcareer, the

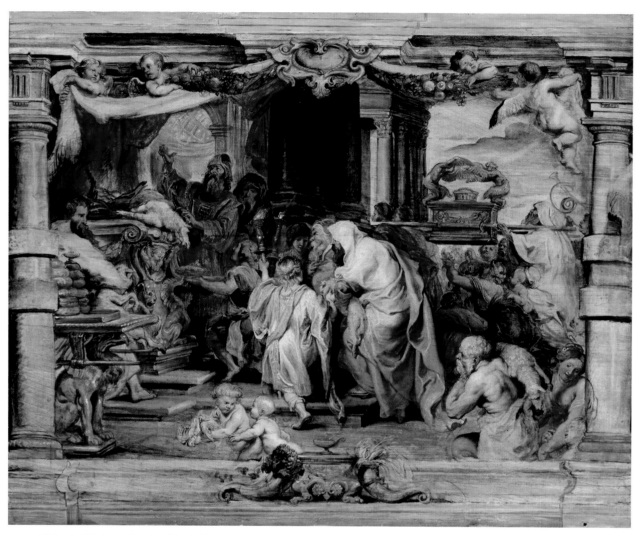

FIG. 9 | Peter Paul Rubens, *Sacrifice of the Old Covenant*, ca. 1625. Oil on panel, 70.8 × 87.6 cm (27⅞ × 34½ in.), Boston, Museum of Fine Arts, Gift of William A. Coolidge, inv. 1985.839.

detailed *modelli* for the *Eucharist* series were apparently not preceded by extensive planning in chalk on paper. Rather, Rubens first composed small scenes in oil on panel, known as *bozzetti*, in which the compositions are seen in the same orientation as the final tapestry.[79] Although separated today, several of these scenes (now in the Fitzwilliam Museum, Cambridge; see, for example, fig. 12) may have been executed on the same panel, thus facilitating consideration of the whole set at one time. The oil sketch for the altar wall, now in Chicago (fig. 18), combines the ideas for separate tapestries and installation in two rows. The subjects and content of all the scenes were probably discussed first with the Infanta and perhaps her spiritual advisers, although Rubens was capable of devising the program. Chifflet regarded Rubens highly

and referred to him as "the most learned painter on earth."[80]

The initial ideas expressed in the *bozzetti* were then developed and expanded according to a proportional system. Rubens painted larger, more detailed oil sketches (*modelli*) for each scene at four times the size of the *bozzetti*, this time with the composition reversed in anticipation of the orientation of the cartoons used by the weavers. Among his most beautiful oil sketches, the *Eucharist modelli* are executed with the energetic, assured brushwork that accompanied his creative design process (see, for example, fig. 9). For all their verve, *modelli* were guides to later stages; Rubens did not view them necessarily as highly finished paintings. Always practical, he summarily indicated repeated elements. Framing columns were worked out on one side but

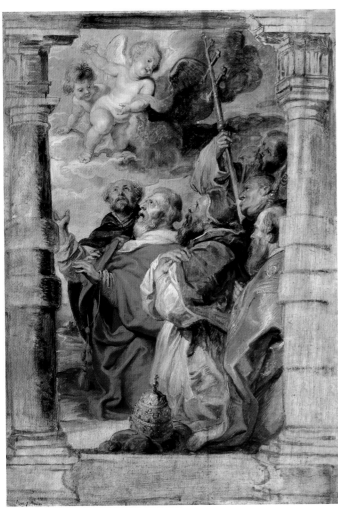

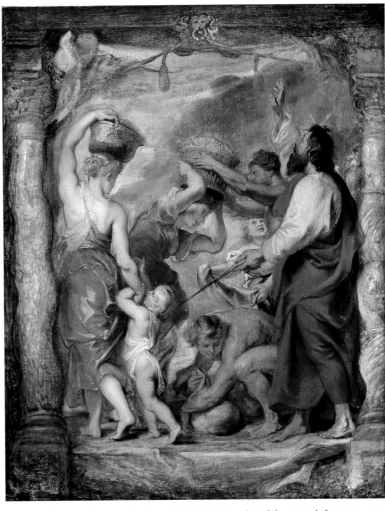

FIG. 10 | Peter Paul Rubens, *The Ecclesiastical Hierarchy in Adoration*, ca. 1625. Oil on panel, 66.5 × 46.5 cm (26³⁄₁₆ × 18⁵⁄₁₆ in.), Louisville, Speed Art Museum, inv. 66.16.

FIG. 11 | Peter Paul Rubens, *The Gathering of Manna*, ca. 1625. Oil on panel, 63.7 × 53.4 cm (25¹⁄₁₆ × 21¹⁄₁₆ in.), Los Angeles County Museum of Art, inv. M.69.20.

not on the other, for example, in the *modelli* for *The Victory of Truth over Heresy* (cat. 4), *The Ecclesiastical Hierarchy in Adoration* (fig. 10), and *The Gathering of Manna* (fig. 11).

The most significant change to the planning of the series at the *modello* stage was the reconsideration of the location of *The Meeting of Abraham and Melchizedek*. In the Prado *modello* (fig. 13 and cat. 2), the Solomonic columns and low viewpoint indicate that it was planned for the upper register. For unknown reasons, perhaps due to new information about the interior gained while Rubens was in Madrid in 1628,[81] the scene was moved, necessitating the painting of a second *modello* (fig. 14), with Tuscan columns and revised viewpoint. Rubens also modified the scene to heighten the intensity of the exchange between the general

and the priest.[82] Some of the *modelli*, such as the second *Abraham and Melchizedek* and *Allegory of Eternity* (San Diego Museum of Art, inv. 1947:8), show evidence of the transfer process.[83]

Painting in oil on panel, particularly on the scale of the *modelli*, which resemble other preparatory sketches for large-scale projects, offered an efficient method of preparation. The artist could have traveled with the panels to discuss the designs with the Infanta or others involved in the project and continued work during his diplomatic activities and preparation of other projects. Isabel showed her appreciation for Rubens's "patterns" (*patrons*) with a gift of "some pearls" (*plusiers perles*) in January 1628, acknowledging his work on the design stage.[84]

From the *modelli*, Rubens's workshop painted cartoons,

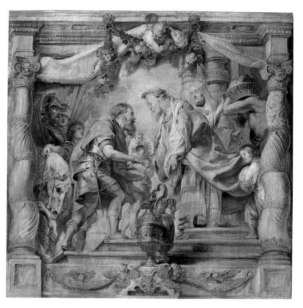

FIG. 12 | Peter Paul Rubens, *The Meeting of Abraham and Melchizedek*, ca. 1622–25. Oil on panel, 15.6 × 15.6 cm (6⅛ × 6⅛ in.), Cambridge, Fitzwilliam Museum, inv. 231.

FIG. 13 | Peter Paul Rubens, *The Meeting of Abraham and Melchizedek*, ca. 1625. Oil on panel, 65 × 68 cm (25⅝ × 26¾ in.), Madrid, Museo Nacional del Prado, P-1696.

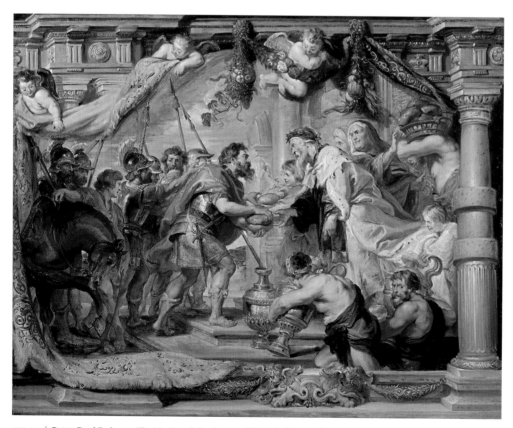

FIG. 14 | Peter Paul Rubens, *The Meeting of Abraham and Melchizedek*, ca. 1625. Oil on panel, 65.5 × 82.4 cm (25¹³⁄₁₆ × 32⁷⁄₁₆ in.), Washington, DC, National Gallery of Art, inv. 1958.4.1.

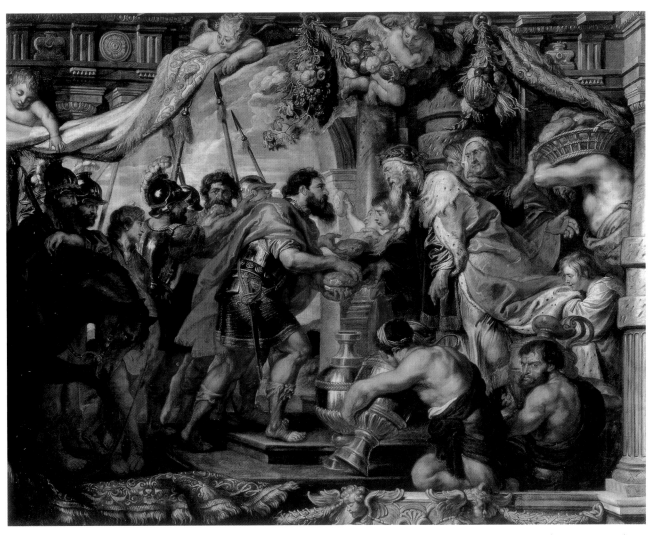

FIG. 15 | Peter Paul Rubens and Workshop, *The Meeting of Abraham and Melchizedek*, ca. 1625–26. Oil on canvas, 451 × 570.9 cm (177⁹⁄₁₆ × 224¾ in.), Sarasota, John and Mabel Ringling Museum of Art, inv. SN 212.

presumably oil on paper, which enlarged the compositions proportionally by a magnitude of about seven to the full size of the finished tapestries. They would have been folded or cut into strips and placed in the loom. Tapestries woven on low-warp looms were worked from the back and were mirror images of the cartoon below. Seven to-scale paintings on canvas from Rubens's workshop have survived (five in Sarasota and two in Valenciennes; see, for example, fig. 15) and are commonly referred to as "cartoons," despite the canvas supports and no sign of damage from use in the loom.[85] However, discussion of the paintings in the John and Mabel Ringling Museum recently raised the possibility that they fulfilled a different function, perhaps as *recordi* for the Infanta to enjoy in the absence of the original tapestries.[86]

Alternatively, they might have served as reference images for the weavers to assist them with the complex compositions.[87] Typical cartoons on paper were presumably made, and the purpose of the large canvases is unclear.

In designing the *Eucharist* series, Rubens and Isabel Clara Eugenia made little concession to tapestry conventions and indeed seem to have sought to obtain the most dramatic textile compositions possible from the most skilled weavers. In this approach, Rubens shared Giorgio Vasari's (1511–1574) awareness of the aesthetic demands of tapestry. Describing a design by Francesco Salviati (1510–1563), Vasari noted, "Into that cartoon Francesco put all the diligence that could possibly be devoted to such a work, and that is required for pictures that are to be

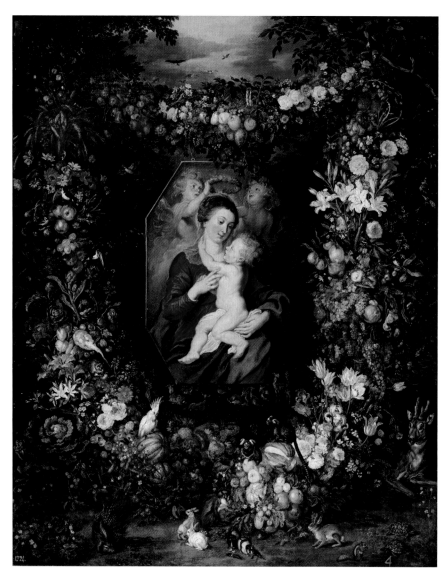

FIG. 16 | Peter Paul Rubens and Jan Brueghel the Elder, *Madonna and Child in a Garland of Fruit and Flowers*, ca. 1620. Oil on panel, 79 × 65 cm (31⅛ × 25⅝ in.), Madrid, Museo Nacional del Prado, cat. 1418.

woven; for there must be fantastic inventions and variety of composition in the figures, and these must stand out from one another, so that they may have strong relief, and they must come out bright in coloring and rich in the costumes and vestments."[88]

The *Eucharist* series is characterized by weighty figures in action, many partially nude, which would have been challenging to model effectively in tapestry. They occupy settings enlivened by dramatic light effects, as in *The Victory of the Eucharist over Idolatry*, where the radiance of the Host held aloft by an angel drives pagans from the dark depths of their temple. The series lacks traditional borders and instead utilizes architectural frames, which

are employed differently in each scene and which also relate to adjacent scenes. The health and productivity of the workshops in Brussels, still able to produce extraordinary sets of tapestries commensurate with those produced for Habsburg rulers in the previous century, reflected the Infanta's efforts over two decades to bolster the tapestry industry with favorable legislation (1606 and 1626) and commissions, notably the *Eucharist* series.[89]

The most notable feature of the eleven large compositions of the *Eucharist* series was Rubens's clever double illusion of a tapestry within a tapestry. The conceit drew attention to the materiality of the work and its skillful approximation of the effects

of painting. Rather than being a secondary decorative element, the flying cherubs are crucial to the "narrative" of unfolding and hanging the "tapestries." Throughout the series, Rubens handled the illusionistic scheme playfully, so that the kneeling figure in *The Victory of the Eucharist over Idolatry* extends over the edge and casts shadows in the architectural frame. For the delight of his patron and the royal viewers of the series in Madrid, Rubens invoked the Flemish strategies of illusion developed over the preceding two decades with specialist colleagues. In devotional paintings such as *Madonna and Child in a Garland of Fruit and Flowers* (fig. 16), the minutely detailed garland hangs in a landscape and surrounds the central scene of the Virgin and Child, whose immediacy belies the presentation as an iconic image.[90] The garlands of fruits, vegetables, and flowers in the *Eucharist* series similarly honor divine generosity.

In the *Eucharist* series, Infanta Isabel Clara Eugenia presented the Descalzas Reales with the most visible and precious decorations for the celebration of the principal feast days. As Rubens must have expected, her dazzling gift joined, and perhaps supplanted, the precious *Siege of Tunis* tapestries as a magnificent representation of Habsburg patronage but from a pious female ruler who occupied a unique position of humility and influence. Her combined piety, sense of duty, and formidable commitment to countering the Protestant threat made the enterprise a high priority for the early years of her sole rule. It was entirely appropriate that she engaged the finest practitioners of painting and weaving in the Southern Netherlands to execute her legacy. In triumphal tone and scope, the *Eucharist* series presented an updated program of the victorious Roman Catholic Church in an era that called for more vigor than the solemnity stipulated by the Infanta Juana in 1572. The *Eucharist* series superbly represented the Infanta Isabel Clara Eugenia's piety and status as "Sanctissima Atque Optima Principum," the most holy and best of leaders.[91]

NOTES

1 According to the founding charter (1572), the feasts of the Entombment (Santo Entierro) and the Resurrection and Octave of Corpus Christi were to be celebrated with great magnificence ("con mucha solemnidad"). De Poorter 1978, vol. 1, pp. 28–30; vol. 2, pp. 419–20, doc. 2. For the arrangement and use of tapestries in the convent, see the essay by García Sanz in this volume.

2 De Poorter 1978 discusses most of the surviving documents, but see also the essay by García Sanz in this volume.

3 García Sanz 1999; see also the essay by García Sanz in this volume. For the *Eucharist* tapestries, see De Poorter 1997; Herrero Carretero 2008.

4 De Poorter 1997, pp. 86–87; Brosens 2011, pp. 180–81.

5 The compositions were engraved. Additional sets of tapestries were woven later in the seventeenth century. De Poorter 1978, vol. 1, pp. 213–22, 237–54. For the provenance of the Prado *modelli*, see the essay by Vergara in this volume.

6 Brosens 2011; Thuillier and Foucart 1967; Held 1980, pp. 123–36.

7 The first comprehensive study by Elias Tormo (1942), who believed the series comprised eighteen tapestries, served as the basis for the important examinations by De Poorter (1978) and Scribner (1982). See also the insightful reviews of these publications: Scribner 1980; McGrath 1981; Martin 1984.

8 Pasture 1925; Freedberg 1988; Duerloo and Thomas 1998; Pollmann 2011.

9 De Maeyer 1955; Van Wyhe 2004; Van Sprang 2005; Duerloo 2012.

10 Sánchez and Saint-Saëns 1996; Sánchez 1998; Gschwend 2002; Eichberger 2005.

11 Duerloo and Thomas 1998; Vergara 1999b; Van Wyhe 2011; Duerloo 2012.

12 For the decrees, see Schroeder 1978.

13 Aubertus Miraeus, dean of Antwerp Cathedral, January 29, 1634, p. 36; Van Wyhe 2011, p. 9.

14 De Villermont 1912. Early commentators on the Infanta's life include Puget de la Serre (1634) and Beverwyck (1638). See also Van Wyhe 2011.

15 Klingenstein 1910; De Villermont 1912.

16 Piot 1888–89, cols. 12–13. For Isabel's early years, see particularly Martínez Hernández 2011.

17 The Infanta, writing to the duke of Lerma, 1600; discussed by Martínez Hernández 2011, p. 32.

18 Martínez Hernández 2011, pp. 28, 31.

19 Martínez Hernández 2011, p. 31; Pérez de Tudela 2011, p. 77.

20 See Duerloo 2012, pp. 30–32.

21 Quoted in Martínez Hernández 2011, p. 39.

22 Calvete de Estrella 2001.

23 Freedberg 1988.

24 Parker 1977.

25 Gachard 1884, pp. 189–90, no. XXIV (September 3, 1582).

26 For the decoration of the Escorial, see Kubler 1982; Checa 1989. For Philip II as patron of the arts, see Checa 1992.

27 De Poorter 1978, vol. 1, pp. 23–25; García Sanz et al. 2010.

28 Sánchez 1998.

29 According to Father Carrillo, the Infanta Juana "caused all her jewels and riches to be brought, and with her own hands adorned with them the litter and the monstrance of the most holy Sacrament." De Poorter 1978, vol. 2, p. 421, doc. 3.

30 De Poorter, vol. 2, p. 420, doc. 2.

31 "Lacual aunque está en poder de su Majestad, est de la fundadora de esta casa, y la dejó al rey don Felipe Segundo, co condición que se haya de

colgar este dia el claustro con ella," De Poorter 1978, vol. 2, pp. 421–25, doc. 3. For the *Siege of Tunis*, see Junquera de Vega and Herrero Carretero 1986, pp. 73–92.

32 The incident was recounted by Johann von Winterthur. See Coreth 2004, p. 14; Merriam 2012, pp. 127–28.

33 "And so indeed did it behove victorious truth to celebrate a triumph over falsehood and heresy, that thus her adversaries, at the sight of so much splendor, and in the midst of so great joy of the universal Church, may either pine away weakened and broken; or, touched with shame and confounded, at length repent." Thirteenth Session (October 11, 1551), Chapter 5, trans. and ed. Waterworth 1848, p. 79.

34 Duerloo 2011, p. 171.

35 Sánchez 1998.

36 For Rubens's equestrian portrait of the duke of Lerma, see Vergara 1999, pp. 11–16.

37 De Maeyer 1955; Brown 1998; Van Sprang 2005.

38 De Ram 1828, p. 387; Willocx 1929, pp. 284–86.

39 De Villermont 1912, vol. 2, p. 45. The Infanta wears the gold collar and jewel in the shape of a bird trimmed with small crossbows commemorating the event in fig. 3.

40 Duerloo 2012, p. 509.

41 Isabel's desires are known from comments by contemporaries such as Giovanni-Francesco Guidi di Bagno, papal nuncio at the Brussels court. De Poorter 1978, vol. 1, p. 26.

42 See Esteban Estríngana 2011, pp. 430–31.

43 Duerloo 2012, p. 504.

44 Sánchez 1998, p. 67.

45 Van Wyhe 2004, p. 413.

46 Quoted in Duerloo 2012, p. 519.

47 Described by Aubertus Miraeus, court librarian. Van Wyhe 2004, p. 421.

48 Miraeus, quoted in Van Wyhe 2004, p. 423.

49 De Villermont 1912, pp. 152–54; Van Wyhe 2004, pp. 419–20.

50 Elbern 1955, pp. 43–48; Held 1980, p. 139; Herrero Carretero 2007, p. 221.

51 Hugo 1627, p. 150.

52 Vlieghe 1987, pp. 119–23; Van Wyhe 2004, p. 421.

53 Elbern 1955, p. 43; Held 1968, p. 6; Esteban Estríngana 2011, p. 435; Libby 2013.

54 De Poorter also suggested the commission could have occurred about 1621–22 but related it to the series serving as a "dowry" for the Poor Clares in Madrid. De Poorter 1978, vol. 1, p. 35.

55 According to Chifflet, "The Infanta sent to the Descalzas at Madrid a set of tapestries showing the figures and mysteries of the Holy Eucharist, the patterns for which were done by Rubens and cost 30,000 guilders. The set of tapestries was worth nearly a hundred thousand." De Poorter 1978, vol. 2, p. 433, doc. 9 (undated but probably written after July 21, 1628). In 1600, the monthly cost of mobilizing the infantry against the United Provinces forces was estimated at 128,700 guilders. Duerloo 2012, p. 117. For a comparison of the *Eucharist* series' cost to later military expenditures, see Libby (2013), who believes that the series constituted one-third of Isabel's recorded expenditures on gifts in 1613–33. I thank Dr. Libby for discussing this issue with me.

56 Henry VIII purchased a set of the *Story of David* in 1528 for the huge sum of 1,500 English pounds, "equivalent to the price of a battleship or the annual income of all but the richest Dukes in the kingdom." Campbell 2002, p. 4. Comparable information about other high-level commissions is limited. During his negotiations with Sir Dudley Carleton in 1618 over an exchange of paintings and tapestries for Carleton's collection of antiquities, Rubens estimated the value of the "least bad" series of tapestries known to him in Antwerp, a history of Camillus in eight pieces (smaller in height than the *Eucharist* hangings, at the equivalent of about 3 m [9 ft. 10 in.]), at 2,442 florins. Magurn 1955, p. 64, letter no. 30 (May 20, 1618).

57 De Poorter 1978, vol. 2, pp. 432–33, doc. 8 (July 21, 1628).

58 As supposed by Held 1980, p. 6; and De Poorter 1997, vol. 1, p. 36. For an important revision to these assessments, see García Sanz 1999, p. 110.

59 Held also considered the delivery of tapestries in the summer of 1628 challenging if they were ordered in 1625. Held 1968, p. 6.

60 De Poorter 1978, vol. 1, pp. 161–63; Herrero Carretero 2007, pp. 229–30; Brosens 2010, p. 24. While the participation of Jan Raes II (1602-1639) in the series cannot be ruled out, the status, experience, and personal connection to Rubens of Jan Raes I suggests he was primarily responsible for this important commission.

61 For the *Siege of Tunis* series, see Delmarcel 1999, p. 14; Karafel 2002. A large tapestry about 5 meters high and 8 meters wide (17 × 26 ft.) with a high warp count (over 5 per centimeter) woven in wool might take five weavers up to sixteen months, and a set of six tapestries of the same dimensions might have required about thirty weavers working between eight and sixteen months, without calculating the time for the designs and setup of the looms; see Campbell 2002, p. 6.

62 Baudouin 1962.

63 Magurn 1955, p. 103, no. 61 (March 15, 1625).

64 For the *Decius Mus* series, see Baumstark 1988; for the *Story of Constantine*, see Brosens 2011.

65 Magurn 1955, p. 411, no. 245 (February 15, 1639). Discussed in Lammertse 2003, p. 11.

66 See the essay by García Sanz in this volume.

67 See the essay by García Sanz in this volume.

68 As proposed by García Sanz in this volume.

69 According to J. López de Hoyos (1569), during the funeral of Infanta Juana, the interior was entirely "whitened with stucco, a mixture of lime and marble, which reflects light in such a way that things can be seen in it." De Poorter 1978, vol. 2, pp. 415–16. The treatment of the interior in the 1620s is unknown. See the essay by García Sanz in this volume.

70 Fermor 1996, pp. 17–21.

71 As portrayed by Andrea Sacchi, Jan Miel, and Filippo Gagliardi, *The Visit of Urban VIII to the Jesuit Church in Rome in 1639*, oil on canvas, 336 × 247 cm (132¼ × 97¼ in.) (Rome, Galleria Nazionale d'Arte Antica, Palazzo Barberini).

72 Merriam 2012, p. 134.

73 Oil on panel transferred to canvas, 204 × 250 cm (80⁵⁄₁₆ × 98⁷⁄₁₆ in.) (Caen, Musée des Beaux-Arts, inv. 172).

74 De Poorter 1978, vol. 1, pp. 199–200; vol. 2, figs. 71–74.

75 Liedtke, 1984, vol. 1, pp. 156–63; vol. 2, pl. 62.

76 A drawing by Rubens after the gem is in the British Museum (1919.1111.22).

77 Rubens copied Giulio's cartoon for *Scipio Welcomed outside the Gates of Rome*. See Wood 2002, pp. 16, 60–61, cat. 36, fig. 4.

78 Vergara 1999a, pp. 115–16.

79 De Poorter 1978, vol. 1, pp. 83–94.

80 Magurn 1955, p. 508.

81 See the essay by García Sanz in this volume.

82 Wheelock 2005, p. 192. Pinholes are visible along the edges of the *Allegory of Eternity* (fig. 43).

83 Wheelock 2005, p. 188. See the essay by Bisacca, de la Fuente, and
 Graindorge Lamour in this volume.

84 "En janvier 1628 furent données à Pierre Paul Rubens plusiers perles, à
 bon compte des patrons de tapisserie pour les cordelièrs de Madrid."
 De Poorter 1978, vol. 2, p. 432, doc. 7. The meaning of "*patrons*" here
 is not clear but probably refers to the *modelli*, which were painted by
 Rubens himself.

85 De Poorter 1978, vol. 1, pp. 133–36.

86 Virginia Brilliant questioned whether the paintings in the John and
 Mabel Ringling Museum of Art are the cartoons for the series. Brilliant
 2011, pp. 40–42. The topic was discussed during the symposium "Peter
 Paul Rubens: Impressions of a Master," John and Mabel Ringling Museum
 of Art, Sarasota, March 30–31, 2011.

87 I thank Charissa Bremmer-David for this suggestion.

88 Campbell 2002, pp. 9–10.

89 T. Campbell, "New Centers of Production and the Recuperation of the
 Flemish Tapestry Industry, 1600–1620," in Campbell 2007, p. 67; De
 Poorter 1978, vol. 1, pp. 163–64.

90 Woollett and van Suchtelen 2006.

91 The phrase is from the marble tombstone composed by the Infanta to
 honor her confessor, Fr. Andrés de Soto, in 1625. See Van Wyhe 2004,
 pp. 441–42.

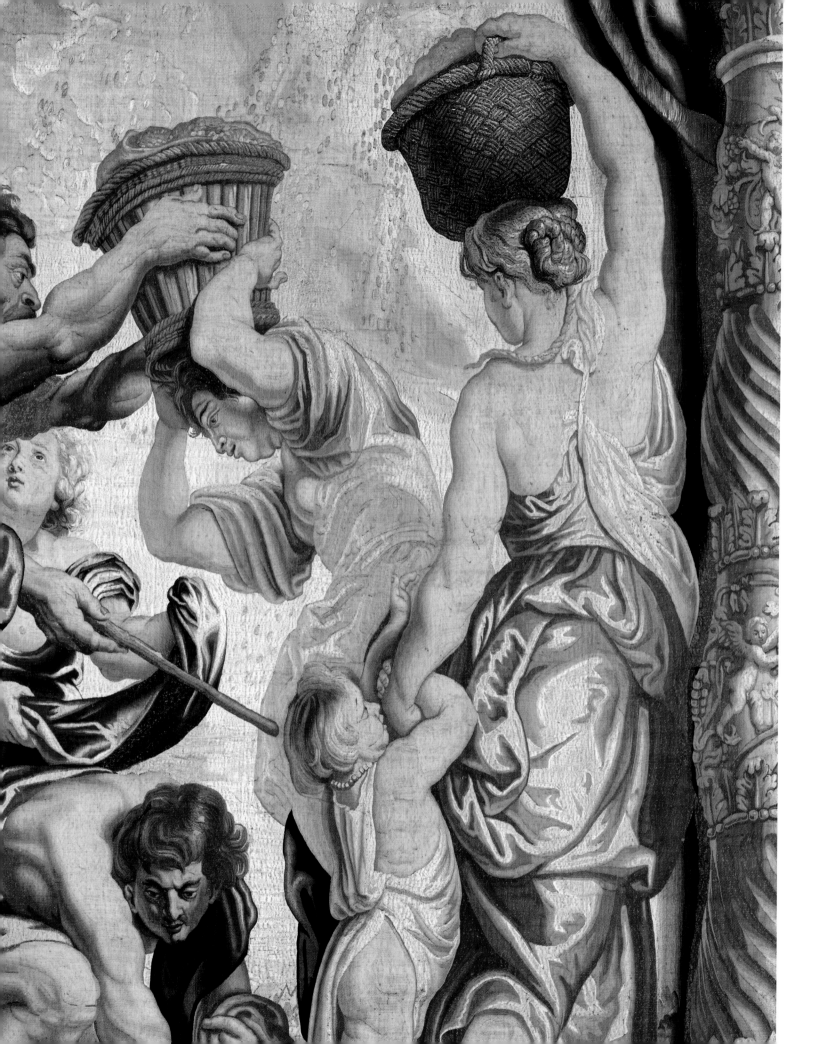

THE TAPESTRIES OF THE *TRIUMPH OF THE EUCHARIST* FUNCTION AND PLACEMENT IN THE MONASTERIO DE LAS DESCALZAS REALES

Ana García Sanz

This essay investigates the possible location of each tapestry in the *Triumph of the Eucharist* series in the Monasterio de las Descalzas Reales (Convent of the Barefoot Royals) in Madrid, the institution for which they were woven *ex profeso*. Since the founding of the Descalzas Reales by Princess Juana of Austria (1535–1573), the convent and its surroundings have been the setting for many celebrations for which the church interior and facades were decorated with tapestries. A seventeenth-century description of these ceremonies, along with an analysis of the plans and elevations of the church, have made it possible to establish a new hypothesis about the arrangement of the tapestries and to propose alternatives to some of the theories held until now. It has been essential in this study to take into account the dimensions and the perspective of each hanging, as well as the dimensions of different spaces within the church, while keeping in mind the changes that have occurred throughout the church's history. The conclusions are in large part the result of a revision of reflections noted by this author in a brief previous study.[1]

The so-called Rubens tapestries, highly regarded since their arrival at the Descalzas Reales, were not studied until the second half of the nineteenth century. Painter and writer Valentín Carderera (1796–1880) published a series of articles in 1868 for the general public that offered interesting information about the placement of the tapestries. Carderera attempted to "take from oblivion, or rather remind the public" of the existence of these tapestry gems "that until the beginning of this century [the nineteenth] were the object of admiration in Madrid . . . , given that they were exhibited in a public plaza."[2] In a later general study on Rubens, Max Rooses focused primarily on the preparatory paintings for the tapestries, but he had little to say about the tapestries' possible arrangement in the convent.[3]

Elías Tormo's three pioneering articles were the first in-depth study of the series; published in 1942, they provided the

first illustrations of the hangings and included proposals as to their layout.[4] Between 1954 and 1968 Victor H. Elbern wrote several works that discussed the Cologne cathedral *Triumph of the Eucharist* series, which was analogous to the Madrid cycle and woven at a later date. In the first of these publications he outlined several considerations relevant to the placement of the tapestries in the Descalzas Reales.[5] An article by Paulina and Juan José Junquera published in 1969 should be added to this overview; they discussed earlier theories and provided interesting reflections.[6]

The first catalogue raisonné of the *Eucharist* series consisted of two volumes in the Corpus Rubenianum Ludwig Burchard by Nora De Poorter, published in 1978. De Poorter analyzed the preparatory works and included an appendix of documents as well as many photographs.[7] At about the same time, Charles Scribner concentrated his studies on the *Eucharist* series, presenting his conclusions in his graduate thesis in 1973, a paper published in 1975, and finally in his doctoral dissertation at Princeton University in 1976.[8] To date, Scribner's contribution is the most rigorous study of the iconographic program and possible arrangement of the tapestries in the Descalzas Reales. In 1988, Wolfgang Brassat published an article with interesting and innovative ideas about the order of the hangings in the convent.[9]

Some of these authors identified two groups of tapestries within the series, intended for two different spaces in the convent: the public cloister, also known as the Capellanes, and the main altar of the church. However, most scholars have regarded the series as a single group. Nora De Poorter considered it "a single monumental composition built up round the spectator,"[10] and Wolfgang Brassat stated that it was "decoration destined entirely for the interior of the church."[11]

COMMISSION AND PRODUCTION

As he designed each tapestry, Rubens may have had in mind an original decorative program for the series as a whole. But before this is addressed, it is necessary to examine new information stemming from recent research.

FIG. 17 | Woven by Jan Raes I, Hans Vervoert, and Jacob Fobert after designs by Peter Paul Rubens, *The Gathering of Manna* (fig. 26), detail.

The commission, traditionally dated to 1625, has been regarded as an ex-voto offered by the Infanta Isabel Clara Eugenia (1566–1633), daughter of Philip II (1527–1598) and regent of the Netherlands, in gratitude for the victory of Spanish troops in Breda in June of that year. However, recent studies have moved that date back to 1622. Further, a document dated 1620 in the archives of the Monasterio de las Descalzas Reales lists a large quantity of silk thread in various colors that was sent from Madrid to the court in Brussels at the request of Isabel Clara Eugenia.[12] The fact that this document is preserved at the convent, along with the colors described, suggests that the shipment requested by the Infanta might be related to the weaving of these tapestries, a possibility that challenges the date that has been widely accepted for the commission.

Regarding the manufacture of the series, a detailed study of the tapestries has yielded new information. The twenty pieces of the series were made in two of the finest ateliers in Brussels at that time: those of Jan Raes I (1574–1651) and Jacob Geubels II (1599–ca. 1633). Examination of the weavers' marks and monograms indicates that twelve of the panels came from Jan Raes I's workshop; there the lesser-known Jacob Fobert and Hans Vervoert collaborated on nine of them, and Vervoert worked on one of the tapestries and wove the last two on his own. Jacob Geubels II, working alone, produced eight tapestries in his workshop. This division of labor implies that the work was carried out simultaneously in the two ateliers, and that once the pieces were finished, they were sent directly from the workshops to Madrid.

Close study of the signatures and marks reveals that Raes and Geubels never worked together. Here it is important to point out that the presence of the signatures of both weavers on *The Meeting of Abraham and Melchizedek* (cat. 3) is the result of later restoration work. In this tapestry Jan Raes I's signature can be seen beside the mark of Brussels-Brabant on the lower selvage. The mark is repeated on the upper selvage, but next to Geubels's signature. The appearance of this type of inscription in this area and the duplication of the city mark on one piece are unusual. An analysis of this tapestry conducted after its recent restoration showed that the city mark and the weaver's signature on the upper part are fragments of another piece that were cut and later integrated into this tapestry. It seems reasonable to believe that the upper mark and signature were taken from *The Victory of Truth over Heresy* (cat. 5), the only weaving in the series that lacks both. The considerable deterioration of the latter tapestry led to restoration of the lateral and lower selvage; thus it is conceivable

that its marks were cut out in order to preserve them and that at some point they were inserted into *The Meeting of Abraham and Melchizedek*. Therefore, it is likely that the maker of *The Victory of Truth* was Jacob Geubels II.[13]

Similarly, a meticulous study of the series revealed that Rubens reflected on and approached his design with unusual care,[14] and that he followed a previously established scheme that would explain the different characteristics of each hanging. It suggests that he approached the project with clear guidelines concerning its destination and principal purpose, and that he listened to suggestions and instructions from Infanta Isabel as well as Infanta Margarita (1567–1633), a nun in the Descalzas Reales who was the daughter of Empress María (1528–1603) and thus Isabel's cousin.

First, it is surprising that Rubens chose a similar architectural style to frame the scenes in fifteen of the twenty tapestries, employing an illusionistic device that had already been used in the previous century but that Rubens applied to greater dramatic effect.[15] The Chicago sketch, or group of the *Adoration of the Eucharist* (fig. 18),[16] supports the conclusion that Rubens decided to arrange into two tiers the fifteen tapestries containing scenes framed by columns, with those framed by Tuscan columns below and those with Solomonic columns above. The rest of the tapestries follow a separate concept, with different sizes and styles. This variation in design and dimensions, which is unusual in a series, is undoubtedly due to the location that each tapestry was meant to occupy according to an established plan. A careful look at these fifteen tapestries, as well as two others that are similarly framed with pilasters and capitals (*Angels Carrying the Monstrance* and *David Playing the Harp*), shows that the architectural elements are rendered from different perspectives, presumably as a function of their future locations. In 1982 Scribner noticed this discrepancy and suggested that most of the tapestries had been devised to be seen from different angles and to be arranged on two levels, and he noted that only two of them had been conceived to be contemplated from the front.[17]

Rubens envisioned an ideal point of view for the entire series, situated precisely between the two tiers of tapestries. This unusually elevated spot suggests that he was highly conscious of the view of the tapestries that the nuns would have had from the upper choir, located opposite the main altar. Also, the height of this ideal viewpoint would have corresponded approximately with the location of the tabernacle or the *manifestador* holding the monstrance in the chancel. All of this would rule out Tormo's

hypothesis that the tapestries were originally designed to decorate the church cloister,[18] in which case this compositional sophistication would lack any purpose.

In sum, based on these observations it is likely that Rubens designed the hangings with specific locations in mind, which explains the complexity of the perspectives and vanishing points and the diversity of the tapestry sizes and styles. Given the lack of documentation, drawings, or specific information on the subject, it is difficult to determine where each tapestry was hung. The matter must be approached by taking into account both the interior of the church in the seventeenth century and the accuracy of Rubens's knowledge of the space. In any event the design itself must have been complex, because the twenty panels had to fit a specific site far from the court in Brussels.[19]

USE AND FUNCTION IN THE CONVENT

The series was principally intended to decorate the church of the Descalzas Reales on two occasions a year: Good Friday and the Octave of Corpus Christi. Both of these focused on the exaltation of the sacrament of the Eucharist. Because the Descalzas Reales had a papal dispensation to display the Host on Good Friday, when other churches were prohibited from doing so, the celebration of the Eucharist had been of great importance to the convent since it was founded. Of particular significance was the public procession held on Good Friday, when the image of a recumbent Christ, attributed to Gaspar Becerra (1520–1568), with the Blessed Sacrament placed in the tabernacle in his chest, was carried through the Capellanes cloister in a unique celebration of this papal privilege.[20]

FIG. 18 | Peter Paul Rubens, *The Adoration of the Eucharist*, 1622–25. Oil on panel, 31.8 × 31.8 cm (12½ × 12½ in.), Chicago, The Art Institute, Mr. and Mrs. Martin Ryerson Collection, inv. 37.1012.

Accounts of several celebrations in Madrid during the Baroque period demonstrate that, despite its main purpose, this tapestry series was also used in other ceremonies, even prior to the completion of the convent. In 1632 the large plaza of the Descalzas Reales was adorned with some of its tapestries in conjunction with a procession of penance for outrages committed against an image of Christ.[21] On that occasion they were hung on the facade of the convent, a practice mentioned frequently throughout the seventeenth and eighteenth centuries.[22] One account dated 1680 refers to the decoration of the exterior of the building with the "best hanging" for the visit of the queen María Luisa de Orleans (1662–1689).[23] There are also reports of the *Eucharist* tapestries being hung inside the church for such festivities, including the 1638 procession in which a painting of Saint Dominic in Soriano was carried through the convent.[24]

According to documentation, the church was dressed with various tapestries for long periods of time that seem to coincide with winter. This can be deduced from an eighteenth-century manuscript that describes the protocol to be followed for each ceremony: "What is done after word has come that her majesty is to visit, if it is winter it is not necessary to hang because the tapestries are already in place, if it is summer that of Corpus is put up," and on another occasion, it emphasizes that "because the tapestries were already in place, the hangings were not moved."[25]

Thus the function of the *Triumph of the Eucharist* tapestries was inscribed in seventeenth-century ceremonial culture, characterized by complex staging in which machinery and contraptions were frequently used to construct decorated settings, even in church interiors. The staging was conducted under the direction of court artists, such as, for example, Sebastián de Herrera Barnuevo or Friar Juan Rizi, or by designers of royal works, as was the case at the Descalzas Reales in 1644 for the celebration of funerary honors for the queen of Poland, Cecilia Renata of Habsburg (1611–1644).[26]

In the seventeenth century the nave had an open, virtually square plan in which seats of honor, tribunes, altars, and all the necessary elements of court protocol were placed, depending on the ceremony. The participation of the king and his family required a tribune,[27] while benches were placed on the sides for other participants according to rank. There were also tribunes in the side chapels and in the nave of the church, occupied by musicians and priests, a custom that continued in the eighteenth century.[28] For many celebrations, especially those held on Good Friday or the Octave of Corpus Christi, there are references to

FIG. 19 | The chancel of the church of the Descalzas Reales covered with hangings and with the altar adorned for the celebration of the Virgin of the Miracle. Photograph from ca. 1910. Madrid, Archivo del Monasterio de las Descalzas Reales.

"circular" use of the church interior during liturgies, in which celebrants walked in procession throughout the entire church—a practice that corresponded with Rubens's scenes perfectly, as they projected and reinforced the idea of movement.

Usually the church walls were completely covered with hangings, and their placement and subsequent removal would have generated considerable expense. There are numerous references to their use, for example when the Infanta Margarita took her vows in 1585,[29] and on such special occasions as royal funerals, when the church was filled with emblems of mourning.[30] A detailed description of the Infanta Margarita's funeral, held in 1633, evokes the appearance of the building: "The holy church of the royal convent of the Descalzas was adorned with its own hangings, the transept and the chapel with rich black and purple cloths, and the body of the church with black damask and

velvet, the steps richly and respectably carpeted."[31] The funeral rites for Emperor Ferdinand II of Austria (1578–1637) proceeded in similar fashion in 1637, when the church was decorated with crimson damask and green velvet hangings, and the main altarpiece with crests bearing imperial coats of arms.[32] Something similar was done for the above-mentioned funeral for the queen of Poland, at which "the chancel of the main altar was hung with gold and black cloth with supports of black velvet worked on an orange field, which made it spectacular and sad, and the rest of the church [was hung] with black velvet of two orders in height."[33] The founder, Princess Juana of Austria, stipulated in her will that both the church and the cloister be decorated with hangings for processions that took place in both spaces.[34] These descriptions and the existence of an inventory of hangings[35] attest to the presence in the convent of a wide variety of these pieces intended to completely cover the church walls. The use of these hangings is also documented in the twentieth century, as shown in a photograph of the chancel from about 1910 (fig. 19).

Music was another essential element in ceremonies. Both Philip II and Philip III (1578–1621) negotiated the construction of an organ in Flanders. Its box and ornamentation were made according to a preplanned design, and it was installed in a tribune of the church, over the chapel of Saint John the Baptist on the left side of the nave, "in the corner of the outer part of the wall."[36] This organ was in use until it was replaced in 1790,[37] and its presence affected the placement of the tapestries on this wall.

ARRANGEMENT FOR CEREMONIAL EVENTS

The church was built by order of Juana of Austria between 1560 and 1564 according to plans by royal architect Juan Bautista de Toledo. It was oriented to the north, which was unusual. From 1614 to 1617 architect Juan Gómez de Mora planned and carried out remodeling work that affected the *sotocoro*, or subchoir (the area below the choir loft), in particular and modified the nuns' choir. Later, in 1756, Diego de Villanueva remodeled the church interior and placed a large oculus over the choir,[38] one of numerous transformations that included the introduction of tribunes, new pulpits, and the removal of several steps at the entry to the chancel. Finally, a fire in 1862 completely destroyed the altarpiece designed by Gaspar Becerra and damaged other areas of the church, necessitating the complete restoration of the building. The substantial alteration of the structure after successive interventions put an end to the hanging of tapestries in the church interior.

Today the chancel has a structure unlike the one it had in the seventeenth century. Several pre-1626 anonymous plans of the church, from the Cassiano dal Pozzo collection,[39] show access to the presbytery by nine steps (which Juan López de Hoyos had mentioned in 1569 as "eleven granite steps"[40]), in contrast to the five there today. This suggests that the original altar stood at a greater height—on a plane similar to that of the two rooms that now stand to each side of the chancel: the funerary chapel of Doña Juana and the communion rail—and occupied a smaller area of the floor of the large chapel than the altar does today.

Documentation related to the Octave of Corpus Christi and Good Friday reflects the fact that on both occasions the chancel was the focus of elaborate, painstaking decoration.[41] Father Juan Carrillo, Infanta Margarita's confessor, stated that in 1616 for the Octave of Corpus Christi altars were added and the church walls were embellished with hangings. The main altar was adorned "from top to bottom . . . with handmade roses and flowers of silk and colors," and rich carpets were spread out on the steps of the altars, which were adorned with large candleholders, crosses, images of saints, and silver pitchers with flowers, incense, and perfume.[42] Father Carrillo carefully described multicolored decoration that flooded the church with light and scent. Carrillo himself expressed, "there is so much to say, that all of the above does not even begin to do justice, nor can it be fairly described, if it is not by resorting to the sight of it. And being so elaborate, each year it grows along with the devotion to the Blessed Sacrament."[43]

Regarding the use of tapestries during these festivities, Carrillo also related that on the day of the Octave, the entire cloister was hung with lavish tapestries showing the siege of Tunis. These had belonged to Charles V, and his daughter Juana of Portugal, the foundress of the Descalzas, left them to Philip II "on the condition that the tapestries be hung in the cloister on this day."[44] Therefore, it can be concluded that Infanta Isabel Clara Eugenia's gift of the Rubens tapestries did not override Doña Juana's wishes, because throughout at least the seventeenth century and part of the eighteenth, the two series coexisted and contributed to the ornamentation of the convent.[45] It would be logical to suppose that when both series were displayed, the Rubens tapestries were hung in the church and the series *The Siege of Tunis* in the cloister or, on other occasions, on the outer facade of the convent.

In the nineteenth century the decoration of the chancel for the Octave of Corpus Christi continued to be complex and com-

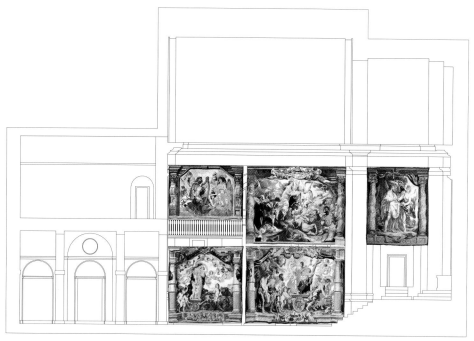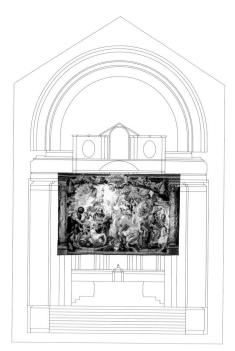

FIG. 20–23 | Proposal for the location of the tapestries of the *Triumph of the Eucharist* in the interior of the church of the Descalzas Reales.

20 | The Gospel side (west): from left to right and top to bottom, *David Playing the Harp, The Victory of Truth over Heresy, The Prophet Elijah Being Fed by an Angel, The Triumph of Divine Love,* and *The Triumph of Faith.*

21 | Chancel (north): *The Triumph of the Church.*

22 | The Epistle side (east): from left to right and from top to bottom, *The Gathering of Manna, The Four Evangelists, The Victory of the Eucharist over Idolatry, The Defenders of the Eucharist,* and *Sacrifice of the Old Covenant.*

23 | Choir wall (south): from left to right and top to bottom, *Musical Angels, Angels Carrying the Monstrance, Musical Angels, The Sacred Hierarchy in Adoration,* and *The Secular Hierarchy in Adoration.*

posed of numerous elements. In a letter after 1808, the abbess Sor María Bárbara de San Luis listed a series of objects removed by the French that had been used for this celebration, including two chandeliers, silver stands with frontals, pyramids, and a red hanging.[46]

The adornment of the chancel for Good Friday was no less elaborate. An idea of its appearance can be gleaned from a drawing in the Galleria degli Uffizi,[47] attributed to Francisco Rizi and dated to about 1660, that Alfonso R. Gutiérrez de Ceballos considered a sketch for scenery intended to cover the main altarpiece of the Descalzas Reales for the festivities.[48] Some features of the drawing clearly resemble works held in the convent, such as

the image of the recumbent Christ by Gaspar Becerra that is still placed on the main altar during the celebration of Good Friday.

All this evidence reveals the presence at both celebrations of a complex decorative program for the chancel that would have affected the arrangement of the tapestries in this space. The fact that, according to descriptions from the time, the main altar would have been completely decorated, along with the higher elevation of the altar from the floor of the chancel compared to the present day, would indicate that in order to be completely visible, tapestries would have had to be hung on the upper part of the altar wall.

Therefore, it seems logical to suppose that this was the location of a tapestry intended for the upper level and the largest in the series, *The Triumph of the Church* (fig. 25 and cat. 7). The complex, brilliant, and baroque composition of this work also encapsulated the iconographic program of the entire group. The dimensions of the tapestry—almost 5 meters tall by 7½ wide (about 16 by 25 feet)—fit the space available on the wall of the chancel above the altar (see fig. 21).

Rubens conceived this tapestry as the principal piece of the commission and differentiated it from the rest even in the first sketches.[49] Both the architectural framework and the perspective of the scene are designed for a frontal view, from below looking upward, which supports the idea that it was intended

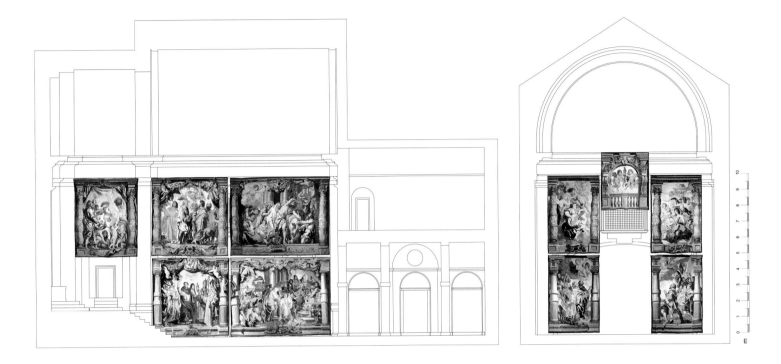

to be positioned over the main altar. Furthermore, the presence of Solomonic columns confirms that it belongs to the group of tapestries conceived for the upper level, although in this case, because of the lack of available space, without the accompaniment of another hanging below it.

In the majority of the tapestries, including the piece over the main altar, the movement of the scenes flows from left to right. The series' processional sense suited the liturgy of eucharistic ceremonies, in which the celebrants moved throughout the church's interior using different altars. This explains the design Rubens formulated for the central tapestry, in complete accord with the rest, that deliberately indicated movement that would guide the faithful to the chapel of Saint Sebastian, through the doors of which processions entered the Capellanes cloister.

The Gathering of Manna and *The Prophet Elijah Being Fed by an Angel* (figs. 26, 24), bordered with Solomonic columns and thus intended for the upper level, would have hung next to the main panel. Their dimensions, perspectives, vanishing points, and subject matter demonstrate that they were designed to form a pair. Iconographically, the presence of these two prefigurations of the Eucharist near the main altar would have been fully justified. The dimensions of these two tapestries, around 500 × 410 cm (197 × 161½ in.), perfectly fit the side walls of the chancel. There the pieces would have flanked the central panel and

formed a group with it, as if they were the doors of an enormous triptych. Two lateral altars situated on each side of the main altar would have occupied the lower parts of these walls, so again it would have been unnecessary to hang similar panels in the space below. The perspectives in these three tapestries and their horizon lines would have been at the same height as that of the tabernacle or the monstrance, which would reinforce the meaning of the decorative program.

To date, most studies have supported the hypothesis proposed by Tormo in 1942 that the chancel was decorated with the so-called altar veil or curtain, a group of five tapestries on two levels that appears in the aforementioned oil sketch of *The Adoration of the Eucharist* in the Art Institute of Chicago (fig. 18). These five tapestries do not include the device of a fictive tapestry. The ones in the lower level show the civil and ecclesiastical hierarchies; the upper-level tapestries show angels playing musical instruments and singing. Rounding out this composition is a tapestry of smaller dimensions, in which two angels hold aloft a monstrance (figs. 27–31).

Tormo proposed that this grouping of tapestries was intended to cover the altarpiece of the main altar of the church during Holy Week celebrations.[50] His reasoning was based on the tradition of hanging veils or tapestries for Lent, a widespread practice in Germany, Austria, Switzerland, and France during the

fourteenth and fifteenth centuries[51] and still observed in Spain in the seventeenth century.[52] However, veils were oil paintings done on huge pieces of serge, principally representing scenes from the Passion rendered in pale colors or in grisaille. Many of these altar veils evoked the structure of an altarpiece or employed architectural elements in their composition, as in the case of the grouping formed by the five tapestries in the Chicago sketch. Nevertheless, apart from the technical difficulties of hanging this grouping on the main altarpiece, as well as questions of iconography, objective data indicate that this group was actually planned to be placed at the foot of the nave, around the choir grille (see fig. 23), a hypothesis already put forth by, among others, Brassat, who offers the most detailed arguments regarding this possibility.[53]

The first piece of evidence in support of this theory comes from the Chicago sketch, which some authors regard as Rubens's design for a fresco.[54] Clearly visible at the center is a grille or screen behind which, rather than neutral space, there is the suggestion of a curtain suspended from a circular element in the manner of a canopy, and below and to the right, what seems to be a human figure. Although some scholars paid attention to the grille in the sketch, they continued to defend the opinion that these hangings were intended for the main altar. However, a review of the convent's archives verifies that the only grille that existed in the church was that of the choir, always located in the upper part of the south wall according to the express wishes of the first community.[55] López de Hoyos referred to this screen in detail in 1569, describing it as "very sturdy" and recording its dimensions and its appearance with spikes like the points of a diamond (*puntas de diamantes*),[56] a description that matches the current grille.

Another indication that this group was intended for the south wall of the church is that placement of the tapestries according to the sketch would achieve a width of almost 10 meters (33 feet), far exceeding the 7 meters available on the wall of the high altar but fitting the south wall of the church almost perfectly. De Poorter noticed this discrepancy in the measurements, but she maintained Tormo's theory regarding the installation of these tapestries in the chancel.[57] Curiously, De Poorter contemplated the possibility of their placement on the south wall of the church, but she dismissed it, claiming a supposed difficulty in hanging them there. She underestimated the expertise of workers and artists in installing the complex structures and ingenious mechanics needed for the temporary decorations characteristic of celebrations in seventeenth-century Madrid.[58]

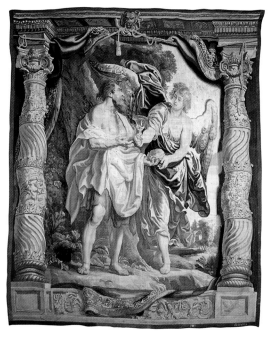

FIG. 24–26 | Chancel tapestries

24 | Woven by Jacob Geubels II after designs by Peter Paul Rubens, *The Prophet Elijah Being Fed by an Angel*, 1625–33. Wool and silk, 500 × 410 cm (197 × 161⅓ in.). Patrimonio Nacional, Madrid, Monasterio de las Descalzas Reales, inv. 00610320.

25 | Woven by Jan Raes I after designs by Peter Paul Rubens, *The Triumph of the Church*, 1625–33. Wool and silk, 490 × 750 cm (193 × 295¼ in.), Patrimonio Nacional, Madrid, Monasterio de las Descalzas Reales, inv. 00610325.

26 | Woven by Jan Raes I, Hans Vervoert, and Jacob Fobert after designs by Peter Paul Rubens, *The Gathering of Manna*, 1625–33. Wool and silk, 500 × 410 cm (197 × 161⅓ in.), Patrimonio Nacional, Madrid, Monasterio de las Descalzas Reales, inv. 00610321.

There were many workshops dedicated to such tasks, involving specialized artisans working under such artists as Gómez de Mora, who participated in the design and execution of the scenery for the Octave of Corpus Christi in 1644 in Madrid. Photographic documentation of the convent shows that this type of complex staging lasted well into the twentieth century (see fig. 19).

However, the proposed placement of this group of tapestries on the south wall presents certain problems when compared to Rubens's painting in the Chicago sketch. On the one hand, the actual dimensions of the tapestries are not reflected in the sketch, nor are those of the south face of the church with the grille in the central part. Installation of the five panels would completely cover the 10 meters (33 feet) of available space between the cornice and the floor of the church, and it would leave

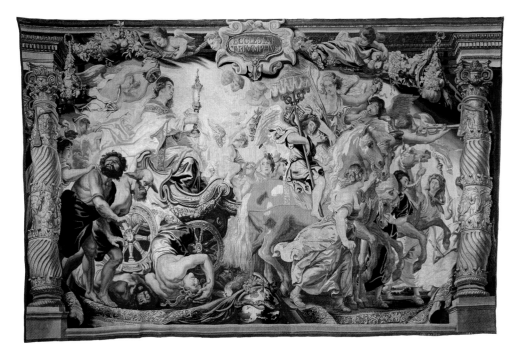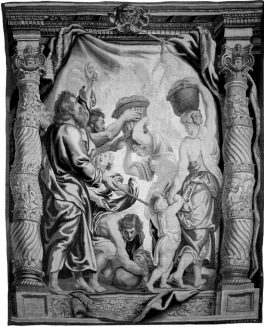

in the middle of the lower part an opening for accessing the nave from the *sotocoro*, something that is not confirmed in the sketch. On the other hand, the current location of the choir railing would prevent the alignment of the three upper panels as shown in the painting, which necessitates a return to certain questions already raised by other authors. First, how accurately could Rubens have known the space for which he designed the tapestries, and second, what was the impact of successive architectural remodeling in this part of the church? The account by López de Hoyos mentioned above describes the location of the railing as "opposite the main altar." Although there are no data on this matter, some of the remodeling of the church might have entailed an elevation of the floor of the choir. This would explain why documentation from the end of the seventeenth century indicates that access to the choir was by way of a stairway with seven steps, making up for a difference in floor level with the antechoir.[59] In the current appearance of the choir, the grille is extremely low, practically resting on the ground. This fact shows that Rubens could have worked on the design of this group of tapestries using outdated architectural information. Rubens's planned arrangement for the series would have been more feasible had he considered the chancel and the choir to be on the same level, as López de Hoyos has suggested.

A second problem discussed by De Poorter is that the placement of these hangings on the wall of the choir would have impeded the view of participants in the subchoir. However, it can be argued that originally this was a narrow space, divided into nine sections framed by pillars, whose only purpose was to afford access to the body of the church and to separate it from the space of the large plaza. Both zones, nave and subchoir, were perfectly differentiated in terms of dimensions, appearance, and functionality, keeping the subchoir excluded from the scene of ceremonies. Gómez de Moral's remodeling attempted to unite it with the central body of the church, but ceremonies continued to be set primarily in the nave and the chancel.

Another doubt arises from the painting or tapestry that occupies the lower part of the Chicago sketch, which shows a garland and, in the lower corners, the bread and chalice that symbolize the Eucharist. Its location reveals new discrepancies with regard to the actual dimensions of the church. If the tapestries were really hung as they appear in the sketch, they would reach the floor. Only a narrow space would remain below this center hanging, preventing passage from the subchoir to the nave.

Beyond the differences between the actual space and that represented by Rubens, it seems that the painter did this sketch with the idea of arranging these five tapestries around the grille of the nuns' choir without paying much attention to the true measurements, with which he would undoubtedly become increasingly familiar in subsequent phases of the design. According to this line of reasoning, this sketch should be regarded as a

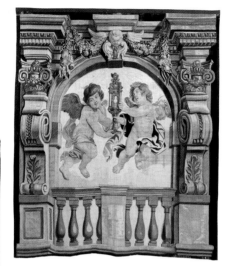

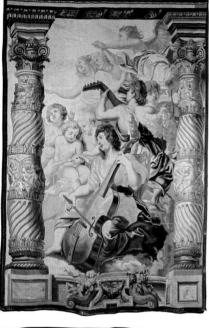

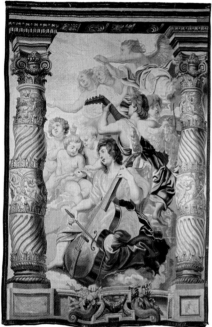

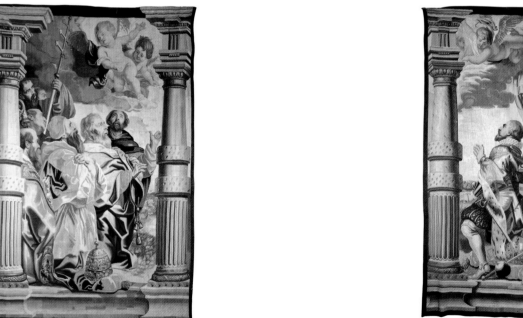

preliminary idea in the creative process, focused principally on showing the combination of the five panels on a single wall surface.

Once the eight panels intended for the chancel and the choir wall were assigned, the next step would have been to determine how to decorate the lateral walls of the church. Grouping the remaining tapestries according to their perspectives shows the impossibility of creating two matched groups. This suggests that the two walls, despite being of the same dimensions, did not have an identical appearance, perhaps as a result of the organ on the left side of the church, which undoubtedly affected the decoration.

The perspectives and orientation of the remaining scenes confirm that four hangings make up a cohesive group. The connection between two of them, *The Four Evangelists* and *The Defenders of the Eucharist*,[60] has been accepted throughout the literature. Together with these, the decoration on the east wall would have been made up of the tapestries *The Victory of the Eucharist over Idolatry*, on the upper level, and *Sacrifice of the Old Covenant*,[61] on the lower part, scenes that were already grouped together by Scribner (see fig. 22). These four compositions display a similar orientation and a scenic continuity across the scenes, which may be observed in such specific details as the matching edges of the fictive tapestry in the lower panels (figs. 36–39).

The decoration of the west wall poses other difficulties. Documentation suggests that the nuns' confessional was in this

area, as well as the access point to the pulpit and the above-mentioned organ tribune. These elements would have made this wall substantially different from the facing wall. Taking this into consideration along with the characteristics and dimensions of the panels, it is possible to form a coherent grouping with *The Triumph of Faith*[62] and *The Triumph of Divine Love*[63] on the lower level and *The Victory of Truth over Heresy* on the upper level.[64] The resulting empty space would have been occupied by the organ tribune, although no specific information about its appearance is available (fig. 20).

In this combination, and taking into account the existence of the tribune, the hanging *David Playing the Harp* could have fit.[65] With a width very similar to that of *The Triumph of Divine Love* and a height close to 3½ meters (11½ feet), it would have served as a backdrop for the tribune, a purpose that would justify its iconography. Its perspective corresponds to that of the other tapestries in this group (figs. 32–35).

An earlier proposal, based solely on the arrangement of architectural elements, paired this hanging with *Angels Carrying the Monstrance* and therefore positioned it on the south wall. This theory has been disproved by the fact that the size of the wall would not have provided sufficient space for this arrangement.[66]

The current proposal, regarded as the master plan for the layout of the tapestries in the church, does not rule out the possibility that they were also combined in other ways, as shown in documentation. This potentiality may have been taken into account by Rubens when he designed the series, and it might explain the existence of an anonymous drawing that appeared on the art market, which is regarded as a copy of an original by Rubens and shows four of the tapestries arranged in a line.[67] This drawing must have come from the early stages of the creative process, because *The Meeting of Abraham and Melchizedek*,[68] a hanging that is surrounded by a number of unknowns, still appears to be framed by Solomonic columns (fig. 40 and cat. 3).

This tapestry is the one that raises the most uncertainties, with respect to both its design and its place in the overall decorative program. It is evident that throughout the creative process certain doubts arose concerning its location within the church, causing successive radical modifications surely made as Rubens received new instructions.

The first sketch for *The Meeting of Abraham and Melchizedek* (see fig. 12),[69] shows that at the beginning this panel was planned for a space on the upper level and had measurements similar to those of *The Triumph of Divine Love*, meant for the lower tier, and

FIG. 27–31 | Tapestries on the choir wall: from left to right and top to bottom.

27 | Woven by Jacob Geubels II after designs by Peter Paul Rubens, *Musical Angels*, 1625–33. Wool and silk, 495 × 320 cm (195 × 126 in.), Patrimonio Nacional, Madrid, Monasterio de las Descalzas Reales, inv. 00614224.

28 | Woven by Jacob Geubels II after designs by Peter Paul Rubens, *Angels Carrying the Monstrance*, 1625–33. Wool and silk, 350 × 311 cm (138 × 122½ in.), Patrimonio Nacional, Madrid, Monasterio de las Descalzas Reales, inv. 00614222.

29 | Woven by Jan Raes I, Hans Vervoert, and Jacob Fobert after designs by Peter Paul Rubens, *Musical Angels*, 1625–33. Wool and silk, 494 × 312 cm (194½ × 123 in.), Patrimonio Nacional, Madrid, Monasterio de las Descalzas Reales, inv. 00614218.

30 | Woven by Jacob Geubels II after designs by Peter Paul Rubens, *The Sacred Hierarchy in Adoration*, 1625–33. Wool and silk, 500 × 330 cm (197 × 130 in.). Patrimonio Nacional, Madrid, Monasterio de las Descalzas Reales, inv. 00614216.

31 | Woven by Jan Raes I, Hans Vervoert, and Jacob Fobert after designs by Peter Paul Rubens, *The Secular Hierarchy in Adoration*, 1625–33. Wool and silk, 500 × 330 cm (197 × 130 in.), Patrimonio Nacional, Madrid, Monasterio de las Descalzas Reales, inv. 00614217.

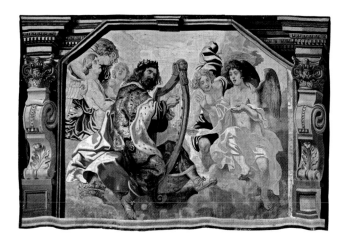

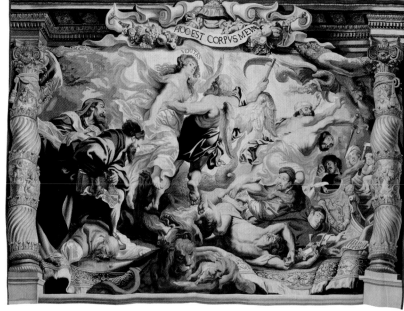

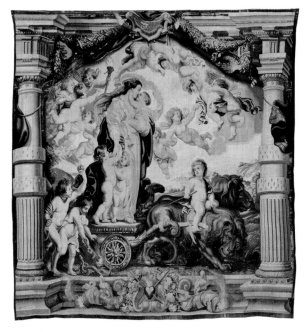

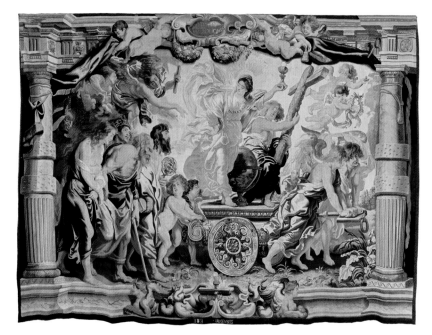

FIG. 32–35 | Tapestries on the Gospel side (west).

32 | Woven by Jacob Geubels II after designs by Peter Paul Rubens, *David Playing the Harp*, 1625–33. Wool and silk, 330 × 485 cm (130 × 191 in.), Patrimonio Nacional, Madrid, Monasterio de las Descalzas Reales, inv. 00614223.

34 | Woven by Jan Raes I, Hans Vervoert, and Jacob Fobert after designs by Peter Paul Rubens, *The Triumph of Divine Love*, 1625–33. Wool and silk, 497 × 495 cm (196 × 195 in.), Patrimonio Nacional, Madrid, Monasterio de las Descalzas Reales, inv. 00610323.

33 | Woven by Jacob Geubels II after designs by Peter Paul Rubens, *The Victory of Truth over Heresy*, 1625–33. Wool and silk, 470 × 652 cm (185 × 256¾ in.), Patrimonio Nacional, Madrid, Monasterio de las Descalzas Reales, inv. 00614221.

35 | Woven by Jacob Geubels II after designs by Peter Paul Rubens, *The Triumph of Faith*, 1625–33. Wool and silk, 490 × 660 cm (193 × 260 in.), Patrimonio Nacional, Madrid, Monasterio de las Descalzas Reales, inv. 00614219.

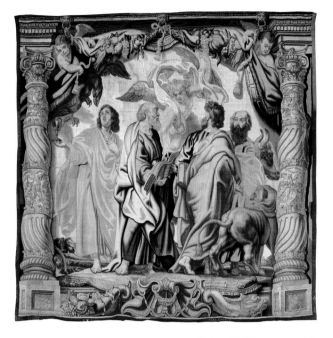

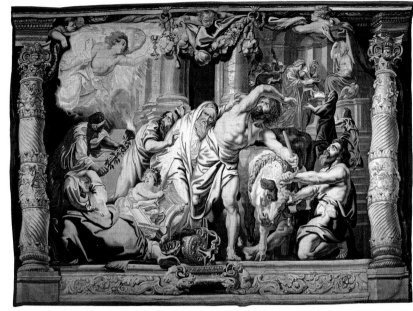

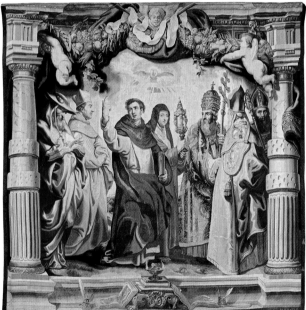

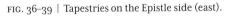

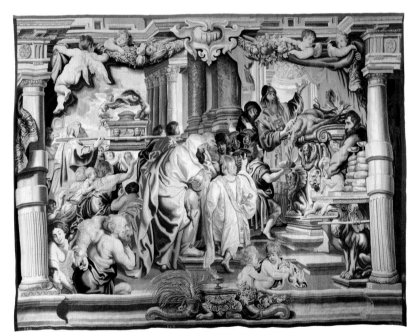

FIG. 36–39 | Tapestries on the Epistle side (east).

36 | Woven by Jan Raes I, Hans Vervoert, and Jacob Fobert after designs by Peter Paul Rubens, *The Four Evangelists*, 1625–33. Wool and silk, 500 × 490 cm (197 × 193 in.), Patrimonio Nacional, Madrid, Monasterio de las Descalzas Reales, inv. 00610322.

38 | Woven by Jan Raes I, Hans Vervoert, and Jacob Fobert after designs by Peter Paul Rubens, *The Defenders of the Eucharist*, 1625–33. Wool and silk, 500 × 485 cm (197 × 191 in.), Patrimonio Nacional, Madrid, Monasterio de las Descalzas Reales, inv. 00618366.

37 | Woven by Jan Raes I, Hans Vervoert, and Jacob Fobert after designs by Peter Paul Rubens, *The Victory of the Eucharist over Idolatry*, 1625–33. Wool and silk, 500 × 660 cm (197 × 260 in.), Patrimonio Nacional, Madrid, Monasterio de las Descalzas Reales, inv. 00610319.

39 | Woven by Jan Raes I, Hans Vervoert, and Jacob Fobert after designs by Peter Paul Rubens, *Sacrifice of the Old Covenant*, 1625–33. Wool and silk, 490 × 670 cm (193 × 264 in.), Patrimonio Nacional, Madrid, Monasterio de las Descalzas Reales, inv. 00614220.

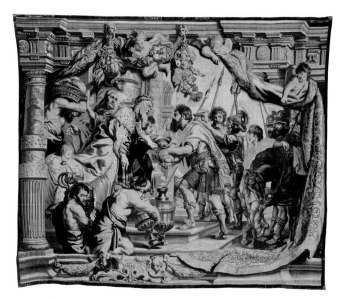

FIG. 40 | Woven by Jan Raes I, Hans Vervoert, and Jacob Fobert after designs by Peter Paul Rubens, *The Meeting of Abraham and Melchizedek*, 1625–33. Wool and silk, 500 × 587 cm (197 × 231 in.), Patrimonio Nacional, Madrid, Monasterio de las Descalzas Reales, inv. 00610324.

the same characteristics as the *modello* (panel painting) in the Museo del Prado (fig. 13 and cat. 2). However, later changes to the architectural framework visible in the *modello* at the National Gallery in Washington, DC, indicate the change of its intended location, then reestablished as the lower level, which also implied an increase in its dimensions (see fig. 14).[70]

When the tapestries destined for the lateral walls of the church are grouped, this hanging remains outside the margin of possible combinations, because there is no space on the lower wall that can be assigned to it with a perspective similar to that of the hangings on the west wall. Neither do its dimensions correspond to any of those with the same perspective hanging on the upper level. Furthermore, the device of a fictive tapestry is more evident in this piece, as it completely hides one of the columns of its architectural framework. This makes the artificial scenery more effective and invites the viewer to imagine that the small angel that holds up the tapestry at its right end does so for a reason. Once more, observation of the composition and its details offers interesting information. Undoubtedly Rubens intended to show more clearly here than in the rest of the hangings the angels' actions of hanging and taking down. The folds formed by the fictive tapestry gathered by the *putti* would have been level in height with the door of Saint Sebastian, through which eucharistic processions entered the cloister. These characteristics of the

composition allow for the proposal of a new hypothesis: that this piece was designed to be hung in the west corridor of the Capellanes cloister, on the church exterior, dramatically connecting the interior space of the church with that of the cloister. This would maintain a certain solemnity of decoration with *The Siege of Tunis* tapestries and other hangings according to the tradition established by the foundress in the mid-sixteenth century.

Or this hanging might have replaced *The Triumph of Hope*, of which only a preliminary sketch was made.[71] It also contained a fictive tapestry that hid two columns and its perspective would have adapted to the same purpose. A reasonable theory can be put forth on this point: Rubens designed the first sketches to completely decorate the church interior, connecting this space with the cloister using the tapestry *The Triumph of Hope*. While he was executing the *modelli*, the artist received new information about the church and realized that the combination proposed for the west wall had to be modified. Surely indications from the Infanta Margarita and from Isabel Clara Eugenia herself determined the elimination of this panel and its replacement with *The Meeting of Abraham and Melchizedek*, a hypothesis proposed by Scribner.[72] These changes themselves suggested the creation of the tapestry *David Playing the Harp* to complete the decoration of the west wall, adjusting it to the organ tribune.

Finally, the last three tapestries that finish the series, whose inclusion in the group has been questioned by various experts, speak to a completely different concept (figs. 41–43). Their appearance is more like that of paintings framed by classic gilded egg-and-dart moldings, which suggests that they served as such in specific locations in the church, or possibly the cloister, and that their design and size corresponded to this function.

Again, the measurements of each one of them contributed relevant information. The dimensions of the two small hangings, *Allegory of Charity* and *Allegory of Divine Wisdom*, would have permitted their placement over lost portraits of Juana of Austria and her sister Empress María by Juan Pantoja de la Cruz, which were hung on the lateral walls of the chancel and were destroyed in the fire of 1862.[73]

Perhaps the tapestries covered these paintings on certain occasions, but they could also have been intended to cover, for some celebrations, the small lateral altarpieces of the nave, given that their measurements were very similar. However, both proposals are acceptable only if we assume that these tapestries were versatile and had been designed by Rubens as a complement to the central decorative program.[74]

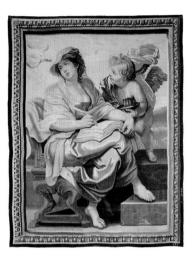

FIG. 41 | Woven by Jan Raes I after designs by Peter Paul Rubens, *Allegory of Charity*, 1625–33. Wool and silk, 260 × 200 cm (102⅜ × 78¾ in.), Patrimonio Nacional, Madrid, Monasterio de las Descalzas Reales, inv. 00610327.

FIG. 42 | Woven by Jacob Geubels II after designs by Peter Paul Rubens, *Allegory of Divine Wisdom*, 1625–33. Wool and silk, 260 × 200 cm (102⅛ × 78¾ in.), Patrimonio Nacional, Madrid, Monasterio de las Descalzas Reales, inv. 00610328.

FIG. 43 | Woven by Jan Raes I and Hans Vervoert after designs by Peter Paul Rubens, *Allegory of Eternity* or *Allegory of the Succession of the Popes*, 1625–33. Wool and silk, 500 × 244 cm (197 × 96⁄16 in.), Patrimonio Nacional, Madrid, Monasterio de las Descalzas Reales, inv. 00610326.

Similarly, the tapestry *Allegory of the Succession of the Popes*[75] was also conceived as a pictorial work. Apart from its iconographic complexity, it does not form a pair with any of the other hangings. Its size is similar to that of the lateral doors of the church, so it could have been planned to decorate them on certain occasions.[76] As in the case of the two previous tapestries, some scholars have regarded this hanging as a later addition and have even shifted the date of its production and arrival at the convent. Jan-Albert Goris and Julius Held proposed a date of 1630, while Ludwig Burchard moved it to 1635. It was Tormo's opinion that these three panels were not designed by Rubens; however, De Poorter believed that they formed part of the series and furthermore that they were essential to understanding it.[77]

What remains to be determined is the date that the tapestries of the *Eucharist* were installed in the church according to Rubens's original program. Nineteenth-century writings are full of information about the ceremonies for the Octave of Corpus Christ and Good Friday and the use of the tapestries to decorate only the walls of the cloister during the respective processions. These sources lament that these ceremonies were gradually losing their splendor and that, with their habitual use in the cloister, the tapestries' earlier purpose and arrangement inside the church would be forgotten. A document from 1850 states that "the entire enclosure of the Descalzas has been decorated

for almost two hundred years with the extremely beautiful and celebrated tapestries of the Triumphs,"[78] without specifying the layout of the pieces. In 1856 it was explained how "in prosperous times for the community, the Octave ended with a procession that went all through the area of the plaza that stands in front of the church, with a canopy as in the Corpus Christi procession, as well as profusely adorned altars to hold the monstrance."[79] Greater simplicity in the celebrations must inevitably have meant a purely ornamental use of the tapestries, to the detriment of the original ideological discourse.

This variation in the use of the tapestries might be the reason that Carderera specifically noted that "now they tend to be placed in the outside cloister of the convent," when referring in 1868 to the procession of the altars of the Octave of Corpus Christi. Carderera adds an even more specific bit of information by indicating that until the middle of the first third of the nineteenth century, they decorated the plaza "of the above-

mentioned convent, hung on its walls and part of those of the Monte de Piedad." He adds furthermore that they served as back-drops for portable altars improvised from paintings, reliquaries, vases of flowers, and other "devotional treasures."[80]

The lack of a coherent iconographic program for the arrangement of the tapestries in the cloister was also reflected in a small leaflet published in 1881[81] and in the inventory of 1925, which lists the tapestries located in the cloister on Good Friday, for the procession of the Santo Entierro (Holy Entombment), and on the Octave of Corpus Christi for the procession of the altars.[82] In both cases, the series was incomplete and the hangings were displayed without consideration or logical order.

This reconstruction of the original placement of the Rubens tapestries in the church of the Descalzas Reales has attempted to reveal the artist's unified concept for this group of hangings in accordance with an established program. It is evident that in this undertaking Rubens enjoyed great freedom, with which he approached both the design of each scene and the overall presentation of the series, thus successfully creating an artistic ensemble difficult to surpass.

NOTES

1 See García Sanz 1999; this study, in turn, was updated for a paper presented at the Rubens Symposium held in the Ringling Museum in Sarasota in March 2012. This essay is an expanded and revised version.

2 Carderera 1868, p. 218.

3 Rooses 1886–92, vol. 1, p. 72.

4 Tormo 1942; the articles were assembled in a single volume in 1945, which will be cited hereafter.

5 Elbern 1954.

6 Junquera and Junquera 1969.

7 De Poorter 1978.

8 Scribner 1975 and 1982.

9 Brassat 1988. He later published his doctoral dissertation, in which he deals with aspects of this same series (Brassat 1992).

10 De Poorter 1978, vol. 1, p. 63.

11 Brassat 1988, p. 45.

12 Madrid, Archivo del Monasterio de las Descalzas Reales (hereafter AMDR), 54/9, *Memoria de las sedas flojas de matizar . . . para enviarlas a Bruselas a la Serenísima Infanta Nuestra Señora*, 1620.

13 Future study of the entire body of graphic and textual documentation on the restoration process could help to confirm the date when this conservation work was carried out. The earliest photographs published by Elías Tormo show that by 1942 the marks and signature had already been transferred from one tapestry to the other. Perhaps this modification corresponds to the frequent restoration and tightening work done between 1880 and 1890.

14 Freedberg 1995, p. 59.

15 Sandtner 2010, pp. 200 and 297.

16 Oil on panel, 31.8 × 31.8 cm (12½ × 12½ in.), inv. 37.1012.

17 Scribner 1982, pp. 113–23.

18 Tormo defended this idea because he regarded the series as a two-part commis-

sion in which the first and principal group of eleven tapestries was intended for the cloister; see Tormo 1945, pp. 22 and 78.

19 Depauw 1993, p. 195.

20 The veneration of the recumbent Christ is characteristic of the convents of the Poor Clares. The procession held in the Descalzas Reales arose from a religious drama established by Saint Francis Borgia in Gandía. See García Sanz 2010, pp. 24–28.

21 During the procession, the spacious plaza was decorated with the tapestry *The Siege of Tunis* and with "the one held by the Royal Convent of the Descalzas of the Triumphs of the Blessed Sacrament, gift of the lady Infanta from Flanders"; in Peña 1632, fol. 11v. This information comes from Javier Portús (Portús 1998). The series *The Siege of Tunis*, linked to the Descalzas Reales, is dated to 1558, and it was apparently a copy commissioned by Maria of Hungary of the *princeps* made by Willem de Pannemaker from 1548 to 1554 for Charles V. This copy was inherited by Philip II and turned over to his sister for its use in the convent. There are different theories concerning the ownership of this series; see González García 2007, pp. 43–45.

22 See, for example, Mendoza y Berdugo, Manuel, *Libro de varias curiosidades, parte pertenecientes a esta real casa y parte tocantes a fuera de ella, todo de sagradas ceremo-nias . . . todo desde 18 de julio de 1756 en adelante*, Biblioteca del Monasterio de las Descalzas Reales (hereafter BMDR) F-28, fol. 69. It mentions the task of hanging tapestries on the entire facade, for which 151 reales were paid to the hanger, an expense that included reinforcements, ropes, and nails, plus 11 reales to four young men to do all the work.

23 See *Varios sucesos vividos en el monasterio de las Descalzas Reales desde 1677 hasta 1684*, AMDR, 16/1, fol. 2v.

24 *Colocación de la milagrosa imagen del glorioso patriarca santo Domingo de Soriano. Procesión y octavario solemne que se celebró en su capilla*, Madrid, Francisco Martínez, 1638, included in Simón Díaz 1964, vol. 1, pp. 237–47.

25 *Libro de varias curiosidades*, fols. 22 and 53.

26 See the description of the ceremonies in "Honras que se celebraron en la villa de Madrid . . . por su majestad de la señora reina de Polonia y Suecia . . . en los diez y siete y diez y ocho de junio de este año de 1644," in Salvá and Sainz de Baranda 1852, pp. 562–68.

27 "Hallaron hecha la Tribuna que en el Templo desta Real Casa cae al Altar Mayor, en donde en las fiestas públicas oyen y asisten los Reyes a los Oficios Divinos" (They found the Tribune built in the Church of this Royal House on the Main Altar, where the Royals hear and attend Divine Services on public feast days). Juan de Palma 1636, fol. 54.

28 On this custom, see in AMDR, 7/33, the 1722 letter from senior chaplain Gregorio de Mercado y Morales to the abbess of the Descalzas Reales, Sor Isabel de Jesús, in which he reminds her of the damage that preparing the wooden tribunes for the feasts of All Souls and Christmas would cause in the church. He mentions the wood tribunes for these celebrations arranged in the side chapels, where "they damage the altars, the gilding on the railings, and break the tiled floor."

29 BMDR, F-8, *Libro de la sacristía del monasterio de las Descalzas Reales 1575–1614*, fol. 53v, where the expense is recorded as "one real for nails to put up the hangings in the church when the Infanta took her vows as a nun," surely a reference to the Infanta Margarita. The manuscript mentions the workers who helped to put up the hang-ings in the church at this event and what they charged for work that took them "two half days." The document includes abundant information on *colgar la iglesia*, the custom of hanging tapestries in churches at the end of the sixteenth century.

30 Juan López de Hoyos, *Hystoria y relación verdadera de la enfermedad felicíssimo tránsito, y sumptuosas exequias fúnebres de la sereníssima reyna de España doña Isabel de Valoys, nuestra señora*, Madrid, Pierres Cosin, 1569, reprinted in Simón Díaz 1964, vol. 1, pp. 20–54.

31 Palma 1636, fol. 276.

32 Ochoa 1850–70, vol. 2, p. 338.

33 Salvá and Sainz de Baranda 1852, p. 563.

34 See *Real fundación de la capilla y monasterio de religiosas franciscas descalzas de la primera regla de Santa Clara, que en la villa de Madrid dotó y fundó la sereníssima señora doña Juana*

de Austria, infanta de Castilla y princesa de Portugal, por los años de 1572 con las declaraciones que a ella hizo en Gumiel de Mercado a 15 de octubre de 1602 el señor rey don Phelipe III como patrón y protector que era, confirmadas por la santidad de Clemente VIII en 24 de marzo de 1601, Madrid, Imprenta de Francisco Xavier García, 1769, p. 56.

35 AMDR, 39/9, *Relación de las colgaduras que tiene a su cargo el guardarropa del Monasterio de las Descalzas Reales del dinero que se entrega a la capilla y a su personal los días que se celebra entierro y cuenta de la cera . . .*, n.d. [1735].

36 AMDR, 1/9, *Modificaciones del Rey* [Philip II], *patrono del Monasterio de las Descalzas Reales, a la escritura de fundación que dispensó su hermana doña Juana de Austria*; see also *Real fundación de la capilla y monasterio de religiosas franciscas . . .* , p. 22.

37 *Órganos* 1999, pp. 232–36.

38 On the architectural changes in the convent, see Sancho 1995, pp. 144–55.

39 Now in Windsor Castle, they were studied in Marías and Bustamante 1991; see also Sancho 1995, pp. 148–49.

40 Juan López de Hoyos, *Hystoria y relación verdadera . . .* , cited by Simón Díaz 1964, vol. 1, p. 30.

41 The feast of the Octave was celebrated in the royal monasteries with great solemnity, and the churches were decorated with tapestries and hangings. This took place in the nearby monastery of the Encarnación, where tapestries from the series *Autos Sacramentales* (Allegorical plays in praise of the Eucharist) and from the *History of Samson* were hung both in the church and on the portico. See the reference to these tapestries in Capmany 1858, vol. 2, pp. 44–45.

42 See Carrillo 1616, fols. 36ff. Furthermore, he mentions the use of hundreds of candles and candlesticks and fragrant waters for the fonts containing holy water. The material purchased to produce the flowers for the Octave of Corpus Christi is mentioned in a document from 1779; AMDR, 79/16 bis.

43 Carrillo 1616, fols. 38–38v.

44 Ibid., fol. 37v.

45 Herrero Carretero (2008, p. 54) states that the series *The Siege of Tunis* was used in the Descalzas Reales until the reign of Charles III (1716-1788). Abundant documentary information refers to their habitual use in the convent during the eighteenth century: AMDR, 7/18, *Correspondencia de sucesivas abadesas de las Descalzas Reales relativa a los tapices y colgaduras que adornan las fachadas del monasterio durante la Octava del Corpus, la festividad de Nuestra señora del Milagro y la Aclamación del rey* [Philip V], years 1701, 1706, 1718, 1722, and 1724.

46 AMDR, 18/4, *Inventario de bienes presentado por la abadesa de las Descalzas Reales, sor María Bárbara de San Luis, al capellán mayor, con los objetos y alhajas pertenecientes al citado Monasterio*, 1816.

47 Published in Pérez Sánchez 1972, p. 102, no. 114. Francisco Rizi, *Altar fingido para un Cristo muerto*, ca. 1660. Pen, sepia, gray, blue, and pink ink and wash, black pencil outlines, 470 × 485 mm (18½ × 19 in.) (Florence, Galleria degli Uffizi, Gabinetto Disegni e Stampe, no. 10558 S).

48 Rodríguez G. de Ceballos 1992, pp. 142–43. Information cited and analyzed in Ruiz Gómez 1998.

49 This differentiation in size can already be seen in the sketch in the Fitzwilliam Museum in Cambridge (oil on panel, 16.5 × 24.4 cm [6½ × 9⅝ in.], inv. 228), whose measurements, compared to those of the others, suggest that Rubens already regarded this scene as the principal one.

50 "An idea for an immense curtain to liturgically cover the entire altarpiece of the main altar in Holy Week." Tormo 1945, p. 22.

51 The so-called veils of the Passion, or tapestries of hunger, arose in the Middle Ages in central Europe. A fine example that has come down to the present is the Gothic Lent tapestry in the cathedral of Gurk in Carinthia, Austria, dated to 1458. For an overview of this subject, see Villers 2000.

52 Of great interest in this context are the *Curtains* of Cheste (Valencia). Although they were done in 1850, they refer to this same decorative concept.

53 Brassat 1988.

54 Hubala 1990, pp. 118–19.

55 *Regla de Nuestra Madre Santa Clara y Constituciones coletinas*, Madrid, Luis Sánchez, 1620, pp. 56–57 and 61. According to this rule, the church could not have more

than three altars: the main altar in the chancel and two others on the sides of the nave and in their own chapels, so that the nuns could see them from the choir. Despite the fact that the constitutions established the existence of a low choir as a precept with a small window for the nuns to take communion, the founding mothers preferred a high choir for greater isolation. Therefore, they requested the corresponding dispensation from the father general and they informed the princess doña Juana. Thus, from the start, the choir was placed at the foot of the church on a higher floor.

56 Juan López de Hoyos, *Hystoria y relación verdadera . . .* , cited by Simón Díaz 1964, vol. 1, p. 30.

57 See Herrero Carretero, 2010, p. 279, where the elevation of the chancel published by De Poorter in 1978 with the five panels of the *Group of the Adoration* arranged on the altarpiece, perfectly noting the lack of accommodation to this space.

58 De Poorter 1978, vol. 1, p. 105.

59 AMDR, 27/1, *Documentación relativa al proceso de beatificación de la infanta sor Margarita de la Cruz . . .* , 1689, fols. 455–56: in recognizing the spaces that the Infanta occupied, it stated that "via a stairway of seven steps they went up to the choir."

60 The dimensions of both are approximately 490 × 495 cm (193 × 195 in.).

61 Both have dimensions of about 490 × 670 cm (193 × 264 in.).

62 Dimensions: 490 × 660 cm (193 × 260 in.).

63 Dimensions: 497 × 495 cm (196 × 195 in.).

64 Dimensions: 470 × 652 cm (185 × 256¾ in.).

65 Dimensions: 330 × 485 cm (130 × 191 in.).

66 García Sanz 1999, pp. 116–17.

67 Anonymous, after an original by Rubens, *Four scenes from the series The Triumph of the Eucharist*, auctioned in London in 1981, reproduced in De Poorter 1997, pp. 78–105, ill. 25.

68 Dimensions: 490 × 587 cm (197 × 231 in.).

69 Cambridge, Fitzwilliam Museum, oil on panel, 15.6 × 15.6 cm (6⅛ × 6⅛ in.), inv. 231.

70 Washington, DC, National Gallery of Art, oil on panel, 96.8 × 113.4 cm (38⅛ × 44⅝ in.), inv. 1958.4.1.

71 In the Richard L. Feigen collection in New York, oil on panel, 16.2 × 20.3 cm (6⅜ × 8 in.); Sutton, Wieseman, and Van Hout 2004, pp. 176–77.

72 Scribner 1982, pp. 121–23.

73 The tapestries measure 260 × 200 cm (102 × 78 in.). The paintings by Pantoja de la Cruz would have been of small dimensions, similar to those of the 1863 works by Pedro Pardo painted to take their place. The tapestries would have covered the painting and the framing on the wall.

74 Sutton, Wieseman, and Van Hout 2004, pp. 166–67. Sutton concludes that these three tapestries are not connected to the original iconography of the series and, given their smaller dimensions, can only be understood as "filler" within the original cycle.

75 Dimensions: 490 × 250 cm (193 × 96 in.).

76 In the seventeenth century there was a door-like opening in the east wall, a space that is currently occupied by Gaspar Becerra's painting *Saint John the Baptist*.

77 According to information in Sutton, Wieseman, and Van Hout 2004, pp. 174–75.

78 Monlau 1850, p. 160.

79 Fernández Villabrille 1856, p. 232.

80 Carderera 1868, pp. 218–19.

81 *Descripción* 1881. Curiously it says that the hanging *The Gathering of Manna* was placed on the main door of the cloister, through which processions exited. A tapestry hung like a curtain, which could be removed to let people pass, was a normal practice.

82 *Inventario de los bienes del Monasterio de las Descalzas Reales*, 1925, p. 129. Archivo Departamento de Conservación, Patrimonio Nacional.

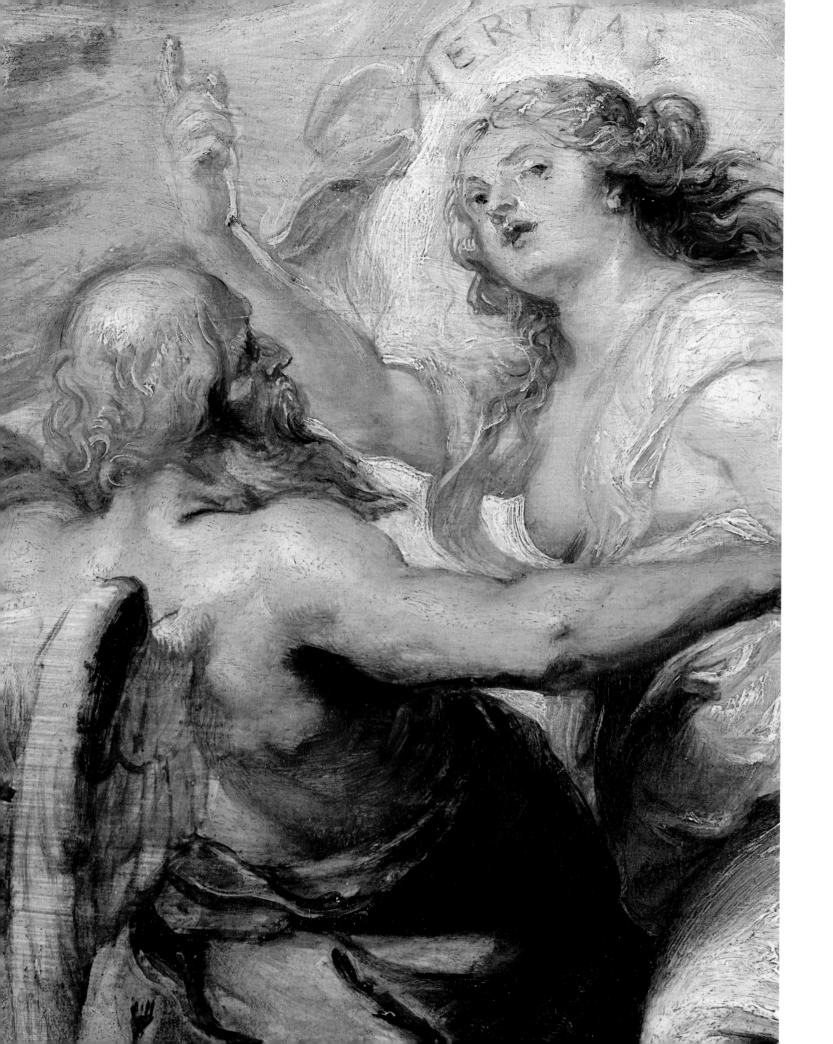

HIGH AND PASSIONATE SONGS
THOUGHTS ON RUBENS'S
PICTORIAL LANGUAGE

To understand the world at all, sometimes you could only focus on a tiny bit of it, look very hard at what was close to hand and make it stand for the whole.

—Donna Tartt, *The Goldfinch*

I

The art of Rubens is the art of a time of crisis. The world that he paints appears seamless, so powerful and rotund, so harmonious and incontestable, as to dispense with any doubt.

Rubens belongs to a time that has been called "the waning of the Renaissance," when questions such as "where does authority come from?" "what is truth and how is it achieved?" or "can one rely on anything?" could not be answered as firmly as they could just a couple of generations earlier.[1] The answer to this sense of crisis was reaction. In 1616, the Holy Office of the Roman Catholic Church, responsible for defending religious orthodoxy, positioned itself against the theories of Galileo, causing a Roman cleric to say, "So here we are at last, safely back on solid earth."[2] Scholar Justus Lipsius, a leading figure in the revival of Roman Stoicism, whose favorite pupil was Rubens's brother Philip and whose doctrine was also important for the painter, was one of the most famous proponents of the need for a renewed absolutism and a single state religion in the Southern Netherlands. In Rubens's homeland, because of its proximity to Protestant territories and being a spearhead of the Spanish monarchy, these ideas held a special urgency. Even more than in other parts of Europe, monolithic authority strove to keep in check a disintegrating order.

Many signs of the fundamental fissure that was taking place in the early seventeenth century can be found in Rubens's correspondence and in sources close to him. On January 4, 1619, when he was negotiating a copyright valid for Holland for engravings that reproduced his paintings, he wrote to Pieter van Veen, a lawyer in The Hague (who was the brother of his former teacher Otto van Veen), in the following terms: "I should like

information on how I ought to proceed to obtain a privilege from the States General of the United Provinces. . . . I, being an uninformed novice in these things, would like to know whether, in your opinion, this privilege is necessary, and also whether it would be respected in such a free country."[3] In spite of his entrepreneurial mentality, Rubens felt uneasy about a society no longer bound by the strict hierarchical system that made absolutist Europe secure, for business as well as for life.

Numerous laws reaffirming the privileges of the aristocratic classes were enacted as reactions against change. Among them was legislation that defended the exclusive rights of the nobility concerning hunting introduced in August 1613 by the archdukes (as Isabel Clara Eugenia and her husband, the archduke Albert of Austria, were known), which was justified "because there is little order regarding hunting, and we have received many complaints from our governors in the provinces, because the edicts of our predecessors and our own edicts have not been maintained and observed."[4] This, and other such laws, defended ancient social customs precisely because they were being contested. As Susan Koslow has convincingly argued, Rubens painted at least one hunting scene (*A Wolf and Fox Hunt*; New York, Metropolitan Museum of Art) that can be directly linked to this legislation, and thus to the need to reassert ancient privileges.[5]

In this historical context the Infanta Isabel Clara Eugenia, together with her husband ruler of the Southern Netherlands, commissioned Rubens to design twenty tapestries that were meant to extol the mystery of the Eucharist. Rubens was the perfect image maker for a time in need of assertion. In the *Eucharist* series he was a propagandist working in the service of the Roman Catholic Church and the Spanish monarchy.

In Rubens's triumphant images for the *Eucharist* series good and evil are clearly separate, with the former having vanquished the latter. In *The Triumph of the Church*, a winged youth holds the papal tiara above the head of the female personification of the Church, who carries the monstrance in her hands and whose resplendent chariot with gem-studded wheels tramples her enemies. Two figures walk next to the chariot, one of them bound

FIG. 44 | Peter Paul Rubens, *The Victory of Truth over Heresy* (cat.4), detail.

49

by ropes, eyes covered, the other with the ears of an ass. They represent Blindness and Ignorance. The winged Victory that holds the keys of Saint Peter, a papal emblem, looks out at us seeking complicity.

The image is so assertive in its presentation of the triumphant march of the Church that it could make us forget the tribulations of the time. None of the figures in the picture strive to understand the sacramental mystery, as they do in the most famous thematic precedent for this series, Raphael's *Disputa*. There is no debate here—or rather, the debate is over.

The Victory of Truth over Heresy speaks of gigantic conflicts, with much at stake. The allegorical figure of Truth, led by Time, points to the phrase *Hoc est corpus meum* (This is my body), the words pronounced during the mass when, according to Christian doctrine, the bread is miraculously transformed into the flesh of Christ. A group of figures tries to flee from the advance of Truth. They appear scared, even wimpish. They are the enemies of the true creed. John Calvin, the Protestant reformer, can be recognized because of his similarity to known portraits: he is the man with a cap and pointed face and beard who holds a book in his hands. Luther, heavyset, lies below him, dressed as a monk. The man with a nude torso, in the foreground, holding (or losing hold of) a monstrance, is probably Tanchelm of Antwerp, a twelfth-century heretic who argued against the transcendence of the Eucharist. Two of the figures who flee at left probably represent Muslims and Jews. One wears a turban, the other holds a knife; perhaps he intends to use it to profane the Hosts that he carries in his robes, as Nora De Poorter, who has studied this series most carefully, suggests.[6] Next to them is an iconoclast: a man with a hammer who prepares to destroy a statue of the Virgin and Child.

The identity of the figures who trail behind Truth is unclear. They seem to be her followers, and they advance with great effort. They move forward carrying heavy books, the difficulty of their task made manifest by the fallen man they step over. The next hurdle is the dragon. The figure closest to us fixes his gaze on the shrieking creature, frequently used in the Bible as a symbol of evil and occasionally of Satan. The moment that we witness here is of a truth that is as inevitable as the outcome of the fight that takes place in the foreground between a cunning but wounded fox (used by Augustine, Jerome, and later sources as a symbol of heresy) and the noble and powerful lion, which goes about its business in all seriousness.

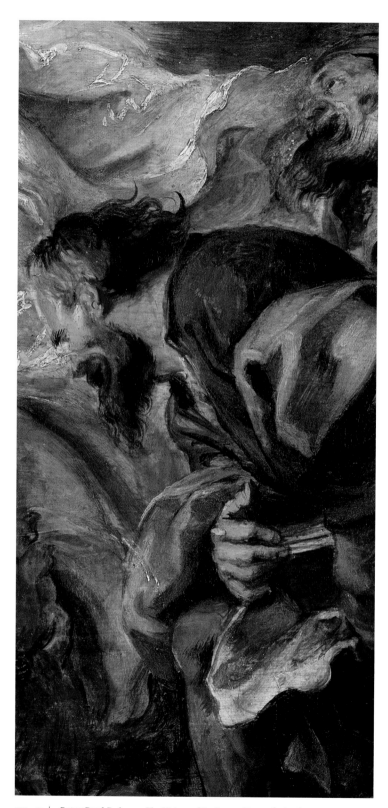

FIG. 45 | Peter Paul Rubens, *The Victory of Truth over Heresy* (cat. 4), detail.

The *modelli* for the *Eucharist* series are working instruments: they were made by Rubens in the early or mid-1620s as designs for a set of images to be woven into tapestries. They were painted on panel, and in them Rubens worked out most of the details of the final scenes. The images in the *modelli* were painted in reverse, a necessity imposed by the process of preparing tapestries. They were preceded by smaller and less fully worked out sketches and followed by large-scale cartoons and finally by the tapestries. There is a consensus among Rubens aficionados that the *modelli* for the *Eucharist* series are very good Rubens pictures. Much of this essay is based on studying the six *modelli* that belong to the Prado. Some of them have suffered damage, apparent in the wearing of the paint in specific areas or in isolated losses. But they retain all their seductive power, and they offer us a dazzling display of Rubens's creative talent.

A notable quality of the *modelli* for the *Eucharist* series is unity of action, in the Aristotelian sense that we can instinctively order all the information provided by the images into a single system. None of the objects or actions disturbs our ability to concentrate on the whole. The stories told in each scene can be grasped in a single mental act. As psychologists and philosophers of aesthetics have shown us, the reason unity of action provides aesthetic satisfaction has to do with the fact that it echoes our instinctive attempt to order all things into a single and complete system, which is an essential requirement for understanding. This sense of organic unity that is conspicuous in the individual, small-scale scenes of the *Eucharist* series is less apparent in the full ensemble. The group of twenty tapestries is too large to grasp in one view, and it is not likely that they hung together very often.

It is a curious fact that the organic unity of the scenes is felt strongly in the *modelli*. Because the weaving of the images reversed their direction, Rubens made the figures left-handed, and the direction of the action is from right to left instead of the opposite, which is more common and natural for a Western public. In the *modelli* the actions of the figures and the movement of the groups are represented with such conviction that the orientation of the image does not inhibit our perception of the scene.

The variety in the surfaces of these paintings is such that it seems to echo the richness of the soul of the artist. Concave and convex strokes alternate and contrast with each other, creating a crescendo of energy. This is apparent in the heads of the horses in *The Triumph of the Church* and in the lion and the fox in

FIG. 46 | Peter Paul Rubens, *The Triumph of the Church* (cat.6), detail.

The Victory of Truth over Heresy. In some sections of the pictures, the strokes are less descriptive than in others. In *The Defenders of the Eucharist*, the velvet tunic of Saint Augustine, the second figure from the left in the *modello*, is defined by parallel lines of different sizes and directions, which create volume and texture. Visible below them are the long lines left by the brush that applied the priming to the panel. Broad areas of wash are used to create shadows. From the underdrawing stage to the final glazes, the different layers of paint are applied thinly and remain transparent, all of them contributing to the final appearance of the paintings. We feel here that we are witnesses not to a stylistic option or a conscious language but rather to the array of resources that the painter unselfconsciously brings to his craft as he goes about the business of painting. The verbal richness is such that it makes other painters seem mechanical in approach.

Human figures in motion and relating to each other were the basic component in the language of the majority of European painting since Greek sculpture of the Classical period. Rubens brought to this system an extraordinary combination of emphasis and harmony. The scenes in the *Eucharist* series seem categorical and choral in equal measure. The interrelating figures are thoughtfully arranged following the classical ideal of an asymmetrical balance of forms, which is suggestive of movement. Rubens was a master choreographer. The positioning of the limbs suggests actions—most often very expressive or even violent actions. The crescendo pace of each image contributes a confident tone to the whole. Overlapping with the general harmony of the scenes and contributing to their complexity are individual and duet performances. In *The Victory of the Eucharist over Idolatry*, the man with the ax near the sacrificial ox and the robed, fallen figure with a lyre are mirror images, their *contraposto* poses echoing the way one figure is set against the other. In *The Victory of Truth over Heresy*, the old man who personifies time appears to lead Truth in an acrobatic dance. The arms and heads of the fleeing Moor and Jew also seem to form part of a designed sequence of movements. The paintings by Rubens evoke musical metaphors. We are aware of his sense of rhythm, his emphasis, his timing. Forms are linked to each other like notes in a musical scale, with the figures ascending or descending in rapid or slow succession, closely or more distantly spaced.

The idea that a pleasing arrangement of parts was a key ingredient of beauty was another basic tenet of classical art that Rubens adhered to. In a text that reflects contemporary ideas of beauty and demonstrates how their relevance went well beyond art, Giovanni Della Casa wrote in his book of manners, *Galateo*, published (posthumously) in 1558, that "where there is an appropriate measure among the parts and the whole, there beauty lies."[7] Beauty and harmony were understood as reflections of an ideal world and of the beauty of the soul. Their opposite was a reflection of baseness: "vices are such ugly and improper things that their disharmony displeases and perturbs every composed and well balanced soul."[8] Only the figures that embody evil in Rubens's scenes lack grace and decorum. Even in the presence of these reprobate characters harmony reigns, brought to bear on the discombobulated figures by the heavenly creatures above.

Characterization is a key ingredient of how we relate to painted images of people. As with the poses, the most expressive facial expressions in the *Eucharist* series belong to those figures whose excess is a sign of their baseness. In *The Victory of Truth over Heresy*, the participants in the sacrifice of the ox to Jupiter react hysterically, their mouths open, to the presence of the bearer of the Host. Their opposites are the personifications Divine Love in *The Triumph of Divine Love* and the Church in *The Triumph of the Church*, whose attitudes are calm; we know that they will endure.

In *The Defenders of the Eucharist*, Rubens makes a subtle distinction between the attitudes of the six men and that of Saint Clare, patron saint of the convent where the tapestries of the *Eucharist* series were to hang. Saint Jerome and Norbert, the eleventh-century saint who defended the sacrament of the Eucharist, stand to one side. Opposite them are the bishops Saint Ambrose of Milan and Saint Augustine, and also Pope Gregory, whose devotion to the sacrament of the Eucharist was profound and who here directs his thoughtful gaze toward the monstrance. Dressed in a black and white habit is Saint Thomas Aquinas, holding his *Summa Theologica*. These are the figures who define and uphold the doctrine of the Eucharist. With lips closed tight and brows furrowed, they seem to ponder the meaning of the miraculous Host.

The woman in the center looks at us with greater confidence than her companions. She seems possessed by a knowing calmness, as she bears the monstrance with the Eucharist. The contrast with the debate going on in her surroundings is surprising. The reason for this is that Rubens has transformed Clare into the Infanta Isabel Clara Eugenia, the figure at the heart of this commission. Her features are easily recognized because of their similarity to those in portraits of her made by Rubens, her court painter and adviser.

FIG. 47 | Peter Paul Rubens, *The Victory of Truth over Heresy* (cat.4), detail.

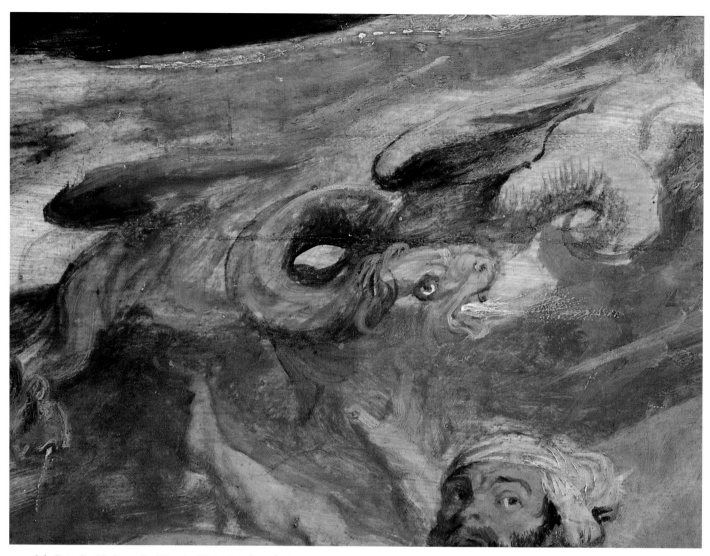

FIG. 48 | Peter Paul Rubens, *The Triumph of Divine Love* (cat. 9), detail.

In addition to endowing each of his figures with animated expressions, Rubens makes them relate to one another, turning them into participants in a narrative. The result is that when contemplating scenes by Rubens we often have the feeling that he was a witness to what he paints. And thus that what he paints is true.

Rubens was so concerned with making his paintings seem emotionally alive that even his animals can take on a human appearance. The lion in *The Victory of Truth over Heresy* seems to express a human emotion: he is strong, sure of his triumph and intent on teaching a lesson to the agonizing fox-cum-heretic. The dark strokes above his eyes define his frowning brow. In *Divine Love* the lions are no longer symbolic signifiers but rather

participants in the unfolding story. They seem tired from the weight they pull. Their attitudes are comical but also touching.

As part of his ongoing research into painted forms, Rubens compared a head of Julius Caesar with the head of a horse and also with features of a bull. On one occasion he drew the neck of a horse and next to it the neck of a statue of Venus, adding the inscription: "The comparable beauties of mares and women."[9] This is a reflection of his love of horses, which shows through in much of his art—not least in *The Triumph of the Church* scene in this series. It also shows his readiness to bestow on one type of creature the features of the other.

There was an important recent precedent for this, the physiognomic studies of Gianbattista della Porta, who published his

De humana physiognomonia in Naples in 1586 and saw it through many editions in different languages in the following years (a copy of this book is documented in the library of Rubens's son Albert).[10] This was the best-known and most recent example of a field of study that held that traits of the human character could be inferred by comparing human appearance with that of animals. Drawing from these ideas and from his own interests, Rubens conferred on animals a human look to an extent matched by very few artists. Even the sculpted rams in *The Victory of the Eucharist over Idolatry* and the flying dragon in *The Victory of Truth over Heresy* seem to possess human feelings.

Rubens was not a radical innovator. Few artists were during his time. This was not a quality as prized as it has been since the late nineteenth century, or at least not one that was understood in the same way during his time. Rather than invent new ideas, artists during the early modern period combined old ones and worked to extract from them new meaning.

The illusionist trickery present in the *Eucharist* series scenes drew from earlier artists and also included an innovation. The tapestries that were the end goal of Rubens's designs were meant to hang in front of the interior architecture of a church, or occasionally (as Ana Garcia Sanz shows in her essay in this volume) covering the exterior facades of buildings. Instead of traditional tapestry borders, Rubens's designs include images of columns and architraves that act as frames for the narrative scenes. When the tapestries were hung, the architecture represented in them would substitute for the real architecture of the interior or exterior of the building. The main scenes of each tapestry take place in a feigned tapestry that hangs from fictive architecture or is placed behind the columns. In some of the scenes, there are elements—garlands, some putti and a few other figures—that are painted in front of the fictive tapestries, casting a shadow onto them. The impression that different levels of reality coexist in the tapestries is clearer in the final hangings and in the cartoons than in the *modelli*, where some details, such as the borders of the feigned tapestries, remain to be worked out.

The sophistication and ambiguity of Mannerist taste favored the imaginary play with spatial illusion. In 1584 Lomazzo wrote that the ability of painters consisted in "showing false and deceitful sights, instead of the true."[11] Rubens was an heir to these ideas. His inspiration for the combination of different levels of reality in the *Eucharist* series, and for the idea of depicting the main scene in a fictive tapestry, comes from Italian fresco

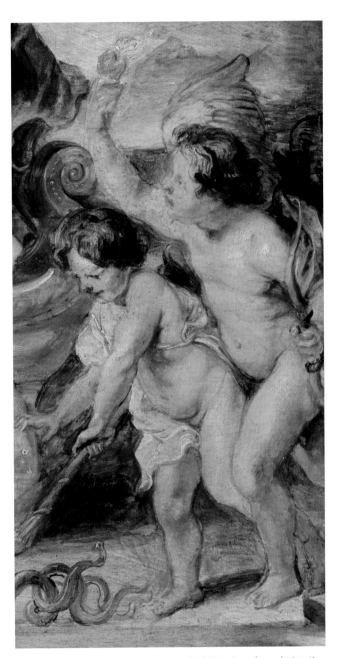

FIG. 49 | Peter Paul Rubens, *The Triumph of Divine Love* (cat. 9), detail.

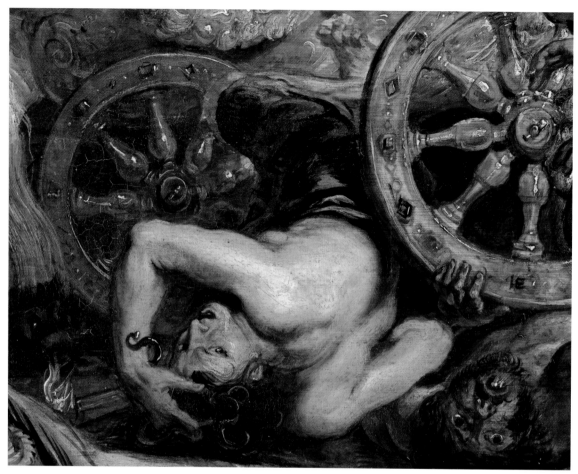

FIG. 50 | Peter Paul Rubens, *The Triumph of the Church* (cat. 6), detail.

decoration of the sixteenth century. In 1518 Raphael designed the central scene of the vault of the gallery of Psyche, in the Farnesina, in Rome, as a trompe l'oeil tapestry hanging from fictive garlands. In the Sala di Constantino in the Vatican in 1519–21 Raphael and his followers, especially Giulio Romano, painted large images of a complicated illusion in which the central scene was shown in painted tapestries hanging from a painted frieze and folding at the sides.

In the art of tapestry designers had experimented with illusionism for some time, most notably in the borders of the tapestries. These were made to look like windows, with the sights seen through them taking on the appearance of reality. But it was Rubens, in the *Eucharist* series, who first designed a tapestry within a tapestry. This is perhaps not a huge boundary moment if we consider how it grew out of its precedents. But it shows his inventiveness and his interests in current artistic trends. It was also to be very often imitated.

Though Rubens tried his hand at illusionism, he was not as devoted to it as some of his contemporaries. More characteristic of his art are its archaisms, a result of his deep knowledge of the art of the past and the wealth of meanings it carried. Volumes have been written about Rubens borrowings from antiquity and from Renaissance art. Few artists of his time were as knowledgeable about the art of the Renaissance, and no artist of the Renaissance or Baroque period was as informed about classical antiquity or had a library on that subject equivalent to his. His use of earlier art in his paintings is imbued with an extraordinary sense of life. We feel when viewing his paintings that the past, especially antiquity, is alive and nearby.

The scenes from the *Eucharist* series offer a prime example of Rubens's impassioned engagement with earlier art. The general compositional scheme of some of the Eucharist scenes is based on images of Roman triumphs, which had interested artists since the beginning of the Renaissance, most notably Andrea Mantegna,

who was a predecessor of Rubens as court artist to the Gonzaga in Mantua. In *The Triumph of the Church* the horses recall the way the animals were often represented in ancient art—in the arch of Titus, for example, where they prepare to pull the quadriga, or in a sarcophagus with a relief showing the abduction of Proserpina, now in the Casino Rospigliosi, in Rome, which Rubens drew and used as a source of inspiration in his own paintings of the same theme.[12] The rendition of the conqueror trampling the vanquished in a tightly knit, puzzle-like group could have been taken by Rubens from a battle scene of Emperor Trajan that was incorporated into the Arch of Constantine, between the Forum and the Coliseum, or from similar compositions. The reasons for choosing such classical sources in this and other scenes from the *Eucharist* series are the same as those that Rubens explained in a letter of September 1636 to his friend Nicolas-Claude Fabri de Peiresc: he said of the book *Roma sotterranea* by Antonio Bosio that it represented the "simplicity of the primitive Church, which though it surpassed all the world in piety and true religion, remained far behind paganism in grace and excellence."[13]

In *The Victory of the Eucharist over Idolatry* the subject matter allowed the artist to give full rein to his learning. Images of pagan rituals and sacrifices were known to Rubens from the relatively few descriptions that existed, such as Guillaume du Choul's *Discours de la religion des anciens romains*, and also from ancient works of art, such as statues, public monuments, sarcophagi, reliefs, coins, or cameos, that he knew from direct observation during his years in Italy. These could satisfy his interest in details of costume and objects and teach him about customs such as the use of the *patera*, or bowl, from which the incense is delivered to the flames, in this painting.

The sacrificial ox must have been inspired by Rubens's study of the famous *Farnese Bull* in the Farnese palace in Rome. The ancient statue of Jupiter Capitolinus in the background of the same scene was known through numerous copies. It is possible that the fallen pitcher in the foreground was inspired by a pitcher reproduced in the book *Electorum Libri II*,[14] published by Rubens's erudite brother Philip in 1608 with comments on ancient customs and objects and illustrated by images provided by the painter.

Many more ancient and Renaissance sources used in the scenes of the *Eucharist* series could be cited. The point to make here is that Rubens used his own erudition to gain a closer look at art and life and to offer that insight to his public. We do not feel that his extensive culture is self-serving; he shares his knowledge as an offering of something different and distant.

The Solomonic columns present in some of the scenes of the *Eucharist* series provide another example of how intricately woven Rubens's art was with that of his predecessors and also of the sense of vital pulse that he brings to his paintings. He had first used this same type of twisted or Solomonic column in Rome in 1601–2, in one of three paintings that he did for the church of Santa Croce in Gerusalemme, and he would paint the same columns often throughout his career. Raphael famously included very similar Solomonic columns in his designs for *The Healing of the Lame Man*, one of the scenes of his tapestry series *The Acts of the Apostles*, which attained great fame and which Rubens certainly knew.

The twisted columns used by Raphael, Rubens, and other artists are based on the set of twelve such columns that existed in the Basilica of Saint Peter in Rome. The emperor Constantine had brought them to the city and installed them in the old basilica in the fourth century. They were believed to come from a temple of Solomon (they are now known to be of a later date) and owed their appeal to the connection to biblical times that their presumed origin provided. This, together with the grape and vine decoration of sections of the columns, made them suitable to the Eucharist tapestries.

In depicting the Solomonic columns, Rubens emphasized the subtle optical effects that had been part of the design of columns since antiquity. The different sections of the shafts do not follow a regular pattern. Some protrude more than others, as if they were laid on top of each other following an asymmetrical axis. Some sections are shorter than others, and the fluting does not follow a regular pattern. These variations create the impression of columns that bend and spring forward. They seem muscular, as if animated with life. Rubens's understanding of the visual dynamics of architecture and his ability to make it palpable to us are an example of a quality that we often find in his painting: he manages to provide an experience instead of merely pointing to one.

FIG. 51 | Peter Paul Rubens, *The Victory of the Eucharist over Idolatry* (cat. 8), detail.

The qualities of Rubens's art are different from those generally appreciated by the modernist tradition in painting and in our postmodern times. Among artists who were roughly Rubens's contemporaries there was a greater fascination with Caravaggio, Velázquez, and Rembrandt than with the Flemish master. Velázquez's pictures at first glance seem simple, as natural as life itself. The Spanish writer Juan Francisco de Andrés de Uztarroz wrote in praise of Velázquez in his *Obelisco histórico* (published in 1646): "El primor consiste en pocas pinceladas obrar mucho, no porque las pocas no cuesten, sino que se ejecuten con liberalidad, que el estudio parezca acaso y no afectación" (The ability consists in creating much with few strokes, not because this takes less work, since they are applied generously, but so that they appear spontaneous and not affected). This apparent lack of artificiality has appealed to times prone to a commonsense realism and offers a useful contrast to Rubens's style. For José Ortega y Gasset, everything before Velázquez was "ensueño, delirio, fabula, convención, ornamento de gracias formales" (fantasy, delirium, fable, convention, superfluous formal ornament).[15] It is hard to resist the thought that he had Rubens in mind when writing these words. The comparison between Velázquez's pictorial language and the Fleming's allegorical and rhetorical manner of storytelling can make the latter seem remote.

In Caravaggio and Rembrandt, it is the emphatic expression of the self that speaks to our time, their exploration of psychological depths, of what it means to be human. They both expose themselves in their canvases, with chilling or comical images of biblical or historical characters that seem to feel, to suffer from self-doubt the way we do. In Rubens the boundary between an older way of being in the world and our own has not yet been brought down. In his paintings content is transmitted not through the personal but mainly through the vehicle of myth, storytelling, and allegory.

Martin Warnke has written, "Hardly anything articulated in Rubens's works can be attributed to his life."[16] This statement rings true. We do not find anywhere in Rubens's paintings an equivalent to Caravaggio's portrayal of himself in the head of the dead Goliath. In Rubens the appeal is to the archetypical, not to the personal. And yet if not a specific biographical circumstance, there is a personal quality in Rubens that is reflected in his art and is a key to his greatness: his passionate involvement with things around him and with life itself. For Rubens, the patterns

formed by trees or clouds in nature, the cosmic sense that comes with the deep darkness of a night sky studded with stars, the power inherent in flexed muscle, the pleasures and pains of love, the appeal of sensuous lust, the art of his beloved ancients and of the more recent past, are more fascinating, more intense than for the rest of us, or so it appears from his portentous ability to return them to us in an exalted state. Rubens's ability to bring the feeling of pulsating life to his paintings ignites in us a sense of heightened vitality. This is one of the best measures of the greatness of a work of art.[17] There is a vivacity and an earnest authenticity in Rubens's art that makes it seem natural. The expressive poses and emphatic expressions that we find in his paintings, the carefully choreographed rhythm of the scenes, the deceptive trompe l'oeil, are qualities that run the risk of seeming self-conscious and self-advertising. But he is driven by his urge to put forth his proposals and never appears to be in awe of himself. The wealth and intricacy of Rubens's sources of inspiration in the *Eucharist* series are an example of the way in which his art unfolds naturally from previous works of art. He constantly reflects on them, but there is no "anxiety of influence" in the Flemish master.[18] He was spurred by the creations of his precursors.

Rubens's paintings communicate even before they can be understood. In his paintings of the *Eucharist* series, his invitation to immerse ourselves in the mysteries of the Eucharist is full of hopeful optimism: we are witnesses to a luminous realm, elevated above the corruption of the earth. The world of high principles and intense feelings that he creates is so well forged, so complete, so definitive, that it takes on the aura of the canonical. These qualities connect with us because the appeal of Rubens's art, the empathy that it elicits, is from a realm that transcends specific content. It is Rubens's pictorial language that seduces us.

NOTES

1 "The waning of the Renaissance" refers to the title of Bouwsma 2000. The questions reproduced in this paragraph are taken from Rabb 1975, p. 33.

2 Rabb 1975, p. 47.

3 All the letters quoted in this essay are taken from the English translations published in Magurn 1955.

4 V. Brants, *Recueil des ordonnances des Pays-Bas: Règne d'Albert et Isabelle, 1597–1621*, II, pp. 186–96; cited in Koslow 1996, p. 700.

5 Koslow 1996.

6 De Poorter 1978.

7 Della Casa 2013. The quote is from p. 66.

8 Della Casa 2013, p. 69.

9 Van der Meulen 1994, vol. 1, pp. 78–79; Jaffé and Bradley 2005, p. 22.

10 For this matter, see De Clippel 2008, pp. 111–36. For Rubens bestowing human emotions on lions, see also Wheelock 2005, pp. 170–71, esp. n. 34, p. 173.

11 In his *Trattato dell'arte della pittura, scoltura et architettura*, Milan, 1584 (the English comes from the translation by R. Haydocke published in Oxford in 1598; taken from Wheelock 1991, p. 186).

12 Van der Meulen 1994, vol. 2, cat. 139.

13 Magurn 1955, p. 405.

14 As suggested by Van der Meulen 1994, vol. 1, p. 109.

15 Ortega y Gasset 1959, p. 43.

16 Warnke 1977. The quote comes from the English edition of 1980, p. ix.

17 This measure of the greatness of art comes from Henry Bergson, who, according to George Steiner in *The Poetry of Thought: From Hellenism to Celan* (published by New Directions in 2011), found it lacking in Proust's novel *À la recherche du temps perdu*.

18 *The Anxiety of Influence: A Theory of Poetry* is the title of an influential book by Harold Bloom published in 1973, which deals with the issue of influence and creative originality in poetry.

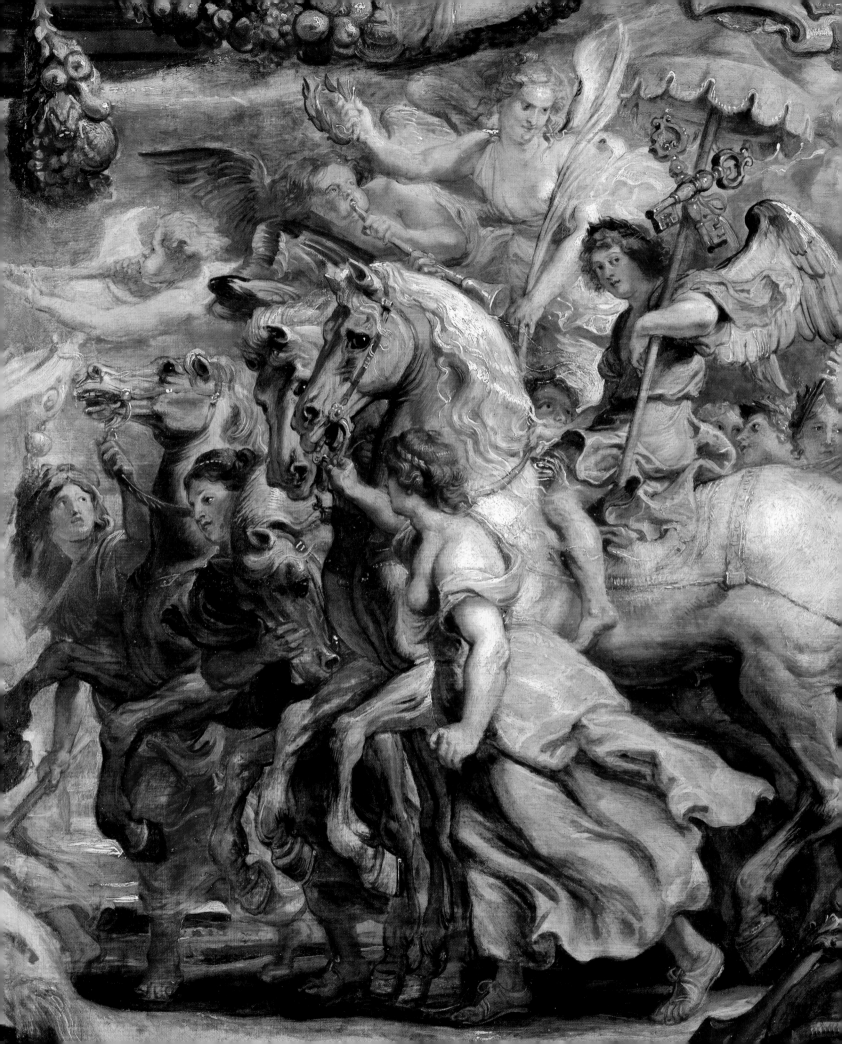

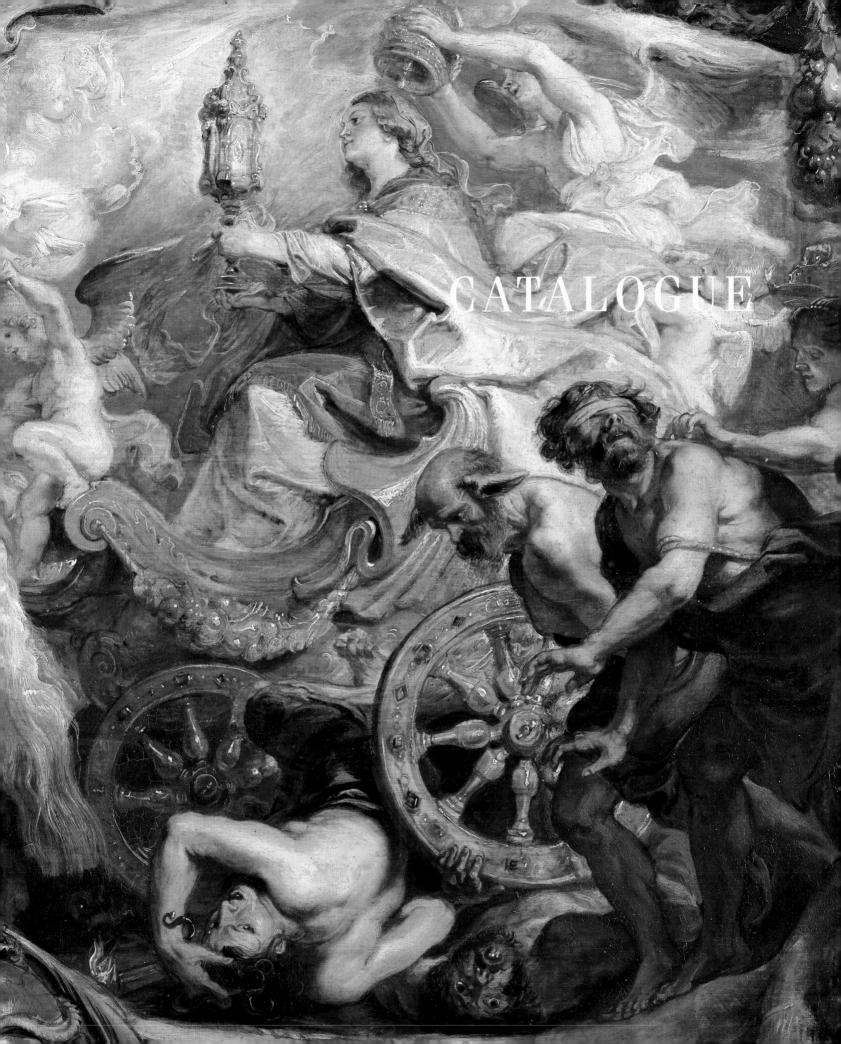

CATALOGUE

1

Peter Paul Rubens
The Defenders of the Eucharist

ca. 1625
Oil on panel
65.5 × 68 cm (25¹³⁄₁₆ × 26¾ in.)
Museo Nacional del Prado, P-1695

Seven saints from different eras, recognized by the Counter-Reformation Church for their efforts to safeguard and promote the Eucharist, march across a landscape. Three bearded Doctors of the Church dressed in rich gold copes lead the procession: Saint Ambrose (ca. 340–397), who looks out at the viewer; Saint Augustine (354–430), seen from behind; and Saint Gregory the Great (ca. 540–604), holding the papal cross, who gazes back along the procession. In the center, Saint Clare of Assisi (1194–1253), dressed in a Franciscan habit, holds a splendid monstrance containing the Host. The patron saint of the Descalzas Reales and the namesake of the Infanta Isabel Clara Eugenia, Saint Clare is endowed by Rubens with the Infanta's mature features. The bareheaded Dominican Saint Thomas Aquinas (1225–1274) asserts the doctrine of the Eucharist and its inspiration in the Holy Spirit above with an eloquent gesture. The dignified figure clad in a white habit is probably Saint Norbert (ca. 1080–1134), itinerant preacher and founder of the Premonstratensian order, who quelled Tanchelm's anti-eucharistic heresy in Antwerp (1124). Saint Jerome (ca. 347–420), in cardinal's scarlet, is so focused on his Vulgate translation of the Bible that he scarcely notices his companions. The dove of the Holy Spirit dispenses heavenly radiance over the procession. Two cherubs unfurl the fictive tapestry, which is tied to Tuscan columns. Various accouterments of writing (oil lamp, ink pots, quills, and books) in the foreground symbolize the formulation of Roman Catholic doctrine by these saints.

2

Peter Paul Rubens

The Meeting of Abraham and Melchizedek

ca. 1625
Oil on panel
65.5 × 68 cm (25¹³⁄₁₆ × 26¾ in.)
Museo Nacional del Prado, P-1696

In the Old Testament (Genesis 14:17–24), Melchizedek, priest-king of Salem, meets the victorious general Abraham, presents him with bread and wine, and blesses him. Dressed in a gold, fur-lined cloak and wearing a crown of laurels, the elderly Melchizedek leans toward the powerful armored Abraham, who bows as he ascends the steps to gratefully accept the king's offering. Their eyes meet and hands pause in correspondence at the center, emphasizing the powerful moment of exchange that constituted the first prefiguration of the Eucharist in the Bible. Theologians regarded Melchizedek as a precursor of Christ and his offering as the antecedent to the Last Supper and institution of the Eucharist.

Rubens reworked this important scene, after apparently changing its location in the cloister. His second *modello* (Washington, DC, National Gallery of Art, fig. 14) presents a more direct view of the encounter, in keeping with a position closer to the viewer. The second *modello* and the tapestry are more elaborate than the Prado sketch, with impressive architecture and additional priests and soldiers in the two retinues—almost twice the number of figures. Rather than a static illusion of the wine vessels standing on the edge of the frame as in the first sketch, Rubens created the dynamic illusion of two muscular servants ascending stairs from a cellar below bearing gilt wine vessels. Originally planned as a square composition, Rubens's final composition is the only one in the series in which the fictive tapestry covers the column on one side.

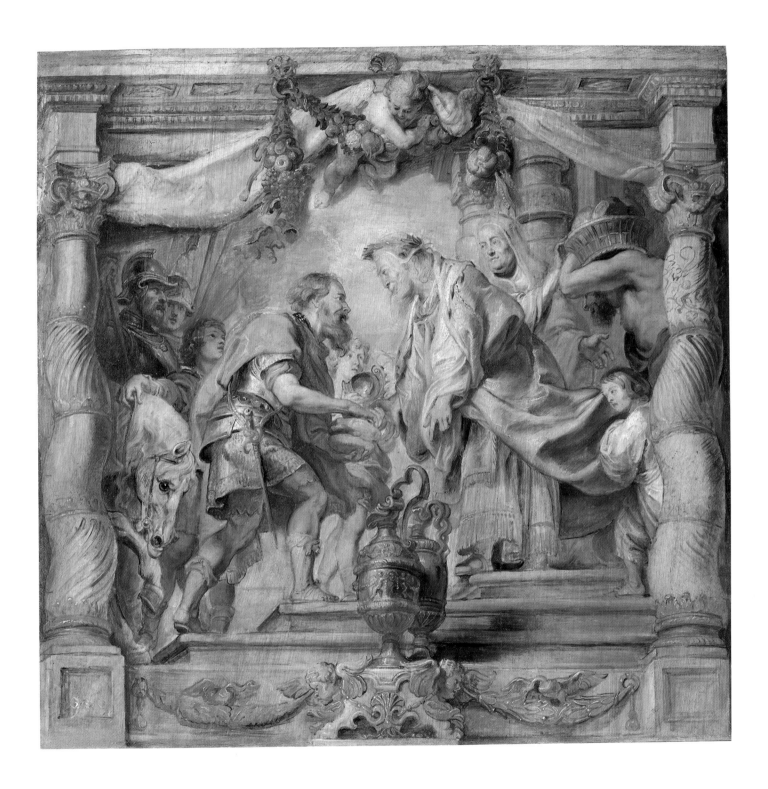

3

Woven by Jan Raes I, Hans Vervoert, and
Jacob Fobert after designs by Peter Paul Rubens
The Meeting of Abraham and Melchizedek

ca. 1625–33
Wool and silk
500 × 587 cm (197 × 231 in.)
Patrimonio Nacional, Madrid, Monasterio de las Descalzas
Reales, inv. 00610324

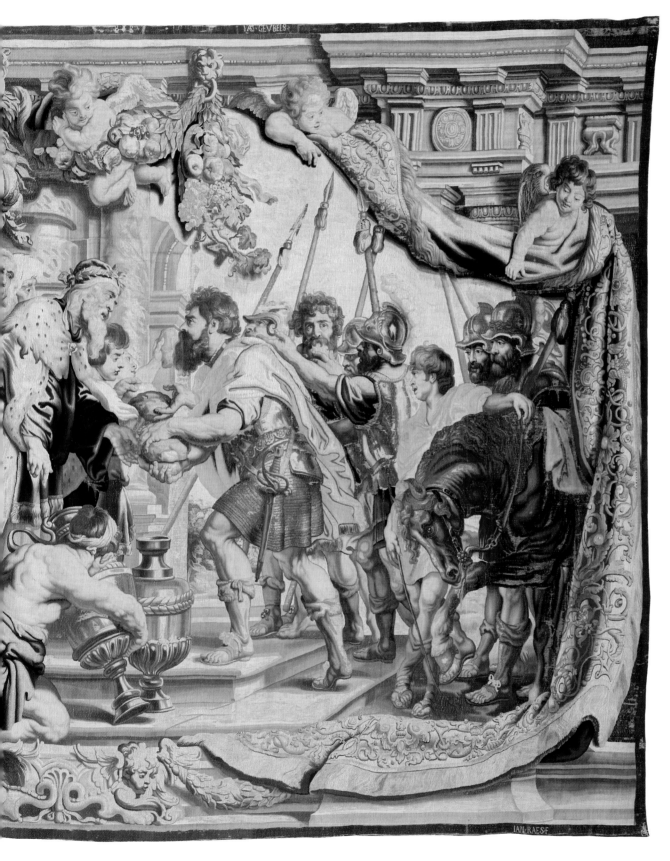

4
Peter Paul Rubens
The Victory of Truth over Heresy

ca. 1625
Oil on panel
64.5 × 90.5 cm (25⅜ × 35⅝ in.)
Museo Nacional del Prado, P-1697

The allegorical figure of Truth (identified by the inscription above her head), led by Time, gestures toward to the lettering *Hoc est corpus meum* (This is my body), the words said during the mass when, according to Christian doctrine, the bread is miraculously transformed into the flesh of Christ. The dragon that they trample is a symbol of evil. The enemies of the true creed flee from the advance of Truth. Among them are John Calvin, with a cap and pointed beard; Luther, dressed as a monk; and a man with nude torso holding a monstrance who probably represents Tanchelm of Antwerp, who argued against the Eucharist. A man with a white turban and another with a knife (probably meant to be used to profane the Hosts that he carries in his robes) likely represent Muslims and Jews. Next to them is an iconoclast, a man with a hammer who prepares to destroy a sculpture of the Virgin and Child. Behind Truth are two figures with heavy books who appear to be her followers, at the cost of great effort. The victory of truth is as inevitable as the outcome of the fight that takes place in the foreground between a cunning but wounded fox (used by Augustine, Jerome, and later sources as a symbol of heresy) and the noble and powerful lion.

5

Woven by Jacob Geubels II after designs by
Peter Paul Rubens
The Victory of Truth over Heresy

ca. 1625–33
Wool and silk
470 × 652 cm (185 × 256¾ in.)
Patrimonio Nacional, Madrid, Monasterio de las
Descalzas Reales, inv. 00614221

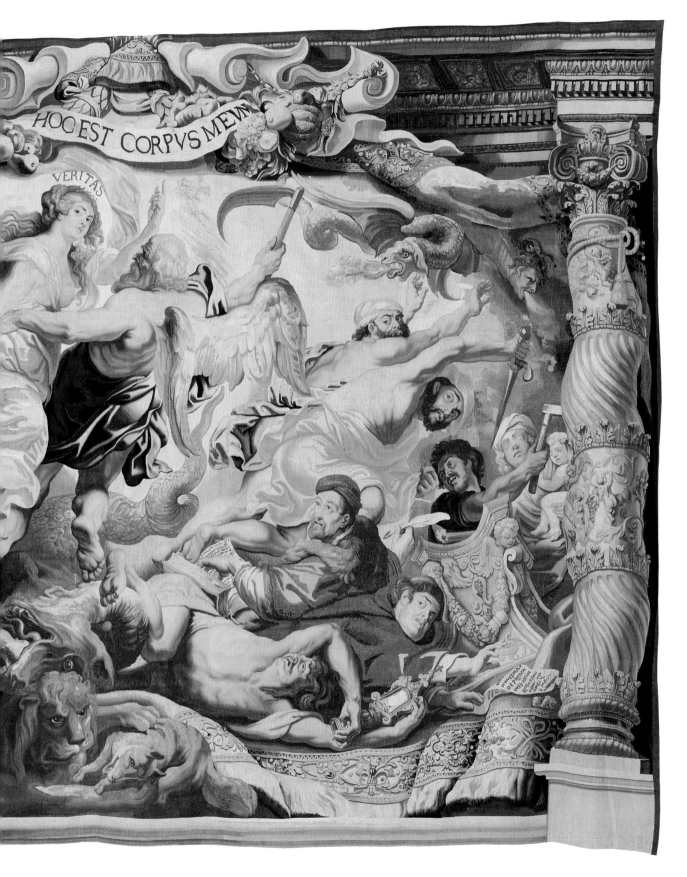

HOC EST CORPVS MEVN

VERITAS

6

Peter Paul Rubens
The Triumph of the Church

ca. 1625
Oil on panel
63.5 × 105 cm (25 × 41⁵⁄₁₆ in.)
Museo Nacional del Prado, P-1698

The Triumph of the Church is the largest of the twenty scenes that Rubens designed for the *Eucharist* series. The tapestry was probably meant to occupy a central position above the altar in the church of the convent of the Descalzas Reales. Rubens conceived this spectacular scene as a Roman triumph, thus combining Christian iconography with classical elements. A woman who represents the Church sits in a chariot. With both hands she holds the vessel in which the eucharistic Host was carried in processions and exposed to the faithful. Behind her is an angel who places the papal miter on her head, and in front an angel holds an umbrella or canopy with silver and gold keys, symbols of the papacy. Another angel carries the palm branch and laurel wreath that symbolize victory.

The gem-studded wheels of the chariot crush three figures, an action that represents the triumph of the Church over evil. The two figures who walk next to the chariot, one of them bound by ropes, eyes covered, the other with the ears of an ass, represent Blindness and Ignorance. Behind them a woman carries the light that they fail to see. At the bottom is a symbolic image of the eternal victory and rule of the Church over the world: a globe is surrounded by a serpent biting its tail, symbolizing eternity. The helm is a symbol of governance, and the palm represents victory.

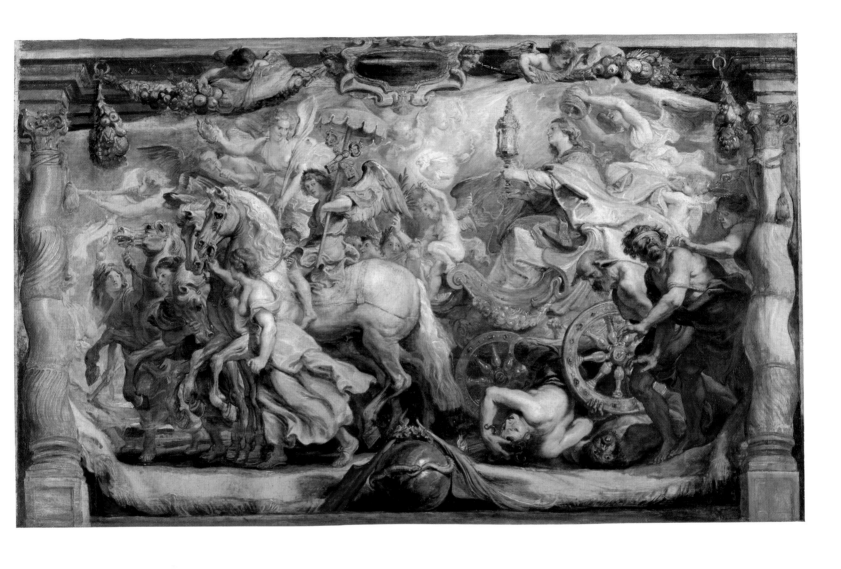

7

Woven by Jan Raes I after designs by
Peter Paul Rubens
The Triumph of the Church

ca. 1625–33
Wool and silk
490 × 750 cm (193 × 295¼ in.)
Patrimonio Nacional, Madrid, Monasterio de las
Descalzas Reales, inv. 00610325

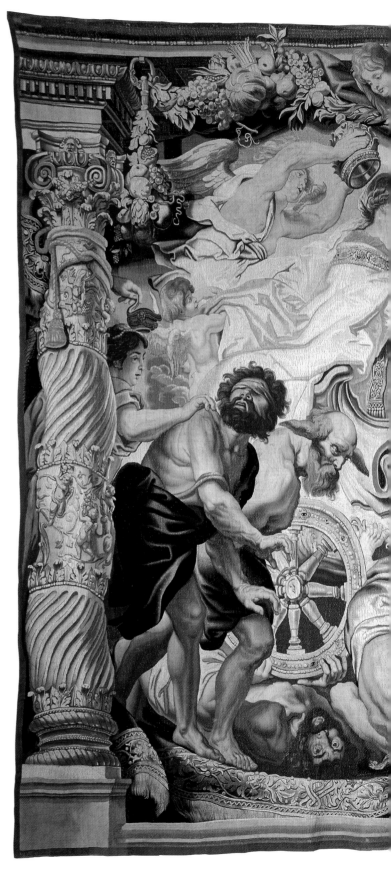

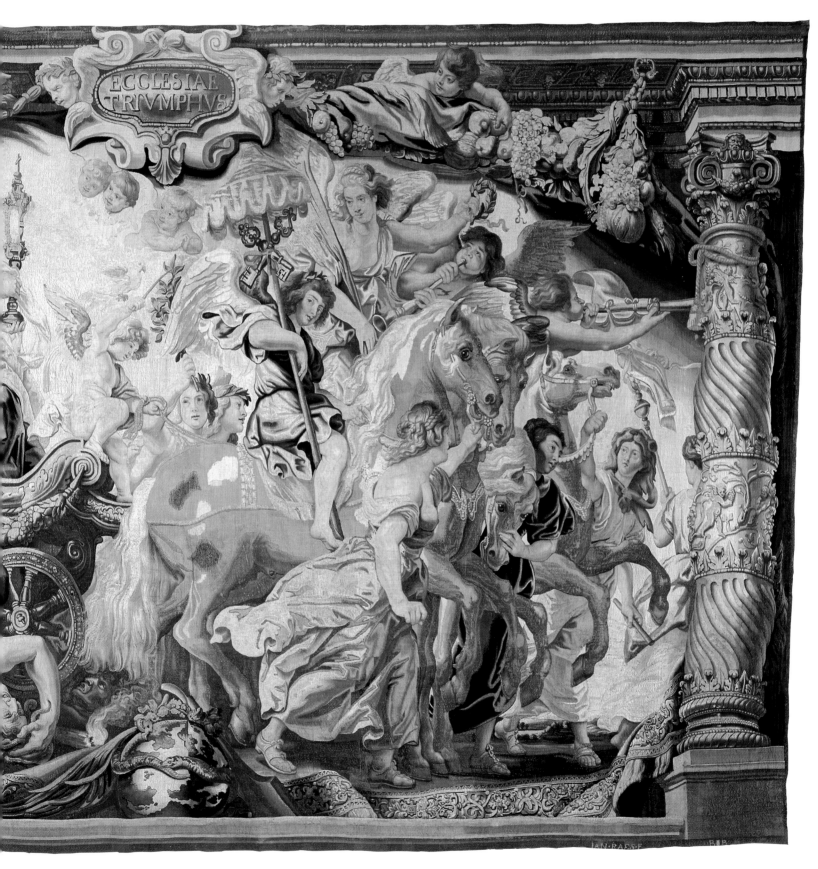

The text visible within the image: "ECCLESIAE TRIVMPHVS"

8

Peter Paul Rubens
The Victory of the Eucharist over Idolatry

ca. 1625
Oil on panel
65 × 91 cm (25⁹⁄₁₆ × 35¹³⁄₁₆ in.)
Museo Nacional del Prado, P-1699

The Sacrament, shimmering above a chalice held aloft by an angel, brilliantly illuminates the interior of a Roman temple dedicated to Jupiter Capitolinus where pagan sacrifices are under way, driving the participants before it. In the center, a muscular slaughterer strides toward the viewer, shielding his eyes from the radiance, followed by an older and a younger priest. To one side, another servant, on his knees, strains to hold a sacrificial ox by its horns. In the chaos, a stone altar teeters precariously and an ornate gold vessel is overturned, pouring the libation of wine out of the scene and into a marble basin in the architectural frame supported by carved rams' heads. In the dark recess of the temple, rites are said by the light of torches and before an altar at the foot of a statue of the god Jupiter. Three winged cherubs unfurl the "tapestry" of *The Victory of the Eucharist over Idolatry* at the top, pulling it behind the swag of fruit in the center and up to the edge of the architecture. Twisted (Solomonic) columns with gilt bases and capitals frame the sides.

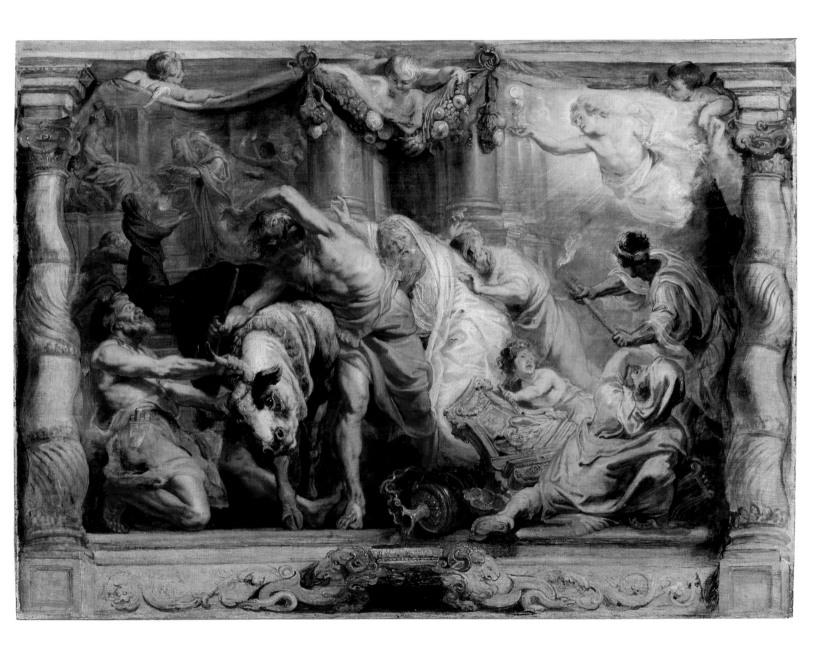

9
Peter Paul Rubens
The Triumph of Divine Love

ca. 1625
Oil on panel
65.5 × 66.5 cm (25¹³⁄₁₆ × 26³⁄₁₆ in.)
Museo Nacional del Prado, P-1700

A woman who represents Divine Love stands on a chariot surrounded by child angels. At her feet is a pelican feeding its young with blood drawn from its own breast, a symbol of the sacrifice of Christ and also of the Eucharist since the Middle Ages. One of the angels tries to burn two entwined snakes, which probably symbolize sin. The luminous realm in this image echoes the love of Christ delivered by the mystery of the Eucharist.

It is characteristic of Rubens that in order to make his paintings seem emotionally alive he paints animals that take on a human appearance. The lions here seem tired from the weight they pull. Their attitudes are a bit comical but also touching.

In the *modello* for this image the paint is so thinly applied that traces of an underlying inscription can be seen. It is near the top of the scene and reads *Caritatis*. With the aid of an infrared camera the full inscription can be read as *Triumphus Caritatis* (Triumph of Charity). This inscription was probably by Rubens himself, indicating the subject to be painted on this panel.

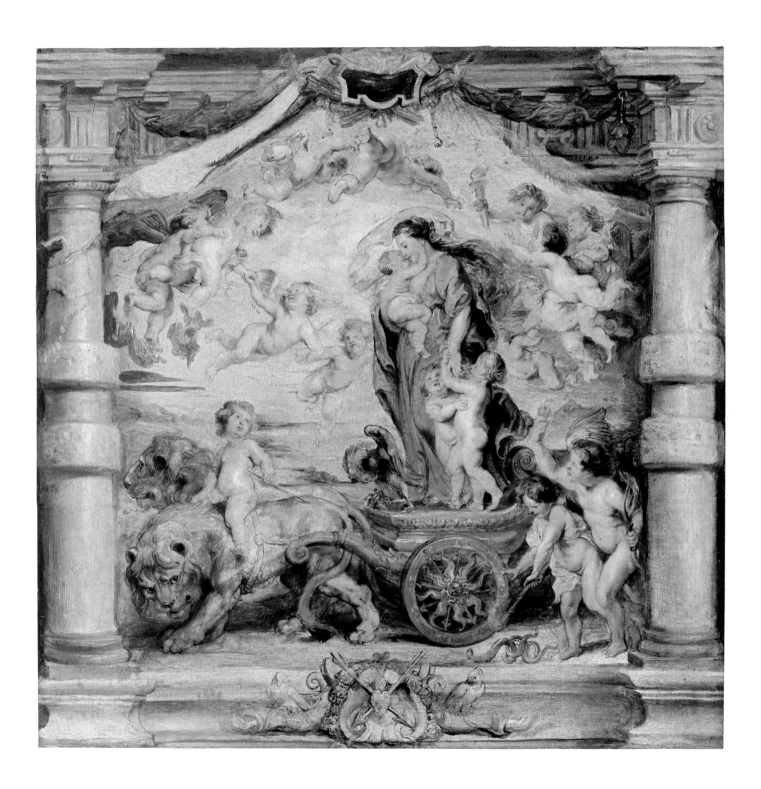

10

Woven by Jan Raes I, Hans Vervoert, and
Jacob Fobert after designs by Peter Paul Rubens
The Triumph of Divine Love

ca. 1625–33
Wool and silk
497 × 495 cm (196 × 195 in.)
Patrimonio Nacional, Madrid, Monasterio de las
Descalzas Reales, inv. 00610323

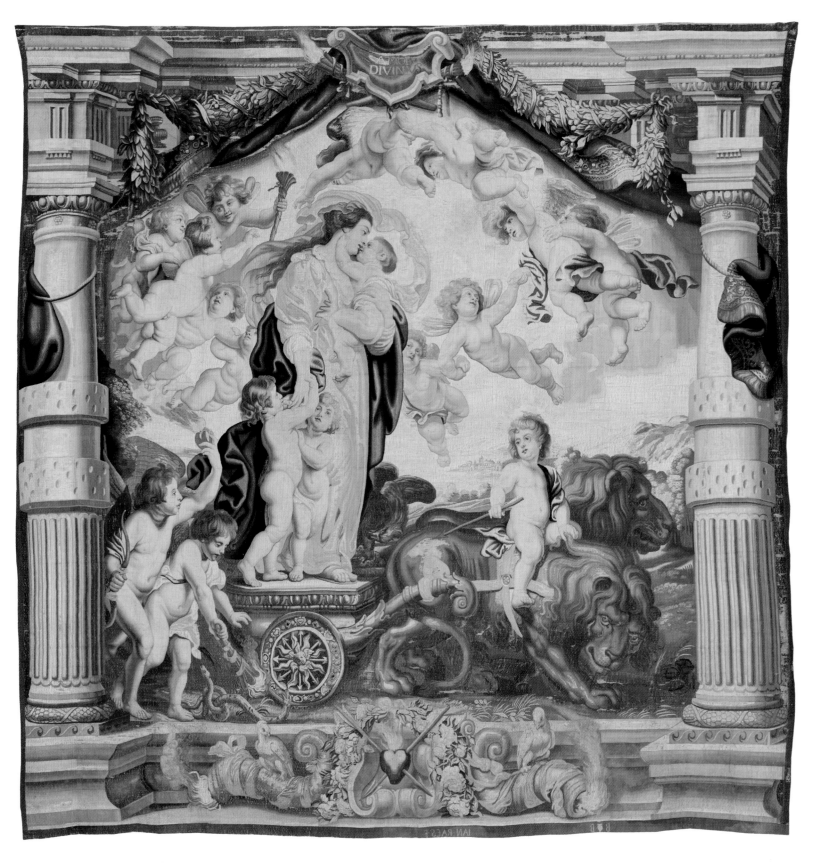

THE RESTORATION OF SIX PANEL PAINTINGS BY RUBENS SUPPORTS

George Bisacca, José de la Fuente, and Jonathan Graindorge Lamour

The Getty Foundation Panel Paintings Initiative, devoted to spreading awareness of the structural conservation of panel paintings, was conceived in 1995 after an international symposium that established the fundamental principles on the subject. It was there that, in light of the limited number of experts in this highly specialized field of restoration, a consensus was reached regarding the need to create a network of professionals and, above all, to facilitate the transmission of their knowledge to following generations through training and residency programs.

The Museo del Prado, given the considerable number of panel paintings in its holdings and its collaborative commitment to conservation and knowledge sharing, promptly responded to the call of the Panel Paintings Initiative. The first project carried out in the museum as part of the initiative was the restoration of Albrecht Dürer's panels *Adam and Eve* in 2008. This work was financed by the Getty Foundation with the collaboration of the Metropolitan Museum of Art and its conservator specializing in the structural conservation of panel paintings, George Bisacca. In 2011 the Prado and the Getty Foundation decided to undertake conservation work on Rubens's series *The Triumph of the Eucharist*, in part because it offered an ideal opportunity to train young professionals. The restoration of this prestigious group of panels was necessary given their deteriorated condition, but they also constituted an ideal training project given the variety and extent of the damage. For two years, roughly ten individuals from different countries were sent to the Prado to learn alongside José de la Fuente, the museum's painting conservator. The overall context and the diverse phases of the restoration process of the Rubens series are explained below.

CONTEXT OF THE RESTORATION WORK

The supports of the series of *modelli* for the *Triumph of the Eucharist* tapestries in the Prado were in need of extensive conservation treatment due to major alterations made in the past to the detriment of the originals as conceived by Rubens. Each panel had been enlarged so that the six Prado panels, which originally consisted of three square and three rectangular formats, were transformed into a set of four squares and two rectangles (figs. 53, 54). This change in format probably stemmed from the need to adapt the works to a new location or to new frames.

The condition of the series was cause for concern. The splitting and warping of the supports exacerbated the negative aesthetic impact of the additions, rendering the paintings difficult to appreciate fully. It was therefore decided to treat the supports with the aim of restoring them to the original format as devised by Rubens while ensuring their long-term stability.

ORIGINAL FORMATS AND PANEL CONSTRUCTION

Although *modelli* are more finished versions than *bozzetti*, they are executed on a smaller scale than the future tapestries (approximately 1:7). It is interesting to note that during the different stages of execution from *bozzetti* to tapestries, the format of the compositions was modified.[1]

If the various *modelli* are compared—bearing in mind that the panels were unevenly trimmed at the edges—it appears that all the panels were the same height, 65 ± 1 cm (25⅝ in.). Given the changes the works have undergone, it is difficult to establish their original formats with certainty. However, a comparison with the tapestries and the coherence of the composition of the *modelli* indicate that the current dimensions are fairly close to the original ones.[2] Certain tendencies may be identified through observation: there are three *modelli* in square format (fig. 55, format A) and three rectangular ones whose proportions seem to have been established by simple geometric drawings. These proportions are consistent with rules of harmonic proportion in use at the time (fig. 55, format B). Only *The Triumph of the Church*, the main scene in the series,

FIG. 53 | Original format (color images) and format after enlargement (blue outline).

FIG. 54 | Reverse of the series following the enlargements and cradling.

has an elongated format. In fact, its support is a rectangular panel initially identical to the others but to which Rubens had a piece added at either side after beginning work on it (fig. 55, format C). The resulting format thus accorded with the ideals of the golden ratio.[3] The preparation was fairly carelessly applied to the additions and along the vertical joints, compared to the smooth central section. Analysis confirms that both the support and the paint layer of these additions are contemporary with the central part. Infrared analysis has revealed that the columns flanking the composition, already present in the *bozzetto* of the work (Cambridge, Fitzwilliam Museum), also appear in the first version of the *modello*. After the lateral pieces were added, the columns were painted out and then repainted onto the additions.

GEORGE BISACCA, JOSÉ DE LA FUENTE, AND JONATHAN GRAINDORGE LAMOUR

A B C

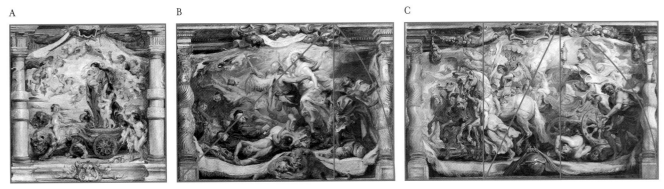

FIG. 55A–C | The three types of format of the series based on simple geometric drawings. Format C coincides with the proportions of Euclid's golden section (in red).

The *modelli* are painted on oak panels consisting of three or four planks glued together with butt joints. The wood of two of the panels comes from Germany; that of the others comes from the Baltic region, where the long winters and dense forests produce slow growing, high-quality wood.[4] Low density, straight grained, and quarter sawn, this wood is particularly stable. During the first half of the seventeenth century, it was exported to the whole of Europe.

In a previous intervention, the supports were thinned by planing, which unfortunately prevents us from appreciating the original appearance of the reverse. The thinning of the panel has exposed the dowels that were used as guides for the gluing. The position of these elements in the thickness of the panel allows us to estimate an original thickness of between 8 mm and 10 mm ($\frac{5}{16}$–$\frac{3}{8}$ in.).

After being completed by the carpenter, panels were subjected to a quality control check by a representative of the painters' guild. If the supports were up to standard, the inspector branded them on the reverse with the mark of the guild using a branding iron. In seventeenth-century works, the mark of the individual carpenter may also appear, usually his own symbol or initials cold-stamped. One panel belonging to the series, *The Meeting of Abraham and Melchizedek* (fig. 14), housed in the National Gallery, Washington, DC, still shows, next to the guild brand, the initials of Michiel Vriendt (active 1636/37), the carpenter from Antwerp who probably constructed the entire series (fig. 56).[5] The panels were delivered to Rubens, who had been commissioned to paint the series. Unfortunately, since the Prado *modelli* have been thinned, all that remains, in the center of only one of the panels, is a darkened sunken area that can be identified as the vestige of the Antwerp brand (fig. 57).

FIG. 56 | Mark of the Antwerp guild featuring the towers and two hands and the initials *MV* of Michiel Vriendt, *The Meeting of Abraham and Melchizedek* (see fig. 14).

FIG. 57 | Remains of the brand of the Antwerp guild in the center of the reverse of the panel of *The Triumph of Divine Love* (cat. 9) and the hypothetical location of the initials of Michiel Vriendt.

SUBSEQUENT ALTERATIONS AND PREVIOUS RESTORATION WORK

At an undocumented date, the supports were enlarged and planed down to achieve a flat surface. The thickness of the panels, which currently varies from 3 to 5 mm (⅛–³⁄₁₆ in.), was reduced and pine sliding "cradles" were attached to the reverses (fig. 58), a practice that became fashionable only around 1770,[6] which leads us to date this intervention shortly thereafter.[7]

This type of reinforcing structure made up of a combination of glued members and sliding members was originally devised to force the panel to remain flat while at the same time allowing the wood of the panel to expand and contract. As shown in figure 58, the members glued to the upper and lower parts secured the connection between the panel (A) and the two additions (B) since they bridged the joints. For the formats enlarged on all four sides, an initial frame glued around the perimeter (C) held everything together. A cradle (D) joined to the latter then covered the original panel. The additions were painted with a thin preparation that allowed the pine wood grain to show through. Their appearance greatly contrasts with that of the original painting.

The photographs dated 1900[8] attest to the deteriorated condition of the works. The treatments carried out after that date were limited to improving the appearance of the painted surface and did not involve the support, which continued to deteriorate further. The effect of the reinforcing structure was to transfer stress to the reverse of the panel. Indeed, the many visible cracks coincide with the positions of the glued members of the cradle (fig. 59). Between the cracks, the panel was free to warp independently, which explains the uneven surface of the support (figs. 60 and 61).

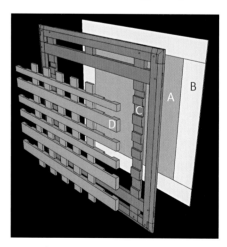

FIG. 58 | Composition of the reinforcing structure.

FIG. 59 | Peter Paul Rubens, *The Triumph of Divine Love* (cat. 9), detail of the damage.

FIG. 60 | Peter Paul Rubens, *The Victory of Truth over Heresy* (cat. 4), detail in raking light.

THE RESTORATION WORK

Treatment consisted in first removing the additions and reinforcement structures that were causing stresses within the original supports and then removing the later painted additions. This was done by making closely spaced incisions in the support cradles to facilitate the removal by carving gouges and hand tools. In this way, the pressure exerted on the original supports was kept to a minimum. The cradling and support structures were gradually reduced, certain parts being maintained until the last moment in order to limit any movement over the most fragile areas of damage.

Next, the painted additions were separated from the original support. Once all the reinforcements were completely removed, the residue of animal glue was first swelled with a synthetic inorganic gel[9] in order to reduce moisture absorption into the reverse of the panel and then cleared.

The next stage consisted in regluing the various open cracks or complete splits. Depending on the particular instance, different adhesives were used. With very narrow cracks, it might be sufficient to inject a fish glue.[10] When the

gap was significant and needed to be bridged, a homogeneous and stable adhesive with bulking agent was used.[11] During the gluing stages (fig. 62), it was essential to take into account the distortions and warping of the support. On the one hand, it is necessary to respect the general overall curvature of the panel, the sum of the individual warps between cracks after the panel was released from the stresses of the reinforcement cradle. On the other hand, if the warping is too significantly pronounced, it will affect the ability to read the image. During the process of joining the splits, the restorer must therefore find a way to attenuate local warps while respecting the overall curvature of the panel (fig. 61).

Once the supports were joined, the panels all displayed fairly consistent curvatures, which, however, did not disturb an overall aesthetic appreciation. One panel, *The Meeting of Abraham and Melchizedek*, was an exception, as it was badly warped, and most of that warp was concentrated between two splits approximately 2 cm (¾ in.) apart. The panel displayed a curvature with

an arc of 4 cm (1⁹⁄₁₆ in.). This extreme case required a special treatment to reduce the curvature, which involved the plastic deformation of the wood and subsequently stabilizing it by impregnating the support with a chemical solution: ethylene glycol–ethanol–shellac.[12] The application of the mixture was repeated, and small weights were progressively added, slowly relaxing the curvature and leading to a permanent rearrangement of the long cell chains within the wood. This treatment is used only in extreme cases and works best with very thin oak panels and in this case proved successful.

The overall cohesion of the supports was restored. However, the panels remained very fragile due to their thinness and pronounced curvature. The supports needed a secondary system that afforded stability but at the same time allowed the dimensional movements of the wood (expansion/contraction, flexing) during environmental fluctuations. Based on the experience from previous treatments, the use of a perimeter strainer with spring mechanisms tailored to the curvature of the panel seemed the most appropriate solution (figs. 63, 64). However, the thinness of the supports and their reaction to environmental fluctuation led us to make modifications. Incisions were made in the strainer, and these were filled with silicone. This made it possible to increase its flexibility without weakening the structure. The springs were then fitted. They connect the strainer to the panel by means of a length of steel braided wire that is inserted into bronze buttons spot-glued to the reverse of the panel. The compromise between the need for reinforcement and the need to allow for movement is achieved by the combination of strainer and springs. Finally, a protective backing of foam board seals the strainer, limiting the support's exposure to dust and buffering environmental fluctuation (fig. 65).

The series of *modelli* is currently displayed in new frames crafted according to seventeenth-century models. The painted additions were retained and again mounted in their previous eighteenth-century frames in order to preserve them for reference purposes.

ASSESSMENT OF THE SET

In addition to being high-quality paintings in their own right, these works are part of the elaboration of ideas for the production of tapestries, which are to be considered the actual finished works. Despite belonging to a series, each support displays a different degree of deterioration. However, we have attempted to achieve the greatest possible uniformity, especially with

FIG. 61 | Overall curvature resulting from the sum of the local warps of the panel.

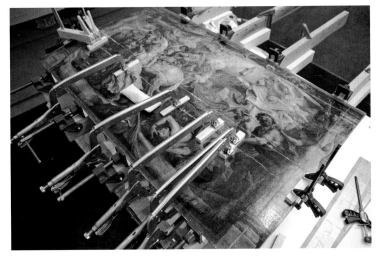

FIG. 62 | The clamping and gluing process.

FIG. 63 | Detail of the spring mechanisms.

FIG. 64 | General view of the panel with the secondary support strainer, showing the curvature.

FIG. 65 | General view of the panel of *The Triumph of the Church* (cat. 6) with the foam board covers in place.

respect to perception of the overall curvature of the works. Although the treatment appears to have been carried out solely on the supports, it has had considerable impact on the legibility of the painted surfaces. It has improved the reading of the paintings by closing the cracks and reducing the warping. But above all, the removal of the additions enables us to newly appreciate Rubens's compositions in a manner that is closer to their original conception.

Finally, the restoration of this unique collection turned out to be an ideal project for the continuing training of a new generation of panel conservators selected for the Panel Painting Initiative, funded by the Getty Foundation. This project has been overseen by Antoine Wilmering, senior grants officer and the soul of the initiative. For a period of nearly two years, the Prado has been a center for the exchange and transmission of opinions and points of view among specialist conservators throughout the world who have been involved in this exceptional endeavor.

NOTES

1 For *The Defenders of the Eucharist*, the composition is almost square (ratio = 1.04) throughout the series, whereas major changes in proportion are found in *Abraham and Melchizedek: bozzetto* = 1; *modello* = 1.03; cartoon = 1.36; tapestry = 1.22 (the values express the ratio of width to height).

2 It is estimated that the original edges of *The Triumph of the Church* were trimmed by no more than 1 to 2 cm (0.39–0.78 in.) in height.

3 On the golden ratio, see, for example, Luca Pacioli, *De divina proporzione* (Venezia, 1509).

4 See the technical essay by Vergara in this volume.

5 This carpenter, a favorite of Rubens, altered supports on many occasions at the request of the artist and was accustomed to making changes of this kind.

6 The "sliding cradle" was first made in France in 1770 by the cabinet-makers to the king, Jean-Louis and François-Toussaint Hacquin, for Rubens's *The Village Fête* (Paris, Musée du Louvre, inv. 1797). Its use spread quickly, and it became not only a structural solution but also an aesthetic trend. See Dardes and Rothe 1998, pp. 269–70.

7 Although the sliding cradles and certainly also the eighteenth-century frames for the paintings (with moldings "in the style of Salvator Rosa" probably designed by the painter and theoretician Anton Raphael Mengs [1728–1779]) must date from *after* 1770, it is likely that the additions were earlier (see the technical essay by Vergara in this volume).

8 Madrid, Museo Nacional del Prado, Lacoste Archive, 1990-15 (box no. 67-73).

9 Laponite RD®.

10 High Tack Fish Glue®, made from codfish by Nordland Products.

11 Epoxy®Araldite1253.

12 First developed by Christian Wolters. See Wolters 1963.

THE RESTORATION OF SIX PANEL PAINTINGS BY RUBENS
PAINT SURFACE

María Antonia López de Asiaín

In conjunction with the restoration of the supports of six panels by Peter Paul Rubens (1577–1640) from the *Triumph of the Eucharist* series and the removal of additions made to the panels, the Museo del Prado took the opportunity to carry out restoration of the pictorial surface of the six works in order to unify their appearance and to rectify damage resulting from inadequate earlier interventions, such as cracks, repainting, and uneven cleaning that hindered the reading of the compositions. The series had never before been treated as a whole; instead, restoration had been carried out on the paintings individually.

Many of the problems that arose during restoration stemmed from differences in the state of conservation among the six works. Two of them, *The Victory of the Eucharist over Idolatry* and *The Triumph of Divine Love* (cat. 8, 9), were severely damaged by earlier restoration that had eliminated the glazes and shadows, resulting in the loss of halftones on the figures and backgrounds and the hardening of the images. Furthermore, only the central scenes had been cleaned, leaving the architectural backgrounds dark. Therefore, the compositions were completely altered and had lost spatial depth. It was necessary to balance the cleaning and retouch with glazes the areas where they had been removed.

Two other panels, *The Meeting of Abraham and Melchizedek* and *The Triumph of the Church* (cat. 2, 6), had been properly restored but as isolated works, without any attempt to integrate them with the group. It was necessary to adapt the state of their cleaning to that of the rest of the works. The two remaining panels, *The Defenders of the Eucharist* and *The Victory of Truth over Heresy* (cat. 1, 4), which lacked restoration documentation, required complete treatment in order to bring them to a state harmonious with that of the rest of the works.

To achieve unity of the group, all cleaning and restoration processes conducted on the paintings were carried out in parallel and also adapted to the schedule dictated by work on the supports.

Once the additions to the panels were removed and the original compositions of the paintings recovered, it was possible to understand the arrangement of the figures, which are positioned almost theatrically in the space of the picture, as if the scenes were taking place on a stage. The pictorial restoration had to complete the recovery process.

The cleaning was also intended to bring to light Rubens's true technique, which is well defined in works as spontaneous as these, where the execution was extremely direct and the preparation left visible as an additional pictorial element (fig. 66). The artist unleashed his masterly combination of technical resources on this preparation: first he applied a translucent wash; then he defined the shadows with parallel or crosshatched lines; after that he applied long brushstrokes with diluted paint to fit the composition and the figures in the background together and then used thicker paint to define the foreground; finally he added thick brushstrokes for the shadows. These sharply defined final touches, with a grainy texture that resembles that of tempera, produced details of great beauty, such as the dragon in the background of *The Victory of Truth over Heresy* (see fig. 48), and discordant tones in others, such as the garment of the female figure holding back the horses in the foreground of *The Triumph of the Church* (fig. 70). In the early stages of this restoration work, some of these brushstrokes seemed to be later additions because of their distinctive texture. However, infrared study confirmed their authenticity: sometimes they were applied beneath brushstrokes that were unquestionably original.

The restoration process began with the cleaning of all the panels, while keeping in mind the uniqueness of each and their varying states of conservation. One of the difficulties of undertaking this cleaning was the complexity of the compositions. The aim was to return to the original distribution of light in order to restore the volume and space of each figure and thus to reestablish the equilibrium of the scenes.

The very quick and light technique characteristic of the sketches is suited to the patina of time, so intervention had to be moderate. First the earlier interventions were studied as a whole in order to compensate for them. This led to the selective elimination of the unevenly applied yellowish varnish.[1] Then the zones that had not been given prior treatment were cleaned

and those that were already clean were merely refreshed. During this treatment, retouching from recent restorations was removed. It was more difficult to eliminate the repainting done on the oil when the pictures had been enlarged at the end of the seventeenth century or in the eighteenth; these repainted areas, covering up to 3 cm (1³⁄₁₆ in.) of the original painting, were insoluble with ordinary products and did not permit the application of gels, because these add moisture and would have softened the stucco of the base. Therefore, the repainting was removed dry with the tip of a scalpel. This method could be used only in areas where the work still had its original varnish under the repainting. The rest of the pictorial surface did not permit even a light scalpel cleaning, as its thin layer could be easily damaged. Removing the repainting as well as the additions was essential for the understanding of each work, given that they were extremely dark and acted as a black frame that compressed the compositions. For example, Rubens had managed to convey the idea of a spatial opening in the background of *The Victory of the Eucharist over Idolatry* by means of the angel that emerges from the heavens with the chalice, but this space was covered up by a dark repainting. When the latter was removed, the figure no longer seemed too clean in contrast to

the heavy repainting but instead became integrated into the ground and recovered its position in space (figs. 67, 68).

The elimination of the repainting on the perimeters permitted a return to the artist's spatial conception, in which the architecture, tapestries, still lifes, and angels that frame the scenes recovered their rightful place. At the same time it was also possible to uncover some of the transposition marks of these *modelli* to boards in order to weave the tapestries; these marks were essential for research on the creative process underlying the series (see fig. 85).

Some areas that had been overcleaned in earlier interventions were not treated with solvents so as to avoid further losses. Therefore, both the varnish and the inadequate repainting were removed with a scalpel. This was carried out, for instance, on the white mantle of the central figure in *The Victory of the Eucharist over Idolatry*, which in the earlier restoration had been painted with a yellowish white to cover an earlier overcleaning. After this layer was removed, at least the trace of the original brushstrokes and a slight nuance of color in the shadows could be recovered. Both actions were essential for identifying the lights and shadows and later for undertaking the reintegration with greater certainty.

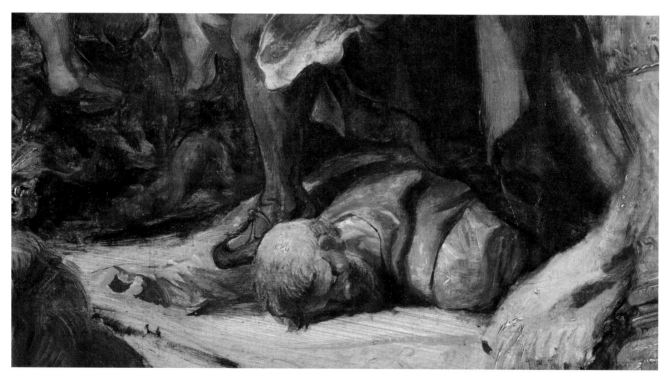

FIG. 66 | Peter Paul Rubens, *The Victory of Truth over Heresy* (cat. 4), detail showing where the painter left the light-colored preparation visible and drew the figures and backgrounds with highly diluted paint, finally adding impasto highlights and details in the foreground.

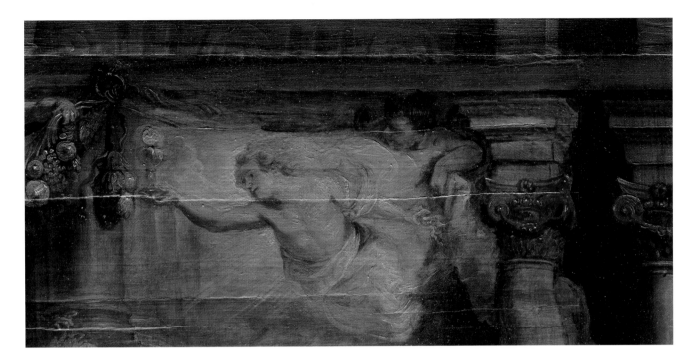

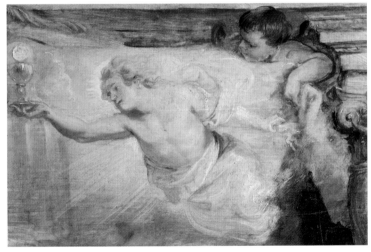

FIGS. 67 and 68 | Peter Paul Rubens, *The Victory of the Eucharist over Idolatry* (cat. 8), detail of the angel prior to removal of the repainting of the background; and the final result.

Beneath the varnish there were some blackish, dirty accretions from smoke that had been unevenly removed in earlier restorations. It was necessary to eliminate them, as they concealed the brushstrokes and hid nuances in the painting.[2]

Similarly, some of the glazes and shadows of the painting were deteriorated. The attire of the female figure detaining the horses in *The Triumph of the Church*, for example, retained remains of dirt that fused the shadow of her skirt with that of the horses' legs, producing confusion in the design. After cleaning and restoring volume and integrity to the fabric, it became clear that some dark carmine brushstrokes in these shadows were damaged and their contours discontinuous and broken (figs. 69, 70). These brushstrokes in the shading were not typically part of Rubens's technique, but because they were similar to other finishing touches in this series they were joined and filled in with retouching to recover their appearance. The corresponding tapestry and a copy made by David Teniers III (1638–1685) in 1673 (Museo Nacional del Prado, P-5978, on extended loan to the Museo de Pontevedra) provided useful information in this process.

The case of *The Victory of the Eucharist over Idolatry* was even more complicated because the panel was in severely deteriorated condition from earlier cleaning. Some zones showed the results of overcleaning. The white cloak of the central figure

FIGS. 69 and 70 | Peter Paul Rubens, *The Triumph of the Church* (cat. 6), detail after cleaning, showing shadows that had deteriorated due to earlier interventions; and the final result, after reconstruction of the glazes.

had lost its shadows and folds and appeared as a uniform mass (fig. 72), and the underlying drawing was visible in the shoulder of the figure behind him. Furthermore, the flesh tones of the kneeling figure were unbalanced (yellow on the leg and orange on the torso), and his blue garb had also lost shadowing, becoming transparent. These problems could be resolved only by reintegration using subtle glazes, which was possible as the result of knowledge of Rubens's technique garnered in these paintings: the shadows on the folds of the mantle were identified by their smooth brushstrokes, without a heavy application of paint; the highlights, by their thick impasto and the deep mark of the brush. Therefore, it was possible to undertake a preliminary reconstruction of these lost shadows by applying glaze to the zones that had a smooth texture. When no information on texture was available, the work was accomplished with the help of documentation that had been preserved, in this case, the copy of the composition also done by Teniers (Museo del Prado, P-5392) and the tapestry in the convent of the Descalzas Reales (fig. 37). The shadows were touched up with a fine black watercolor line on the unvarnished surface, because it was difficult to get an idea of the color of the nuances of the white mantle given the disparity of these two sources: the shadows in the Teniers copy are veiled in carmine and those in the tapestry in the Descalzas Reales in blue. This reintegration was essential in order to both

recover the line of the folds and situate the figure on the plane that corresponds to him in the composition, between the two companion figures (figs. 73, 74).

After the paintings were cleaned, the cracks and lacunae were evened out with stucco.[3] On panels with a uniform texture, the uneven surfaces were particularly disturbing because they produced reflections. Therefore, the stucco had to be exact, as the accuracy of the reintegration depended on it. It was difficult to produce a level surface given the unevenness of the supports and the curved, discontinuous shape of the cracks.

Reintegration was begun with watercolor prior to varnishing, and adjustments were made with pigments applied to the varnish.[4] This final action eliminated the layer of abrasions that hindered proper reading.

In general the losses in the pictorial layer did not affect the essential elements. *The Victory of Truth over Heresy* panel was the only one that had a major lacuna in the center. This seems to have been caused by friction—its edges were uneven and diffused—and perhaps by the fact that the work was resting on a flat surface, because it coincided with the zone of the support's maximum curvature. The X-ray shows that the covering of this loss in an earlier restoration also concealed the edges of the original painting. These edges were recovered in the cleaning process, and although they were deteriorated, it was possible to evaluate

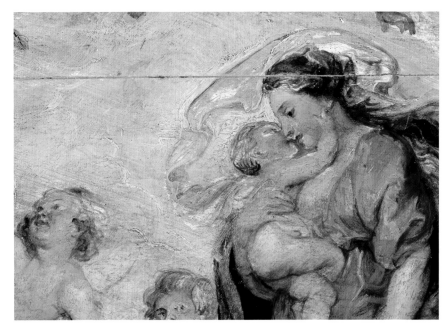

FIG. 71 | Peter Paul Rubens, *The Triumph of Divine Love* (cat. 9), detail of the background of the central zone that had lost part of its gray glaze, leaving the light-colored preparation visible.

FIGS. 72–74 | Peter Paul Rubens, *The Victory of the Eucharist over Idolatry* (cat. 8), details of the state of the central figure before treatment, with the loss of glazes in the shadows that modeled the volumes of the mantle; during the reconstruction process; and after treatment.

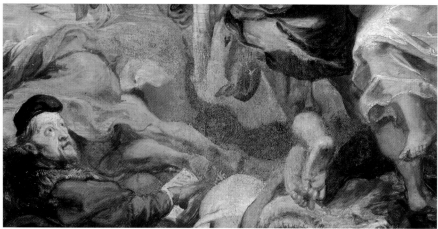

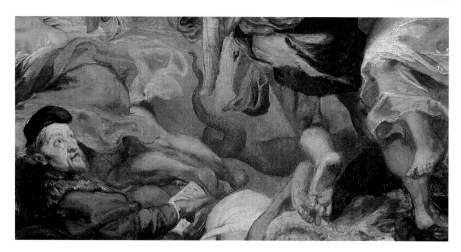

FIGS. 75–77 | Peter Paul Rubens, *The Victory of Truth over Heresy* (cat. 4), details of the process of reintegration of the pictorial loss in the central zone: after cleaning and filling with stucco, which gives the background a light tone to reproduce the original transparency of the light-colored preparation; after reconstructing the volumes and light tones with watercolor, based on historical documentation; and the final result, where a few refined strokes identify the area of reintegration without disturbing the overall appearance.

FIG. 78 | Tapestry by Jacob Geubels II, *The Victory of Truth over Heresy* (cat. 5), detail of the dragon's tail.

FIG. 79 | David Teniers III, *The Victory of Truth over Heresy,* 1673 (oil on canvas, 180 × 285 cm [70⅞ × 112½ in.], Madrid, Museo Nacional del Prado, P-5979), detail of the dragon's tail.

the possibility of reconstructing the lacuna (fig. 75). The greatest difficulty of this restoration work was choosing a criterion for carrying out the reintegration. Given its large dimensions, it was important to reconstruct this panel to restore the meaning of the composition. The earlier reintegration was not accurate, which led to an erroneous dark tone that matched the color of both sides of the sky in darkness, when in reality Rubens had placed the principal focus of light in the painting there. Likewise, an indefinite space had been painted, without any attempt to reconstruct the lost figures. Although the cartoon of this *modello,* which could have served as a guide, has been lost, the tapestry itself shows the dragon's tail trodden by the figures of Time and Truth in the place where there is pictorial loss (fig. 78). However, in the preliminary sketch of this composition in the Fitzwilliam Museum, Cambridge, the tail is oriented toward the opposite side and the aged man representing Time is omitted. Also, in the large-scale copy from the start of the eighteenth century by Teniers the tail is displayed in a position similar to that in the tapestry (fig. 79). Therefore, the tail, if it existed in this *modello,* could not have had a contour identical to that of the tapestry and the copy, and it is certain that it did not end with the same pointed tip bent upward, because in the place that the tip would have occupied there are remains of the painting of the original sky without any figural traces. Nevertheless, the tapestry and copy enable us to make a fairly credible reconstruction. There-

fore, the decision was made that the most proper option was to paint a background with transparent vibrant cloud effects and with a hint of the volume that the tail might have had (figs. 76, 77).

As a final step and in order to protect the panels, an extremely light dammar varnish was applied that allows the richness of the textures that had been hidden to show through, in addition to dissimulating the light reflecting on the cracks and uneven parts.

As a result of this restoration, the six panels can be presented today as a group. Moreover, Rubens's technique has been recovered to reveal the freedom of his brushstroke, the unpainted backgrounds, and the quick final touches that had been hidden by earlier interventions. The images that have been revealed are as close as possible to the originals.

NOTES
1 The mastic resin varnish was dissolved with White Spirit and ethanol.
2 These were soluble with the components of one of the gels formulated by R. Wolbers, without gelling it and extremely diluted in deionized water. This solvent evaporates quickly, and it was thus easy to control. Precision in the process was essential to prevent the aqueous components from being in contact with the preparation of the painting, which is water soluble, especially in areas where the preparation was most exposed.
3 The stucco was made with calcium sulfate and animal glue.
4 This was carried out with Maimeri resin pigments.

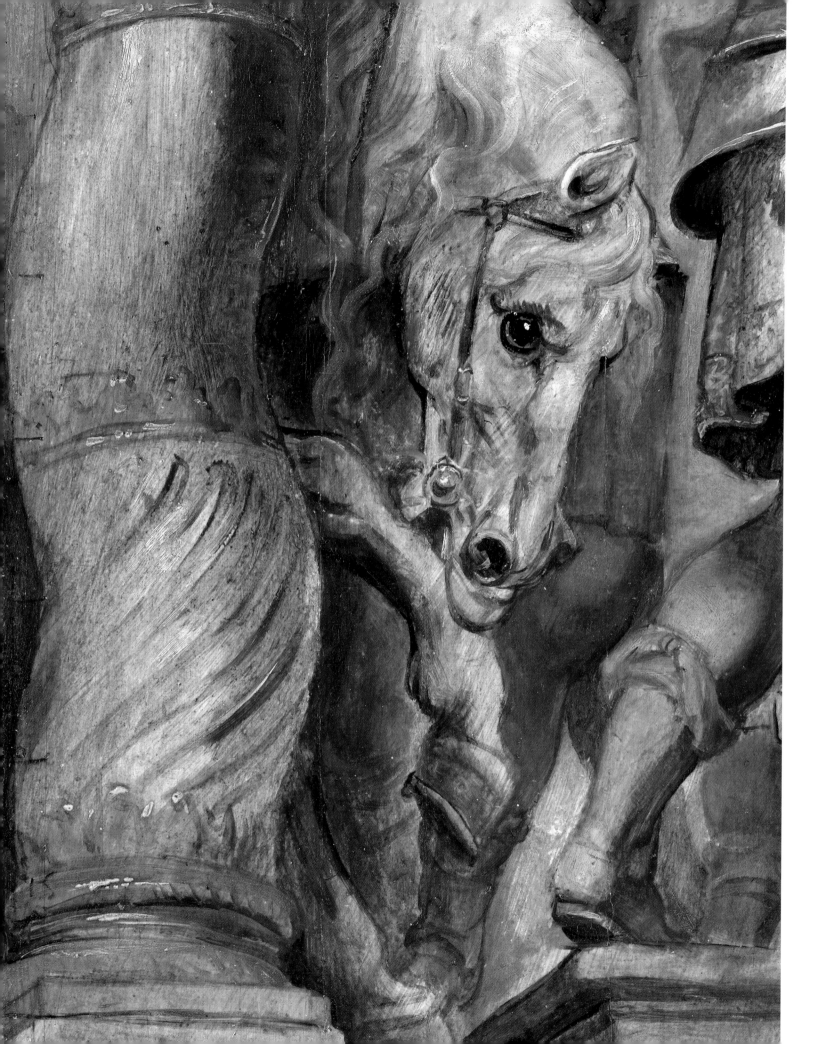

TECHNICAL STUDY OF THE *MODELLI* BY RUBENS FOR THE EUCHARIST SERIES

Alejandro Vergara

The essay by George Bisacca, José de la Fuente, and Jonathan Graindorge Lamour in this volume explains the nature of the additions to the six *modelli*, or large, detailed sketches, made by Rubens for the *Eucharist* series owned by the Prado, the damage they caused to the original sections of the *modelli*, and the process of their necessary removal. Because the wood of the added sections has been identified by George Bisacca and José de la Fuente as pine, the sections must have been made in Spain. What we know about the history of the paintings is insufficient to date the additions with precision. Only a few documents provide relevant information.

The *modelli* are first documented with certainty in 1677, when four of them were listed in the inventory drawn in Madrid of the collection of Gaspar de Haro, seventh marquis of Carpio.[1] This document includes the measurements of the four paintings. In three cases, *The Victory of Truth over Heresy, The Meeting of Abraham and Melchizedek,* and *The Victory of the Eucharist over Idolatry,* the dimensions are about 20 cm larger in height than those of Rubens's original scenes and similar in both height and width to the dimensions of the paintings with the enlargements. This could mean that these paintings had already been enlarged at this time. The fourth painting, *The Triumph of the Catholic Faith,* is recorded as approximately 20 cm (7⅞ in.) smaller in height than the other three and similar to the dimensions of a painting now in Brussels (Royal Museum of Fine Arts of Belgium), which is probably the same item. This painting had a cradle that was removed in 2007. At that time it had no additions.[2] We do not know if it was ever enlarged.

The inventory describes the frames of the four paintings. *The Victory of Truth over Heresy* and *The Triumph of the Catholic Faith* have frames made of pear tree wood with a gilt "perfil" (molding).[3] *The Meeting of Abraham and Melchizedek* has a frame of walnut, with a gilded molding. The frame of *The Victory of the Eucharist over Idolatry* is described succinctly as "black." That some of these frames

are different from each other may indicate that the paintings had been in different collections before that time.

The dimensions of the *modelli* were again provided in 1694, when eight panels of the series were documented in the Alcázar in Madrid after they were sold to the king. They were all said to measure one vara, or approximately 84 cm (33⅛ in.), in height, which is similar to the height of the paintings with the additions, and "slightly more" in width, "without frames."[4] That they were all described as similar in format may be another indication that the additions already existed (the additions, by widening only the narrower paintings, had made the format of the group more similar).

A 1747 inventory of the royal collection includes three of the *modelli* now in the Prado, as well as a copy after a fourth picture from the *Eucharist* series, *The Four Evangelists,* which is listed under no. 965.[5] This is a copy, of mediocre quality, that belongs to the Prado (cat. no. P-1709), as shown by the number *965* painted on the back of its panel support.[6] This copy does not strictly follow the original composition of the *modello*: the architecture at the top and bottom extends farther than in Rubens's original. These architectural sections are based on those that were painted in the additions of the enlarged *modelli*. The support of Prado no. 1709 is made of a single piece of wood and has never been enlarged. The painting was therefore made after the originals by Rubens had been made larger. It follows that this necessarily happened before 1747.[7]

DENDROCHRONOLOGY

Dendrochronological analysis of the supports of the six large sketches made by Rubens for the *Eucharist* series that belong to the Prado was carried out by Maite Jover in the Analysis Laboratory of the Museo Nacional del Prado. The results are described below.

The Defenders of the Eucharist

The support is made up of three planks placed vertically, measuring, from left to right (as seen by the viewer from the front of the painting), 26.4, 26.7, and 14.5 cm (10⅜, 10½, and 5¹¹⁄₁₆ in.). The wood is from southern or western Germany, as shown by

FIG. 80 | Peter Paul Rubens, *The Meeting of Abraham and Melchizedek* (cat. 2), detail.

comparing the growth rings with master chronologies from those regions. Planks I and II (the first two from the left) come from the same tree; their youngest growth rings date to 1609. These are the youngest rings present in the support. No sapwood rings are preserved in these two planks. Plank III has insufficient growth rings for dating. It has eleven sapwood rings, which makes for a lesser-quality panel.

Because the statistics for southern and western Germany show that a minimum of seven sapwood rings existed in the trees and were discarded and assuming that the wood underwent a minimum of two years of seasoning, the earliest possible date when this panel could have been used is 1618. Statistically, it is more likely that approximately seventeen sapwood rings were present in oak trees of German origin and were discarded, making 1628 or later a likelier date for the painting's creation.

The Meeting of Abraham and Melchizedek

The support is made up of three vertical planks of Baltic oak, measuring, from left to right, 28.8, 20.1, and 19.1 cm (11⁵⁄₁₆, 7⁵⁄₁₆, 7½ in.). The youngest growth ring in plank I (the first from the left) dates to 1604. This is the youngest ring present in the support (the youngest growth rings of planks II and III date to 1577 and 1596, respectively). No sapwood rings are preserved in these planks. Given that the statistics show that a minimum of nine sapwood rings present in trees from the region were discarded when panels were prepared and assuming a minimum of two years for seasoning, the earliest possible date when this panel could have been used is 1615. Statistically it is more likely that approximately fifteen sapwood rings were present in oak trees of Baltic origin, making 1621 or later a likelier date for the painting's creation.

The Victory of Truth over Heresy

The support is made up of four horizontal planks of Baltic oak, measuring, from top to bottom, 17.2, 19.0, 18.4, and 9.8 cm (6¾, 7½, 7¼, and 3⅞ in.). Plank I's youngest growth ring dates to 1599. Plank II's youngest ring dates to 1614. This is the youngest growth ring detected on the support of this painting. It is one of thirteen sapwood rings present on this plank of wood. The third plank's youngest growth ring dates to 1598, and there is no sapwood. The fourth (bottom) plank cannot be dated due to the lack of sufficient rings. Assuming that the wood was seasoned for a minimum of two years, the earliest possible date when this panel could have been used is 1616. Statistically it is more likely

that fifteen sapwood rings were present, and thus 1618 or later is a likelier date for the creation of the painting.

The Triumph of the Church

The support is made up of a total of nine planks. A central section is made up of three horizontal planks. Their length is approximately 89.7 cm (35³⁄₁₆ in.). Their height cannot be measured with precision due to the enlargement of the panel; the measurements taken from an X-ray image of the painting are approximately 18.7, 22.2, and 22.7 cm (7⅜, 8¾, and 8¹⁵⁄₁₆ in.), from top to bottom. To the right and left of the central section are two narrow bands, each made up of three pieces of wood, joined horizontally. The grain of the two side sections runs horizontally, as does the grain of all the wood used in the support. There is no access to the growth rings of the three central planks of wood. Only the growth rings of the three planks that make up the left section of the support and the three planks of the right section can be measured.

On the left section of the painting (as seen by the viewer) the three pieces of wood measure 17.2, 24.9, and 18.4 cm (6¾, 9¹³⁄₁₆, and 7¼ in.), from top to bottom. All three pieces are made of Baltic oak, and the first and third planks come from the same tree. The second plank comes from the same tree as the middle plank of the opposite side of the painting. The youngest growth rings in the planks of the left side date to 1595, 1598, and 1597, respectively.

The three pieces of wood that make up the right section of the support are also of Baltic oak, and they measure 16.4, 22.4, and 24.7 cm (6⁷⁄₁₆, 8¹³⁄₁₆, and 9¾ in.). The youngest growth rings in these planks date to 1598, 1598, and 1604, respectively. The latter is the youngest growth ring found on the support. Given that the statistics for the area show that a minimum of nine sapwood rings existed in Baltic oak trees, all of which were discarded when panels were prepared, and assuming that there was a minimum of two years for seasoning, the earliest possible date when this panel could have been used is 1615. Statistically it is more likely that fifteen sapwood rings were present, making 1621 or later a likelier date for the painting's creation.

The Victory of the Eucharist over Idolatry

The support of this painting is identical to the small section added to the right (as seen by the viewer) of The Triumph of the Church. It is made up of three planks of Baltic oak, with the youngest growth ring detected on the support dating to 1604. The earliest possible

date when this panel could have been used is 1615. Statistically it is more likely that fifteen sapwood rings were present, making 1621 or later a likelier date for the painting's creation.

It appears that the support of this painting was made with knowledge of the need that developed during the creation of *The Triumph of the Church* to enlarge the composition. The three planks that make up the support of *The Victory of the Eucharist over Idolatry* were joined together, and then a small section was sawn off for use in the other painting.

The Triumph of Divine Love

The wood of the support is from southern or western Germany. The support is made up of three horizontal planks from the same tree, which is also the same tree from which planks I and II of *The Defenders of the Eucharist* (see above) derive.

The planks measure, from top to bottom, 16.8, 25.4, and 23.5 cm (6⅝, 10, and 9¼ in.). Plank III's youngest growth ring dates to 1607; this is the youngest ring present in the support. The youngest growth rings of planks I and II date to 1606 and 1603, respectively. No sapwood is present in any of the planks. However, because the youngest ring in a plank from the same tree is in the painting *The Defenders of the Eucharist* and dates to 1609, this is the year to take into account for the dating of the panel support.

As in the case of *The Defenders of the Eucharist,* the earliest possible date when this painting could have been made is 1618. Statistically it is more likely that about seventeen sapwood rings existed, making 1628 a likelier date from which the creation of the painting is possible.

In conclusion, dendrochronological analysis of the six supports studied shows that the earliest dates when they could have been used for painting are 1618, 1615, 1616, 1615, 1615, and 1618, respectively. The statistically more likely dates after which the panels probably were used for painting are 1628, 1621, 1618, 1621, 1621, and 1628. The accuracy of these statistically more likely dates can be tested by comparing dates obtained with this method to those of paintings included in published studies and in research recently undertaken at the Prado for which we know the dates (because they are signed and dated). The recent publication *Brueghel: Gemälde von Jan Brueghel D.Ä.*[8] includes results of dendrochronological studies of paintings by Jan Brueghel and his son Jan Brueghel the Younger. Among them are seven paintings that are signed and dated. In two of them this date is earlier (by five

years and by one year) than the statistically obtained likeliest date after which it is probable it was painted. In one case the date coincides with the said date, and in four cases it is later (between two and ten years later).

An article by Pascal Fraiture includes dendrochronological data from four Antwerp paintings from the seventeenth century that are securely dated.[9] This publication includes only the earliest possible date for the creation of the paintings, but the likelier date from which they could have been painted can be inferred. In all four cases the paintings were made later than this date (by 6, 9, 26, and 3 years).

Maite Jover, of the Museo del Prado, has been studying the supports of seventeenth-century Flemish paintings in the museum since 2009. Some conclusions relevant to our study can be drawn at this point. Of seventy-two panels that have been studied so far, only eight have a secure date that can be contrasted with the results of dendrochronology (their Prado inventory numbers are P-1405, P-1433, P-1605, P-1619, P-1621, P-1622, P-2142, and P-1794). One (P-2142) falls on the exact likeliest date after which the panel is likely to have been used; the other seven are later (by 12, 8, 7, 13, 4, 2, and 8 years, in the order listed above).

Although the available data are insufficient to reach definitive conclusions, it appears that, with exceptions, the statistically more likely dates after which the panels could have been used for painting are a useful clue to their dates. Rubens was probably working on the *Eucharist* series by 1627,[10] but we do not know exactly when he began work on the *modelli* or when he finished them. The tapestries belonging to this series arrived in Madrid between 1628 and 1633.[11] Although it is generally assumed that the entire set of *modelli* was finished before some of the tapestries were ready for shipment, it is not impossible that some of the *modelli* were done in 1628 or later and thus that Rubens worked on the designs for the scenes of the *Eucharist* series over several years.

INSCRIPTIONS, MARKS, AND UNDERDRAWING

The six paintings were cradled at an undetermined date. Few if any marks could thus be found on the back of the panel supports. In other *modelli* made for the *Eucharist* series, such as the version of *The Meeting of Abraham and Melchizedek* in the National Gallery of Art in Washington, DC, there is a mark with the brand of the city of Antwerp (two hands and a castle) and the monogram "MV," the mark of the Antwerp panel maker Michiel Vriendt (d. 1636/1637).[12] The same marks appear on the panel support of

FIG. 81 | Infrared detail showing the inscription on *The Triumph of Charity*.

the painting *Angels Playing Music* in Potsdam.[13] The Prado *modelli* were probably made by the same panel maker. A burnt mark that can be seen in the back of *The Triumph of Divine Love* is probably what remains of a panel maker's mark (see fig. 57 in Bisacca, de la Fuente, and Lamour, this volume).

Some inscriptions, marks, and underdrawing have been detected in the Prado's *modelli* for the *Eucharist* series using infrared reflectography. This study was conducted with the help of Laura Alba, from the Gabinete de Documentación Técnica of the Museo del Prado.

An inscription that reads *Triumphus* (or, less probably, *Triumphans*) *Caritatis* is partially visible to the naked eye and is revealed in an infrared photograph of *The Triumph of Charity* (fig. 81). This appears to be in the same handwriting as the inscription in the *modello* for this same series, *Angels Playing Music*. As De Poorter has suggested, the inscriptions are probably by Rubens himself, and they indicate the subjects to be painted on these two panels.[14] Why these inscriptions were necessary in some of the *modelli* and not in others is uncertain.

In *The Meeting of Abraham and Melchizedek* the face of Abraham is overdrawn with a dry medium along its profile, cheekbone, hair, and beard (fig. 82). This type of drawing is not present in any other painting. That it occurs over the paint layers and is schematic in nature suggests that it was made at some point in order to reproduce the head of this figure. Why this was necessary only in this case, and when and by whom it was done, is not known. The proportions of the face of Abraham in the Prado painting are larger than in the second version of the composition that Rubens painted (now in Washington, DC)[15] and larger than the proportions of most figures in the *Eucharist* series. Rubens seems to have wrestled with the size of the figures within the scenes, to judge from the variations we find in the paintings.

Perhaps this drawn profile was used as comparative material to reduce the proportions of the faces in other scenes.

Near the upper left corner of *The Triumph of the Church* there are two irregular circles, one approximately 1 cm in diameter, the other slightly smaller, drawn in a dry, black medium and clearly visible in the infrared images but not to the naked eye (fig. 83). I have not been able to determine their purpose. Because they are on the two sides of the joint (but not symmetrically placed) between the central section of the painting and the panel added to its left when Rubens himself enlarged this picture, they may be related to the process of enlarging the panel.

FIG. 82 | Infrared detail of the face of Abraham in the painting *The Meeting of Abraham and Melchizedek*.

FIG. 83 | Detail of infrared photograph of *The Triumph of the Church* showing two irregular circular lines.

Some traces of underdrawing can be detected in the Prado's *modelli* using infrared photography. In *The Defenders of the Eucharist* there is underdrawing in a wet medium in the area of the festoons at the top of the scene and in the forehead of Isabella. In *The Triumph of Divine Love* there are traces of an additional putto who stood behind the child who sits on a lion. The left wing of the putto above the sitting child is underdrawn and barely shows through the layers of paint. What is left visible was enough for Rubens to achieve his purpose. Underdrawing in black chalk has been detected in some other paintings of this series, such as *The Triumph of the Catholic Faith* (Brussels, Royal Museum of Fine Arts of Belgium).[16] It is apparent when studying the technique of the *modelli* up close that for the most part there is no clear distinction between underdrawing and paint layers. In the sequence that goes from the streaky priming of the panels (left visible, as was characteristic of Rubens) to the thin brown and black lines that define basic features of the compositions to the glazes and lights above, all layers have a degree of transparency that allows them to contribute to the final appearance of the scene. The transparency of Rubens's technique is beautifully displayed in these panels.

In several places Rubens made corrections with white (as in the architecture in the lower right corner of *The Defenders of the Eucharist*) or simply by overpainting (as in the upper right corner

FIG. 84 | X-radiograph showing changes in the outlines of columns in *The Triumph of the Church*.

of the same image, where the architecture was originally larger and was corrected). The infrared images and X-radiography reveal that slight changes were made in the outlines of several of the columns. This is most apparent on the right side of *The Triumph of the Church* (fig. 84). Here Rubens sketched in a first column near the edge of the panel before deciding to enlarge the painting by adding a new section to the support. He then painted a new column in what was the new edge of the painting. The support was also enlarged at the opposite end of the painting, but there is no evidence here that Rubens had already painted part of the scene before deciding to enlarge it.

Most of the Prado *modelli* show a number of marks along their peripheries, visible by infrared imaging or X-radiography (or both) and in some cases also to the naked eye. These are probably traces left on the panels of techniques used to reproduce or enlarge the compositions. The marks are not repeated consistently on all panels and on all sides of each panel. The reason for this is probably that the restorations, additions, and manipulation of the panels throughout their history have removed many marks or caused new ones that make their reading difficult. In addition,

FIG. 85 | Infrared photograph of detail of *The Meeting of Abraham and Melchizedek* showing marks on the left side with the numbers *5*, *10*, and *15*.

artists often removed traces of the systems used to reproduce compositions, which would hinder the appearance of the sketches. It is important to note that some marks on the edges of the panels continue marks made when Rubens's originals were enlarged. Once the enlargements have been removed, it is easy to confuse these leftover marks with traces of those made on the original panels (for example, the thin, short line just below the elbow of the lion in *The Victory of Truth over Heresy*, which is left over from the additions that have been removed).

The marks left on the *modelli* of the *Eucharist* series are consistent enough to show that a systematic campaign of reproducing, enlarging from smaller designs, or making larger versions was carried out. This is only logical in the case of paintings that were based on smaller sketches, and that in turn were used as the basis for the much larger cartoons that the weavers used to make the tapestries.

The Meeting of Abraham and Melchizedek has seventeen marks on the left side (as seen by the viewer) drawn in black, with a

dry medium, every 3.5 cm (1⅜ in.), the first at 3.9 cm (1⁹⁄₁₆ in.) from the top and the last at the same distance from the bottom. They are all at approximately 0.7 cm (¼ in.) from the edge of the painting, and the numbers *5*, *10*, and *15* are inscribed in the corresponding marks (fig. 85). No numbers have been found in any of the other Prado *modelli*. The drawn marks are accompanied by the mark of a pointed object such as a compass point. All these marks can be seen in infrared imaging and with the naked eye. They are probably traces of a grid, the system most commonly used during the Renaissance and Baroque periods to transfer compositions, as mentioned by Francisco Pacheco (who writes that he would enlarge compositions "a veces por la cuadrícula" [sometimes using a grid]) and as explained by Vicente Carducho, Richard Symonds, and Abraham Bosses, among others. Rubens wrote in 1624 that a drawing that he was sending to a friend was perhaps too large but could be reduced "per craticulam sans alterer la proportion" (with a grid, without altering the proportions).[17]

No other marks have been found on this panel. A grid could have been laid over the composition by means such as a string impregnated with material that left fine lines on the prepared panel. Traces of this system could then be removed. The numbers and marks on *The Meeting of Abraham and Melchizedek* are drawn under very thin layers of paint. This indicates that the grid was prepared before the scene was painted and suggests that it was used to make this picture after the smaller sketch (now in Cambridge, Fitzwilliam Museum), which is very different in composition but of similar proportions. I have not been able to verify if the small sketches in Cambridge have grid marks along the edges (they do have lines under the paint layers that frame the composition, isolating it from the surrounding architecture). That the composition in the Prado's *Meeting of Abraham and Melchizedek* was never transferred to a cartoon or tapestry as far as we know but rather was substituted for a different composition of the same theme (now in Washington, DC, National Gallery of Art) also suggests that in this case the grid was not used to enlarge this scene.

Only one other painting in the Prado's set of six *modelli, The Triumph of Divine Love*, shows a set of marks that are separated from each other at the same distance of 3.5 cm (1⅜ in.) (in this case they are visible at the top and bottom). There are no numbers near these marks.

Several other panels—*The Victory of Truth over Heresy, The Triumph of the Church*, and *The Victory of the Eucharist over Idolatry*—have

similar marks near some of their edges, separated by approximately 4.5 to 5 cm (1¾ to 2 in.). In a few cases there are two lines next to each other. It is hard to ascertain if these two lines belong to two different grid systems or if the measurements were corrected at some point during the process. These marks are visible by X-radiography, which means that they are incised. It is impossible to know if they were made before or after the panels were painted by Rubens, because they are in areas of the paintings worked over at the time of the additions to the original compositions. Since these three paintings are considerably wider than the other three Prado *modelli*, the fact that the distance between marks is larger than in the other paintings may be explained as the result of a slightly larger grid.[18]

Nearly all the paintings show traces of a thin line drawn with a dry medium along the entire perimeter of the composition, at a distance of about 0.5 to 0.7 cm (⅛ to ¼ in.) from the edge of the panel. These are probably aids for Rubens that established the limits of the painted field. Some of the pictures (for example, *The Victory of Truth over Heresy*) have a very thin incised line, which may be related to the process of cutting the wood. *The Defenders of the Eucharist* is the only painting on which we have found no traces of marks of the kind found in the other scenes.

In some paintings in this series (for example, in *The Meeting of Abraham and Melchizedek*, in the upper and lower parts of the painting, and in *The Defenders of the Eucharist,* between the hand of Saint Thomas and the head of the figure in a white habit, who probably represents Saint Norbert) there are short, irregular marks (0.5 cm [⅛ in.] or less) on the surface of the painting visible to the naked eye and also in X-radiography. They must be traces of a slight movement of a hard object over the paint surface when it was still wet, possibly of a maulstick with a small head used by the artist to steady his hand.[19]

CONCLUSION

Although this study covers only six of the *modelli* made by Rubens in preparation for the *Eucharist* series, some conclusions can be drawn. As we have seen, dendrochronological analyses show that two Prado panels have 1628 as the likely earliest date for their creation, three have 1621, and one has 1618. This is not proof that these panels were not made earlier, but it suggests that at least some may be later than the date of 1625 generally assigned to them.

As different authors have shown, one of the scenes in the series, *The Meeting of Abraham and Melchizedek*, was probably made to substitute for another that was never fully developed, *The Triumph of Hope*.[20] *The Meeting of Abraham and Melchizedek* was initially planned for the upper of the two levels that the tapestries occupied, and then the design of the columns was changed so that the scene could be moved to the lower level. When the design was changed, the scene was enlarged and the proportions of the figures were reduced.

Some of the paintings have underlying inscriptions (*The Triumph of Divine Love* in the Prado and *Angels Playing Music* in Potsdam), and in only some of them can underdrawing be detected (*The Triumph of Divine Love* in the Prado and *The Triumph of the Catholic Faith,* now in Brussels, Royal Museum of Fine Arts of Belgium). The marks seen with the aid of infrared photography differ from painting to painting. There are some but not many pentimenti. One of the scenes, *The Triumph of the Church*, was enlarged by Rubens as he worked on it. When this was done the section of wood for the addition was taken from another panel that was prepared for use in the painting *The Victory of the Eucharist over Idolatry*. These two paintings at least were therefore made very close in time.

All of this data about the design and creation of the *Eucharist* series indicate that rather than a systematic, mechanical process that was fully planned from its inception, it probably evolved somewhat haphazardly and throughout a fairly extended period of time. This is characteristic of Rubens's large projects, for several reasons. Rubens was extremely occupied with artistic and other endeavors, and he had a penchant for making changes to his paintings. Further, delays in contracts and in the definition of detailed programs could mean that projects took years to complete, especially when people of high position were involved, as was often the case with the Flemish master.

NOTES

1 The document is published in De Frutos 2009, pp. 78–79. Two of the numbers in this inventory, 237 and 238, can still be seen in two of the paintings in the Prado: *The Victory of Truth over Heresy* and *The Meeting of Abraham and Melchizedek* (they are partially covered by the inventory number "966," the number under which the *modelli* were grouped in the eighteenth-century inventories of the Buen Retiro Palace). Suggestions that the paintings had earlier been the property of the Infanta Isabel Clara Eugenia, from whom they passed to the Cardenal Infante Don Fernando and from there to Philip IV, who in turn gave them to Luis de Haro, father of Gaspar, are not based on known documents (this was suggested by Rooses 1886–92, vol. 1, p. 74, who is followed by numerous authors, as explained in De Poorter 1978, vol. 1, pp. 119–21).

2 I owe this information to Joost Vander Auwera, Royal Museum of Fine Arts of Belgium.

3 The transcription of the inventory in De Frutos (see n. 1) uses the term "*versal*" in the first case, but this is a mistake: it should be "*peral*."

4 De Poorter 1978, vol. 2, doc. 22, pp. 457–58.

5 "Una tabla de vara en quadro de otro quattro Euangelistas Copia de Rubenes"; transcribed in Aterido Martínez and Pérez Preciado 2004, vol. 2, pp. 177–78.

6 A different number, *966*, can be seen on the front of the painting. This must mean that it was incorporated into the group of *modelli* for the *Eucharist* series that were all inventoried in the royal collection under that same number in 1771 and thereafter. The number *56* is also visible on the painting (it is from a 1794 inventory of the royal collection). There is another copy of this composition in the Prado, *1702*, but it does not bear the number *965*. From the royal inventories it cannot be determined if the original of this composition had ever been in Spain.

7 Strangely, this copy in the Prado also differs from the original in that it includes Tuscan rather than Solomonic columns. What matters to us here is that the author was following the features of the additions that had been made to Rubens's originals.

8 Neumeister 2013, pp. 410–15.

9 Fraiture 2012.

10 De Poorter 1978, vol. 2, doc. 6.

11 García Sanz 1999, pp. 110–11. For the date of this project, see the essay by Woollett in this volume.

12 See Wheelock 2005, p. 188.

13 De Poorter 1978, vol. 1, cat. 2B, p. 265.

14 De Poorter 1978, vol. 1, cat. 2B, p. 265. The inscription is illustrated in vol. 2, fig. 106. For De Poorter's suggestion, see vol. 1, p. 116.

15 In the Prado painting, the largest possible distance between the top of Abraham's head and the end of his beard measures 8.5 cm. In the painting in Washington, DC, this distance is approximately 7 cm (I owe this information to Arthur Wheelock).

16 See Vander Auwera 2007, pp. 226–29.

17 For the systems that could be used for the transfer of compositions, see Lammertse 2003, pp. 26–30, from which the quotes are taken. The Pacheco quote is from the 1990 edition of his *El arte de la pintura*, p. 434. The Rubens quote is from a letter to Jean Jacques Chifflet of April 23, 1624; see Magurn 1955, p. 97. The numbers in this painting are in a different hand than those found on the grid present in *The Triumphal Chariot of the Victory of Caloo* (Antwerp, Koninklijk Museum voor Schone Kunsten).

18 In the version of *The Meeting of Abraham and Melchizedek* in the National Gallery, which substituted the Prado's version as the *modello* to be followed in the cartoon and tapestry, there are marks and small pinholes at intervals of about 4.2 cm (1¹¹⁄₁₆ in.) on all four edges, according to Wheelock 2005, p. 188. These may be part of the system that we have found in the Prado at 4.5–5 cm (1¾–2 in.). In the painting *The Triumph of the Catholic Faith* in Brussels, there are marks with an interval of 3.2 cm (1¼ in.) on the horizontal borders (I owe this information to Joost Vander Auwera). This painting is similar in dimensions to the larger Prado *modelli*. It is difficult to ascertain if all these marks belong to the same campaigns of enlarging or reproducing or if they were made at different times.

19 Julius Held commented on these marks that he found in several Rubens sketches, in Held 1980, vol. 1, p. 9 n. 8. He suggested that they may have an aesthetic purpose, because they appear on shaded surfaces, creating the effect of flickering light. Rubens did use the back of his brush on occasion, to scratch the surface of the paint with the intention of describing forms (he does this in the eyebrow and the hair of the kneeling Magus in the Prado's *Adoration of the Magi*, in the mane of the horse in the Prado's *Saint George Battles the Dragon*, and also in the vegetation of the Prado's *Vertumnus and Pomona* sketch for the Torre de la Parada). But the marks here are different, and not likely, in my opinion, to have an aesthetic purpose. They are all in the center and on the right side of the paintings, and in many cases in areas of light-colored paint (e.g., the sky above the head of the allegorical figure Charity in *The Triumph of Divine Love*) and not in shaded areas. In this and other cases they do not reveal underlying tones that contrast with the paint surface.

20 Scribner 1975, pp. 525–26, fig. 13. For *The Triumph of Hope*, see also the essay by García Sanz in this volume.

BIBLIOGRAPHY

ATERIDO FERNÁNDEZ, MARTÍNEZ CUESTA, and PÉREZ PRECIADO 2004
A. Aterido Fernández, J. Martínez Cuesta, and J. J. Pérez Preciado, *Inventarios Reales: Las colecciones de pintura de Felipe V e Isabel Farnesio*, Madrid, 2004, II, pp. 177–78.

BAUDOUIN et al. 1962
Frans Baudouin et al., *Rubens Diplomaat* [exh. cat., Elewijt, Rubenskasteel], Brussels, Éditions de la Connaissance, 1962.

BAUMSTARK 1988
Reinhold Baumstark, *Peter Paul Rubens: Tod und Sieg des römischen Konsuls Decius Mus*, Vaduz, Sammlungen des Fürsten von Liechtenstein, 1988.

BOUZA 1998
Fernando Bouza (ed.), *Cartas de Felipe II a sus hijas*, Madrid, Akal Ediciones, 1998.

BETEGÓN DÍEZ 2004
Ruth Betegón Diez, *Isabel Clara Eugenia: Infanta de España y soberana de Flandes*, Isabel Belmonte López (ed.), Barcelona, Plaza Janés, 2004.

BEVERWYCK 1638
Jan van Beverwyck, *Van de uytnemenheyt des vrouwelicken geslachts*, Dordrecht, 1638.

BISACCA and DE LA FUENTE MARTÍNEZ 2011
George Bisacca and José de la Fuente Martínez, "The Treatment of Dürer's Adam and Eve Panels at the Prado Museum," in *Facing the Challenges of Panel Paintings Conservation: Trends, Treatments and Training; Proceedings of a Symposium at the Getty Center, May 17–18, 2009*, Los Angeles, J. Paul Getty Museum, 2011, pp. 10–24.

BOUWSMA 2000
William J. Bouwsma, *The Waning of the Renaissance, 1550–1640*, New Haven, CT, Yale University Press, 2000.

BRASSAT 1988
Wolfgang Brassat, "Für die Einheit der katholischen Liga: Zum politischen Gehalt des Eucharistie-Zyklus von Peter Paul Rubens," in *Idea, Werke-Theorien-Dokumente (Jahrbuch der Hamburger Kunstalle)*, VII, 1988, pp. 43–62.

BRASSAT 1992
Wolfgang Brassat, *Tapisserien und Politik: Funktionen, Kontexte und Rezeption eines repräsentativen Mediums*, Berlin, Mann, 1992.

BRILLIANT 2011
Virginia Brilliant, *Triumph & Taste: Peter Paul Rubens at the Ringling Museum of Art*, London, Scala, 2011.

BROSENS 2010
Koenraad Brosens, "New Light on the Raes Workshop in Brussels and Rubens's *Achilles* Series," in Thomas P. Campbell and Elizabeth A. H. Cleland eds. *Tapestry in the Baroque: New Aspects of Production and Patronage, the Metropolitan Museum of Art Symposia*; New York, The Metropolitan Museum of Art, 2010, pp. 20–33.

BROSENS 2011
Koenraad Brosens, *Rubens: Subjects from History: The Constantine Series* (Corpus Rubenianum Ludwig Burchard, part XIII, no. 3), London and Turnhout, Harvey Miller, 2011.

BROWN 1998
Christopher Brown, "Rubens and the Archdukes," in Werner Thomas and Luc Duerloo (eds.), *Albert & Isabella, 1598–1621: Essays*, Turnhout, Brepols, 1998, pp. 121–28.

CALVETE DE ESTRELLA 2001
Juan Christóval Calvete de Estrella, *El felicissimo viaje del muy alto y muy poderoso príncipe don Phelippe*, Paloma Cuenca (ed.), Madrid, Sociedad Estatal para la Conmemoración de los Centenarios de Felipe II y Carlos V, 2001.

CAMPBELL 2002
Thomas P. Campbell, with contributions by Maryan Ainsworth et al., *Tapestry in the Renaissance: Art and Magnificence* [exh. cat., New York, Metropolitan Museum of Art], New York, Metropolitan Museum of Art, 2002.

CAMPBELL 2007
Thomas P. Campbell (ed.), *Tapestry in the Baroque: Threads of Splendor* [exh. cat., New York, Metropolitan Museum of Art, and Madrid, Palacio Real], New York, Metropolitan Museum of Art, and New Haven, CT, Yale University Press, 2007.

CAPMANY 1858
Antonio de Capmany, *Museo histórico, que comprende los principales sucesos de España y el extranjero*, 2 vols., Madrid, J. Casas y Díaz, 1858.

CARDERERA 1868
Valentín Carderera, "Las tapicerías de Rubens," *El Museo Universal*, año XII, 28–30, 1868, pp. 218–19, 227–28, 234–35.

CARRILLO 1616
Juan Carrillo, *Relación histórica de la Real Fundación del Monasterio de Santa Clara de la Villa de Madrid*, Madrid, Luis Sánchez, 1616.

CAVESTANY 1941
Julio Cavestany, *El marco en la pintura española*, Madrid, Real Academia de Bellas Artes de San Fernando, 1941.

CHECA 1992
Fernando Checa, *Felipe II: Mecenas de las artes*, Madrid, Nerea, 1992.

CHECA et al. 1989
Fernando Checa Cremades et al., *El Escorial: Arte, poder y cultura en la corte de Felipe II*, Madrid, Universidad Complutense, 1989.

CORETH 2004
Anna Coreth, *Pietas Austriaca: Austrian Religious Practices in the Baroque Era*, trans. William D. Bowman and Anna Maria Leitgeb, West Lafayette, IN, Purdue University Press, 2004.

CURIE and BERGEON LANGLE 2009
Pierre Curie and Ségolène Bergeon Langle, *Peinture et dessin, vocabulaire typologique et technique*, Paris, Éditions du Patrimoine, 2009.

DARDES and ROTHE 1998
Kathleen Dardes and Andrea Rothe (eds.), *The Structural Conservation of Panel Paintings: Proceedings of a Symposium at the J. Paul Getty Museum, 24–28 April 1995, Los Angeles*, Los Angeles, J. Paul Getty Museum, 1998.

DE CLIPPEL 2008
Karolien De Clippel, "Defining Beauty: Rubens's Female Nudes," in A.-S. Lehmann and H. Roodenburg (eds.), *Body and Embodiment in Netherlandish Art (Nederlands Kuntshistorisch Jaarboek/Netherlands Yearbook of History Art)*, vol. 58, 2008, pp. 111–36.

DELLA CASA 2013
Giovanni Della Casa, *Galateo, or the Rules of Polite Behavior*, M. F. Rusnak (ed. and trans.), Chicago, University of Chicago Press, 2013.

DE MAEYER 1955
Marcel De Maeyer, *Albrecht en Isabella en de schilderkunst, Bijdrage tot de Geschidenis van de XVIIe—eeuwse Schilderkunst in de Zuidelijke Nederlanden, Verhandelingen van de Koninklijke Vlaamse Academie*

voor Wetenschappen en Schone Kunsten van België, Brussels, Paleis der Academiën, 1955.

DELMARCEL 1999
Guy Delmarcel, *Flemish Tapestry*, New York, Henry N. Abrams, 1999.

DEPAUW 1993
Carl Depauw, "De Eucharistie-cyclus/The Eucharist Series," in Paul Huvenne and Iris Kockelbergh (eds.), *Rubens Cantoor: Een verzameling tekeningen ontstaan in Rubens' atelier* [exh. cat., Antwerp, Rubenshuis], Gent, Snoeck-Ducaju & Zoon, 1993, pp. 192–213.

DESCRIPCIÓN 1881
Descripción de los tapices de Rubens que se colocan en el claustro del Monasterio de las Señoras Religiosas Descalzas Reales, en los dias de Viérnes Santo para la procesión del Santo Entierro y en la octava del Santis-suimim Corpus Christi para la procession de los altares, Madrid, Imprenta de Fortanet, 1881.

DUERLOO 2011
Luc Duerloo, "Marriage, Power and Politics: The Infanta and the Archduke," in Cordula Van Wyhe (ed.), *Isabel Clara Eugenia: Female Sovereignty in the Courts of Madrid and Brussels*, Madrid, Centro des Estudios Europa Hispánica, and London, Paul Holberton, 2011, pp. 154–79.

DUERLOO 2012
Luc Duerloo, *Dynasty and Piety: Archduke Albert (1598–1621) and Habsburg Political Culture in an Age of Religious Wars*, Farnham, Surrey, Ashgate, 2012.

DUERLOO and THOMAS 1998
Luc Duerloo and Werner Thomas (eds.), *Albrecht & Isabella, 1598–1621: Catalogus* [exh. cat., Leuven, Koninklijk Musea voor Kunst en Geschiedenis], Turnout, Brepols, 1998.

EICHBERGER 2005
Dagmar Eichberger (ed.), with contributions by Yvonne Bleyerveld et al., *Women of Distinction: Margaret of York, Margaret of Austria* [exh. cat., Mechelen, Lamot], Davidsfonds, Brepols, 2005.

ELBERN 1954
Victor H. Elbern, *Peter Paul Rubens: Triumph der Eucharistie: Wandteppiche aus dem Kölner Dom* [exh. cat., Essen, Villa Hügel], Cologne, 1954.

ELBERN 1955
Victor H. Elbern, "Die Rubensteppiche des Kölner Domes, Ihre Geschichte und ihre Stellung im Zyklus Triumph der Eucharistie," *Kölner Domblatt*, vol. 10, 1955, pp. 43–48.

ELIAS 1931
H. J. Elias, *Kerk en Staat in de zuidelijk Nederlanden onder de regering der Aartshertogen Albrecht en Isabella (1585–1621)*, Antwerp, De Sikkel, 1931.

ESTEBAN ESTRÍNGANA 2011
Alicia Esteban Estringana, "'What a princess, good God!': The Heritage and Legacy of Infanta Isabel," in Cordula Van Wyhe (ed.), *Isabel Clara Eugenia: Female Sovereignty in the Courts of Madrid and Brussels*, Madrid, Centro des Estudios Europa Hispánica and London, Paul Holberton, 2011, pp. 414–43.

FERMOR 1996
Sharon Fermor, *The Raphael Tapestry Cartoons: Narrative, Decoration, Design*, London, The Victoria and Albert Museum in association with Scala Books, 1996.

FERNÁNDEZ VILLABRILLE 1856
Francisco Fernández Villabrille, *El año eclesiástico: Funciones religiosas, aniversarios, rogativas, procesiones, etc., que la iglesia celebra durante el año*, Madrid, Establecimiento Tipográfico de Mellado, 1856.

FRAITURE 2012
Pascal Fraiture, "Dendro-archaeological Examination of Paintings by Pieter Brueghel the Younger," in D. Allart and C. Currie (eds.), *The Brueg[h]el Phenomenon: Paintings by Pieter Brueghel the Elder and Pieter Brueghel the Younger with a Special Focus on Technique and Copying Practice*, Brussels Royal Institute for Cultural Heritage, *Sciencia Artis*, vol. 8, 2012, pp. 1002–17.

FREEDBERG 1988
David Freedberg, *Iconoclasm and Painting in the Revolt of the Netherlands, 1566–1609*, doctoral thesis, Oxford University, 1972; London and New York, Garland, 1988.

FREEDBERG 1995
David Freedberg, *Peter Paul Rubens: Oil Paintings and Oil Sketches* [exh.cat., New York, Gagosian Gallery], New York, Gagosian Gallery, 1995.

DE FRUTOS SASTRE 2009
Leticia De Frutos Sastre, *El Templo de la Fama: Alegoría del marqués del Carpio*, Madrid, Fundación Arte Hispánico, 2009.

GACHARD 1884
M. Gachard, *Lettres de Philippe II a ses filles les Infantes Isabelle et Catherine, écrites pendant son voyage en Portugal (1581–1583)*, Paris, E. Plon, Nourrit et Cie., 1884.

GARCÍA SANZ 1999
Ana García Sanz, "Nuevas aproximaciones a la serie El Triunfo de La Eucaristía," in *El arte en la corte de los Archiduques Alberto de Austria, Isabel Clara Eugenia (1598–1633): Un reino imaginado* [exh. cat., Madrid, Palacio Real], Madrid, Sociedad Estatal para la Conmemoración de los Centenarios de Felipe II y Carlos V y Patrimonio Nacional, 1999, pp. 108–17.

GARCÍA SANZ 2010
Ana García Sanz, "El monasterio de las Descalzas Reales: Arte y espiritualidad en el Madrid de los Austrias," in *Pinturas murals de la escalara principal: Monasterio de las Descalzas Reales de Madrid*, Madrid, Patrimonio Nacional and BBVA, 2010.

GARCÍA SANZ et al. 2010
Ana García Sanz et al., *La Descalzas Reales: Orígenes de una comunidad religiosa en el siglo XVI*, Madrid, Patrimonio Nacional Fundación Caja Madrid, 2010.

GLEN 1977
Thomas L. Glen, *Rubens and the Counter-Reformation: Studies in His Religious Paintings between 1609 and 1620*, Ph.D. diss., Princeton University, 1975; New York and London, Garland, 1977.

GONZÁLEZ GARCÍA 2007
Juan Luis González García, "'Pinturas tejidas': La guerra como arte y el arte de la guerra en torno a la empresa de Túnez (1535)," *Reales Sitios*, vol. 174, 2007, pp. 24–47.

GSCHWEND 2002
A. Jordan Gschwend, "Los retratos de Juana de Austria posterios a 1554: La imagen de una princesa de Portugal, una regente de España y una jesuita," *Reales Sitios*, vol. 151, 2002, pp. 42–65.

HELD 1968
Julius S. Held, "Adoration of the Holy Sacrament by the Ecclesiastic Hierarchy," *J. B. Speed Art Museum Bulletin*, vol. 27, no. 3, 1968, pp. 2–22.

HELD 1980
Julius S. Held, *The Oil Sketches of Peter Paul Rubens: A Critical Catalogue*, 2 vols., Princeton, NJ, Princeton, University Press, 1980.

HERRERO CARRETERO 2007
Concha Herrero Carretero, entry for cats. 19–24 (paintings and tapestries from the *Eucharist* series), in Thomas P. Campbell (ed.), *Tapestry in the Baroque: Threads of Splendor* [exh. cat., New York, Metropolitan Museum of Art, and Madrid, Palacio Real], New York, Metropolitan Museum of Art, and New Haven, CT, Yale University Press, 2007, pp. 218–33.

HERRERO CARRETERO 2008
Concha Herrero Carretero, *Obras maestras de Patrimonio Nacional: Rubens, 1577–1640, colección de tapices*, Madrid, Patrimonio Nacional, 2008.

HERRERO CARRETERO 2009
Concha Herrero Carretero, *Rubens, 1577–1640, colección de tapices*, Madrid, Patrimonio Nacional, 2009.

HERRERO CARRETERO 2010
Concha Herrero Carretero, "Tapestries for Court and Ecclesiastical Use in Seventeenth-Century Spain," in *Tapestry in the Baroque: New Aspects of Production and Patronage*, New York, Metropolitan Museum of Art, 2010, pp. 274–83.

HUBALA 1990
Erich Hubala, "Peter Paul Rubens: Die Rolle seines Skizzenstils für die Entwicklung seiner Malerei," *Abhandlungen der Braunschweigischen Wissenschaftlichen Gesellschaft*, vol. 42, 1990, pp. 85–126.

HUGO 1627
Herman Hugo, *The Siege of Breda*, 1627; reprint Ilkley and London, Scolar Press, 1975.

JAFFÉ and BRADLEY 2005
David Jaffé and Amanda Bradley, *Rubens: A Master in the Making*, London, National Gallery, 2005.

JUNQUERA DE VEGA and HERRERO CARRETERO 1986
Paulina Junquera de Vega and Concha Herrero Carretero, *Catálogo des tapices del Patrimonio Nacional*, vol. 1: *Siglo XVI*, Madrid, Patrimonio Nacional, 1986.

JUNQUERA DE VEGA and DIAZ GALLEGOS 1986
Paulina Junquera de Vega and Carmen Diaz Gallegos, *Catálogo des tapices del Patrimonio Nacional*, vol. 2: *Siglo XVII*, Madrid, Patrimonio Nacional, 1986.

JUNQUERA AND JUNQUERA 1969
Paulina Junquera and Juan José Junquera, "Descalzas Reales: Serie de tapices; La apoteosis de la Eucaristía," *Reales Sitios*, vol. 22, 1969, pp. 18–31.

KARAFEL 2002
Lorraine Karafel, "The Sack of Tunis" (entry for cat. 50), in Thomas P. Campbell, with contributions by Maryan Ainsworth et al., *Tapestry in the Renaissance: Art and Magnificence* [exh. cat., New York, Metropolitan Museum of Art], New York, Metropolitan Museum of Art, 2002, pp. 428–34.

KLINGENSTEIN 1910
L. Klingenstein, *The Great Infanta Isabel, Sovereign of the Netherlands*, New York, G. Putnam's Sons, and London, Methuen, 1910.

KOSLOW 1996
Susan Koslow, "Law and Order in Rubens's *Wolf and Fox Hunt*," *The Art Bulletin*, vol. 78, December 1996, pp. 680–706.

KUBLER 1982
George Kubler, *Building the Escorial*, Princeton, NJ, Princeton University Press, 1982.

LAMMERTSE 2003
Friso Lammertse, "Small, Larger, Largest: The Making of Peter Paul Rubens's *Life of Achilles*," in Friso Lammertse and Alejandro Vergara (eds.), *Peter Paul Rubens: He leven van Achilles / Peter Paul Rubens: The Life of Achilles* [exh. cat., Rotterdam, Museum Boijmans Van Beuningen, and Madrid, Museo Nacional del Prado], Rotterdam, NAi Publishers, 2003, pp. 11–31.

LAMMERTSE AND VERGARA 2003
Friso Lammertse and Alejandro Vergara (eds.), *Peter Paul Rubens: He leven van Achilles / Peter Paul Rubens: The Life of Achilles* [exh. cat., Rotterdam, Museum Boijmans Van Beuningen, and Madrid, Museo Nacional del Prado], Rotterdam, NAi Publishers, 2003.

LIBBY 2013
Alexandra Libby, "Piety, Politics, and Patronage: Isabel Clara Eugenia and Peter Paul Rubens's *The Triumph of the Eucharist* Tapestry Series," Ph.D. diss., University of Maryland, 2013.

LIEDTKE 1984
Walter A. Liedtke, *Flemish Paintings in the Metropolitan Museum of Art*, 2 vols., New York, Metropolitan Museum of Art, 1984.

LLANOS Y TORRIGLIA 1933
Félix de Llanos y Torriglia, *Desde la cruz al cielo: Vida y muerte de la Infanta Isabel Clara Eugenia*, Madrid, Ediciones "Fax," 1933.

LOMAZZO 1584
Gian Paolo Lomazzo, *Trattato dell'arte della pittura, scoltura et architettura*, Milan, 1584.

LOWE 2003
K. J. P. Lowe, *Chronicles and Convent Culture in Renaissance and Counter-Reformation Italy*, Cambridge, Cambridge University Press, 2003.

MAGURN 1955
Ruth Saunders Magurn (trans. and ed.), *The Letters of Peter Paul Rubens*, Cambridge, MA, Harvard University Press, 1955.

MARÍAS and BUSTAMENTE 1991
Fernando Marías and Agustin Bustamente, "De las Descalzas Reales a la Plaza Mayor: Dibujos madrileños en Windsor Castle de la colección de Cassiano del Pozzo," in *Cinco siglos de arte en Madrid (xv–xx), III Jornados de Arte, 1986, Departamento de Historia del Arte, Diego Velázquez Centro de Estudios Históricos, CSIS*, Madrid, Alpuerto, 1991, pp. 73–86.

MARTIN 1984
Gregory Martin, "Review of 'The Triumph of the Eucharist, Tapestries Designed by Rubens,'" *The Burlington Magazine*, vol. 126, 1984, p. 301.

MARTÍNEZ HERNÁNDEZ 2011
Santiago Martínez Hernández, "'Enlightened Queen, clear Cynthia, beauteous moon': The Political and Courtly Apprenticeship of the Infanta Isabel Clara Eugenia," in Cordula Van Wyhe (ed.), *Isabel Clara Eugenia: Female Sovereignty in the Courts of Madrid and Brussels*, Madrid, Centro des Estudios Europa Hispánica and London, Paul Holberton, 2011, pp. 20–59.

MCGRATH 1981
Elizabeth McGrath, "Celebrating the Eucharist" [review of De Poorter 1978], *Art History*, vol. 4, 1981, pp. 474–79.

MERRIAM 2012
Susan Merriam, *Seventeenth-Century Flemish Garland Paintings: Still Life, Vision and the Devotional Image*, Farnham, Ashgate, 2012.

MITCHELL and ROBERTS 1998
Paul Mitchell and Lynn Roberts, *A History of European Picture Frames*, Seattle, University of Washington Press, 1998.

MONLAU 1850
P[edro] F[elipe] M[onlau], *Madrid en la mano o el amigo del forastero en Madrid y sus cercanías*, Madrid, Imprenta de Gaspar y Roig, 1850.

NEUMEISTER 2013
Mijam Neumeister (ed.), *Brueghel: Gemälde von Jan Brueghel D.Ä.*, Munich, Bayerische Staatsgemäldesammlungen, 2013, pp. 410–15.

OCHOA 1850–70
Eudenio de Ochoa, *Epistolario español: Colección de cartas de españoles ilustres antiguos y modernos*, 2 vols., Madrid, M. Rivadeneyra, 1850–70.

ÓRGANOS 1999
Órganos de la Comunidad de Madrid: Siglos XVI a XX, Madrid, Dirección General de Patrimonio Cultural, Comunidad de Madrid, 1999.

ORTEGA Y GASSET 1959
José Ortega y Gasset, *Velázquez*, Madrid, Revista de Occidente, 1959.

PACHECO [1648] 1990
Francisco Pacheco, *Arte de la pintura* [1648], Bonaventura Bassegoda i Hugas (ed.), Madrid, Cátedra, 1990.

PALMA 1636
Juan de Palma, *Vida de la seteníssima infant sor Margaretia de la Cruz religiosa descalça de S/ Clara*, Madrid, Imprenta Real, 1636.

PARKER 1977
Geoffrey Parker, *The Dutch Revolt*, London, Penguin Books, 1977.

PASTURE 1925
Alexandre Pasture, *La restauration religieuse aux Pays-Bas Catholiques sous les Archiducs Albert et Isabelle (1596–1633)*, Recueil de Travaux, 2me série, Leuven, Librarie Universitaire, 1925.

PEÑA 1632
Juan Antonio de la Peña, *Discurso en exaltación de los improperios que padeció la sagrada imagen de Christo N.S. a manos de la perfidia judaica: Con relación de la magnífica octava, sermons, letras y convent de las Descalzas la seteníssima y religiossíssima infant sor Margarita de la Cruz*, Madrid, Francisco Martínez, 1632.

PÉREZ DE TUDELA 2011
Almudena Pérez de Tudela, "Making, Collecting, Displaying and Exchanging Objects (1566–99): Archival Sources Relating to the Infanta Isabel's Personal Possessions," in Cordula Van Wyhe (ed.), *Isabel Clara Eugenia: Female Sovereignty in the Courts of Madrid and Brussels*, Madrid, Centro des Estudios Europa Hispánica and London, Paul Holberton, 2011, pp. 60–87.

PÉREZ SANCHEZ 1972
Alfonso Emilio Pérez Sánchez, *Mostra di disegni spagnoli*, Florence, Olschki, 1972.

PIOT 1888–89
Charles Piot, "Isabelle-Claire-Eugénie," *Biographie nationale*, vol. 10, Brussels, Bruylant-Christophe et Cie., 1888–89, cols. 12–20.

POLLMANN 2011
Judith Pollmann, *Catholic Identity and the Revolt of the Netherlands, 1520–1635*, Oxford, Oxford University Press, 2011.

DE POORTER 1978
Nora De Poorter, *The Eucharist Series* (Corpus Rubenianum Ludwig Burchard, part II), 2 vols., London and Philadelphia, Harvey Miller–Heyden & Son, 1978.

DE POORTER 1997
Nora De Poorter, "De Triomf van de Eucharistie / The Triumph of the Eucharist," in Guy Delmarcel et al., *Rubens Textiel / Rubens's Textiles* [exh. cat., Antwerp, Hessenhuis], Antwerp, Luc Denys, 1997, pp. 78–105.

PORTÚS 1993
Javier Portús Pérez, *La antiqua procession del Corpus Christi en Madrid*, Madrid, Communidad de Madrid, 1993.

PORTÚS 1998
Javier Portús Pérez, "Las Descalzas Reales en la cultura festiva del Barroco," *Reales Sitios*, vol. 138, 1998, pp. 2–12.

PUGET DE LA SERRE 1634
Jean Puget de la Serre, *Mausolée erigé à la memoire immortelle de tres haute . . . Princesse Isabelle Claire Eugenie d'Austriche, Infante d'Espagne . . .*, Brussels, 1634.

RABB 1975
Theodore Rabb, *The Struggle for Stability in Early Modern Europe*, New York and Oxford, Oxford University Press, 1975.

DE RAM 1828
P. F. X. de Ram (ed.), *Synodicon Beligicum: Acta omnium Ecclessiarum Belgii a Concilio Ttidentino usque ad Concordatum anni 1801* I, Mechelen, Hanicq, 1828.

RODRÍGUEZ G. DE CEBALLOS 1992
Alfonso Rodríguez G. de Ceballos, "Espacio sacro teatralizado: El influjo de las técnicas escénicas en el retablo barroco," in Agustin de la Granja, Heraclia Castellón, and Antonio Serrano (eds.), *En torno al teatro en el Siglo de Oro*, Almería, Instituto de Estudios Almerienses, 1992, pp. 136–54.

ROOSES 1886–92
Max Rooses, *L'oeuvre de P. P. Rubens, histoire et description de ses tableaux et dessin*, I–V, Antwerp, 1886–92.

ROOSES and RUELENS 1900
Max Rooses and Charles Ruelens (eds.), *Correspondance de Rubens et documents épistolaires concernant sa vie et ses oeuvres*, vol. 3 (1622–26), Amberes, 1900.

RUBIN 1991
Miri Rubin, *Corpus Christi: The Eucharist in Late Medieval Culture*, Cambridge, Cambridge University Press, 1991.

RUIZ GÓMEZ 1998
Leticia Ruiz Gómez, "Dos nuevos lienzos de escuela madrilène en la Descalzas Reales de Madrid, y una hipótesis sobre la devoción al Santo Sepulcro," *Reales Sitios*, vol. 138, 1998, pp. 55–62.

SAINSBURY 1859
W. Noël Sainsbury (ed.), *Original unpublished papers illustrative of the life of Sir Peter Paul Rubens*, London, 1859.

SALVÁ and SAINZ DE BARANDA 1852
Miguel Salvá and Pedro Sainz de Baranda, *Colección de documentos inéditos para la historia de España*, Madrid, Viuda de Calero, vol. 21, 1852.

SÁNCHEZ 1998
Magdalena S. Sánchez, *The Empress, the Queen, and the Nun: Women and Power at the Court of Philip III of Spain*, Baltimore, Johns Hopkins University Press, 1998.

SÁNCHEZ and SAINT SAËNS 1996
Magdalena Sánchez and Alain Saint Saëns (eds.), *Spanish Women in the Golden Age: Images and Realities*, Westport, CT, Greenwood Press, 1996.

SANCHO 1995
José Luis Sancho, *La arquitectura de los sitios reales: Catálogo histórico de los palacios, jardines y patronatos reales del Patrimonio Nacional*, Madrid, Patrimonio Nacional, 1995.

SANDTNER 2010
Claudia Sandtner, *Mobile Ausstattungen am Hof der Este in Ferrara: Arazzi als Repräsentationsform des 15. und 16. Jahrhunderts*, Institut für Kunstgeschichte der Universität Stuttgart, 2010.

SCHROEDER 1978
H. J. Schroeder (trans.), *Canons and Decrees of the Council of Trent*, Rockford, IL, Tan Books, 1978.

SCRIBNER 1975
Charles Scribner III, "Sacred Architecture: Rubens' Eucharist Tapestries," *The Art Bulletin* 58, no. 4, 1975, pp. 519–28.

SCRIBNER 1980
Charles Scribner III, "Review of Corpus Rubenianum Ludwig Burchard II: The Eucharist Series; By Nora de Poorter," *The Burlington Magazine*, vol. 122, 1980, pp. 772–73.

SCRIBNER 1982
Charles Scribner III, *The Triumph of the Eucharist: Tapestries Designed by Rubens*, Studies in Baroque History, Ann Arbor, UMI Research Press, 1988.

SIMÓN DÍAZ 1964
José Simón Díaz, *Fuentes para la historia de Madrid y su provincial*, Madrid, Instituto de Estudios Madrileños, 1964.

SUTTON, WIESEMAN, and VAN HOUT 2004
Peter C. Sutton, Marjorie E. Wieseman, and Nico van Hout, *Drawn by the Brush: Oil Sketches by Peter Paul Rubens* [exh. cat., Greenwich, CT, Bruce Museum; Berkeley, CA, Berkeley Art Museum and Pacific Film Archive; Cincinnati, OH, Cincinnati Art Museum], New Haven, CT, Yale University Press, 2004.

SUTTON et al. 1993
Peter C. Sutton et al., *The Age of Rubens* [exh. cat., Boston, Museum of Fine Arts, and Toledo, Toledo Museum of Art], Boston, Museum of Fine Arts, and Ghent, Ludion, 1993.

THOMAS 1998
Werner Thomas, "Andromeda Unbound: The Reign of Albert and Isabella in the Southern Netherlands, 1598–1621," in Werner Thomas and Luc Duerloo (eds.), *Albert & Isabella, 1598–1621: Essays*, Turnhout, Brepols, 1998, pp. 1–14.

THOMAS and DUERLOO 1998
Werner Thomas and Luc Duerloo (eds.), *Albert & Isabella, 1598–1621: Essays*, Turnhout, Brepols, 1998.

THUILLIER and FOUCART 1967
Jacques Thuillier and Jacques Foucart, *Rubens' Life of Marie de Medici*, New York, H. N. Abrams, 1967.

THØFNER 2007
Margit Thøfner, *A Common Art: Urban Ceremonial in Antwerp and Brussels during and after the Dutch Revolt*, Zwolle, Waanders, 2007.

TORMO 1917
Elias Tormo, *En las Descalzas Reales: Estudios históricos, iconográficos y artísticos*, Madrid, 1917.

TORMO 1942
Elias Tormo, "La apoteosis eucarística de Rubens: Los tapices des las Descalzas Reales de Madrid," *Archivo Español de Arte*, vol. 15, 1942, pp. 1–26, 117–31, 291–315.

TORMO 1945
Elias Tormo, *En las Descalzas Reales de Madrid: Los tapices; La apoteosis eucarística de Rubens*, Madrid, 1945.

VANDER AUWERA 2007
Joost Vander Auwera, *Rubens, a Genius at Work: The Works of Peter Paul Rubens in the Royal Museum of Fine Arts of Belgium Reconsidered*, Brussels, 2007.

VAN DER MEULEN 1994
Marjon Van der Meulen, *Rubens: Copies after the Antique* (Corpus Rubenianum Ludwig Burchard, part XXIII), 3 vols., London, Harvey Miller, 1994.

VAN SPRANG 2005
Sabine van Sprang, "Les peintres à la cour d'Albert et Isabelle: Une tentative de classification," in Hans Vlieghe and Kathlijne van der Stighelen (eds.), *Sponsors of the Past: Flemish Art and Patronage,*

1550–1700, Proceedings of the Symposium Organized at the Katholiek Universiteit Leuven, Turnhout, Brepols, 2005, pp. 37–46.

VAN WYHE 2004
Cordula Van Wyhe, "Court and Convent: The Infanta Isabella and Her Franciscan Confessor Andrés de Soto," *Sixteenth Century Journal*, vol. 35, no. 2, Summer 2004, pp. 411–45.

VAN WYHE 2011a
Cordula Van Wyhe, "Piety, Play and Power: Constructing the Ideal Sovereign Body in Early Portraits of Isabel Clara Eugenia (1586–1603)," in Cordula Van Wyhe (ed.), *Isabel Clara Eugenia: Female Sovereignty in the Courts of Madrid and Brussels*, Madrid and London, Centro des Estudios Europa Hispánica and Paul Holberton, 2011, pp. 88–129.

VAN WYHE 2011b
Cordula Van Wyhe (ed.), *Isabel Clara Eugenia: Female Sovereignty in the Courts of Madrid and Brussels*, Madrid and London, Centro des Estudios Europa Hispánica and Paul Holberton, 2011.

VERBERCKMOES 1998
Johan Verberckmoes, "The Archdukes in Their Humor," in Werner Thomas and Luc Duerloo (eds.), *Albert & Isabella, 1598–1621: Essays*, Turnhout, Brepols, 1998, pp. 137–44.

VERGARA 1999a
Alejandro Vergara, *Rubens and His Spanish Patrons*, Cambridge, Cambridge University Press, 1999.

VERGARA 1999b
Alejandro Vergara (ed.), *El arte en la corte de los Archiduques Alberto de Austria, Isabel Clara Eugenia (1598–1633): Un reino imaginado* [exh. cat., Madrid, Palacio Real], Madrid, Sociedad Estatal para la Conmemoración de los Centenarios de Felipe II y Carlos V and Patrimonio Nacional, 1999.

VEROUGSTRATE-MARCQ and VAN SCHOUTE 1989
Hélène Verougstrate-Marcq and Roger Van Schoute (eds.), *Cadres et supports dans la peinture flamande aux 15e et 16e siècles*, Heure-le-Romain, 1989.

DE VILLERMONT 1912
Marie Hennequin de Villermont, *L'infante Isabelle, gouvernante des Pays-Bas*, preface by Godefroid Kurth, 2 vols., Tamines, Duclot-Roulin, and Paris, Librairie S. François, 1912.

VILLERS 2000
Caroline Villers, *The Fabric of Images: European Paintings on Textile Supports in the Fourteenth and Fifteenth Centuries*, London, Archetype Publications, 2000.

VLIEGHE 1987
Hans Vlieghe, *Rubens: Portraits of Identified Sitters Painted in Antwerp* (Corpus Rubenianum Ludwig Burchard, part XIX), London and New York, Oxford University Press, 1987.

WADUM 2009
Jorgen Wadum, "The Antwerp Brand on Paintings on Panels," in *Technical Art History: Painter's Supports and Studio Practices of Rembrandt, Dou and Vermeer*, Amsterdam, University of Amsterdam, 2009, pp. 179–98.

WARNKE 1980
Martin Warnke, *Peter Paul Rubens: Leben und Werk* (English edition: *Rubens: Life and Work*, New York, Barron's, 1980).

WATERWORTH 1848
J. Waterworth (ed. and trans.), *The Canons and Decrees of the Sacred and Oecumenical Council of Trent*, London, Dolman, 1848.

WAUTERS 1878
Alphonse-Guillaume-Ghislain Wauters, *Les tapisseries bruxelloises: Essai historique sur les tapisseries de haute et de basse-lice de Bruxelles*, Brussels, 1878.

WHEELOCK 1991
Arthur K. Wheelock Jr., "Trompe-l'Oeil Painting: Visual Deceptions or Natural Truths?," in Joy Kenseth (ed.), *The Age of the Marvelous*, Dartmouth, Hood Museum of Art, 1992.

WHEELOCK 2005
Arthur K. Wheelock Jr., *Flemish Paintings of the Seventeenth Century: The Collections of the National Gallery of Art Systematic Catalogue*, Washington, DC, 2005.

WILLOCX 1929
F. Willocx, *L'introduction des Décrets du Concile de Trente dans les Pays-Bas et dans la Principauté de Liège*, Liège, Libraire Universitaire, 1929.

WOLTERS 1963
Christian Wolters, "Treatment of Warped Wood Panels by Plastic Deformation, Moisture Barriers, and Elastic Support," in G. Thomson (ed.), *Recent Advances in Conservation: Contributions to the IIC Rome Conference, 1961*, London, Butterworth, 1963.

WOOD 2002
Jeremy Wood, *Rubens: Drawing on Italy* [exh. cat., Edinburgh, National Gallery of Scotland, and Nottingham, Djanogly Art Gallery], Edinburgh, National Gallery of Scotland, 2002.

WOOLLETT 2012
Anne T. Woollett, "Michiel Coxcie and the Revitalization of Religious Paintings in the Southern Netherlands after 1566," in Koenraad Jonckeere and Ruben Suykerbuyk (eds.), *Art after Iconoclasm: Painting in the Netherlands between 1566 and 1585*, Turnhout, Brepols, 2012, pp. 75–94.

WOOLLETT and VAN SUCHTELEN 2006
Anne T. Woollett and Ariane van Suchtelen, with contributions by Tiarna Doherty, Mark Leonard, and Jørgen Wadum, *Rubens and Brueghel: A Working Friendship* [exh. cat., Los Angeles, J. Paul Getty Museum, and The Hague, Royal Picture Gallery Mauritshuis], Los Angeles, J. Paul Getty Museum, 2006.

INDEX